張武俊

CHANG Wu-chun

1942-

目　錄

Contents

部長序

臺灣與攝影相遇至今,積累了相當豐富的影像檔案與作品。攝影做為跨域極廣的藝術創作形式,已然成為再現生活場域、建構集體記憶、記錄歷史發展,以及推動當代影像實驗與文化行動的重要媒介。為了更有計畫的保存珍貴攝影文物,文化部自104年啟動「國家攝影資產搶救及建置攝影文化中心計畫」,邀集專家學者以及攝影創作者,共同投入攝影資產的調查工作,《臺灣攝影家》系列叢書即是重建臺灣攝影發展的重要載體及成果。

本年度的《雷驤》、《張武俊》與《何經泰》三本專書,透過論述書寫、對話訪談、年表彙整與作品呈現等多種撰述方式,以攝影家的生命史為起點,重溯他們初觸攝影、逐步摸索並拓展自身影像語彙的歷程:追索雷驤如何在詩性的紀實作品中透顯人文關懷、張武俊如何以風景人文攝影呈現本土認同、何經泰如何以多樣的攝影技術實驗展現對臺灣社會與文化議題的關注,並探討三位攝影家的影像實踐與臺灣社會發展之間的互動關係。豐富的內容不僅滋養了讀者的文化心靈,並為臺灣攝影影像脈絡提供深具價值的歷史資料。

《臺灣攝影家》系列叢書冀望透過長期的研究出版計畫,顯影更多傑出臺灣攝影家的影像創作與攝影實踐,提供給本土讀者觀看、理解與覺察臺灣攝影發展過程的多樣線索,並透過中英並陳的出版形式,推展跨國界的影像交流,構築臺灣與世界之間持續不斷的對話空間。

文化部部長

Foreword from the Minister of Culture

Taiwan's long history of photography has led to a rich collection of photographic works. As a creative medium with an extremely broad range, photography is an important method for recreating life spaces, building collective memories, recording historic development, promoting contemporary image experimentation, and encouraging cultural activism. To implement a more planned approach towards preserving treasured photographs, the Ministry of Culture launched the "Project for National Photographic Heritage Rescue and the Establishment of a Center for Photographic Culture" in 2015, inviting experts, academics, and photographers to jointly survey the nation's photography resources in order to revisit Taiwan's photographic development. An important vehicle and achievement of the project is the *Photographers of Taiwan* book series.

The three books in the series this year, featuring photographers Lay Hsiang, Chang Wu-chun, and Ho Ching-tai, compile diverse narratives, such as discourses, dialogues, interviews, timelines, and photographs. Using biographical history as a starting point, they show each photographer's introduction to photography, early learning process, and gradual mastery over own image vocabulary. They examine Chang's use of landscape and humanistic photography as tools for identifying with his native land, Lay's use of poetic documentary photography to show humanistic concern, and Ho's use of diverse photographic techniques to express his interest towards Taiwanese society and culture. The books delve into the three photographers' photography practices and how these relate to local social developments. Besides providing readers with spiritual nourishment, the ample information contained in the books makes them a valuable historical resource on the overall history and context of photography in Taiwan.

By adopting a long-term research and publishing plan, the *Photographers of Taiwan* book series highlights the photography and practices of more of Taiwan's best photographers, offering local readers diverse leads to view, understand, and perceive the course of development of Taiwanese photography. At the same time, by publishing in both the Chinese and English languages, we promote international exchanges of photography that support ongoing dialogues between Taiwan and the world.

Lee Yung-te
Minister of Culture

館長序

《臺灣攝影家》系列叢書自2017年開始編印至今,已出版24位攝影家專書。國立臺灣美術館為了促進對臺灣攝影家的深化研究,在2020年進行專書結構重整,以研究主編制度來組織專書的調研工作,透過史料的蒐整與分析,呈現臺灣傑出攝影家的創作歷程及影像內涵。本年度選作的三位攝影家分別為:雷驤、張武俊、何經泰,他們以獨特的鏡頭語言確立自身的影像風格,並透過攝影創作實踐,來探索影像與自然、文化、社會變遷的關係。

雷驤擅長以文字説故事,也透過影像訴説個人、家族記憶與時代歷史。此次專書在大量的史料爬梳與作品彙整的基礎上,發表許多未公開的手稿與創作影像。此外,也透過多人聯合訪談以及文獻、檔案的重整,脈絡化雷驤的影像創作歷程,追索其深厚的人文主義文化關懷,以及他穿梭於文學、繪畫、攝影與紀錄片等各種創作形式間,展現出率性與詩意的創作成果。

張武俊長期關注家鄉臺南的地方景物,以鏡頭發掘日常的地物風貌之美。臺灣南方的惡地、竹林、峽谷,經攝影家之眼,透顯出特殊的氛圍情境與氤氳色調。本專書首度公開張武俊2000年以後的攝影創作,包括《魚塭》與《濱海沙丘》等系列;口述訪談中也特別分享創作過程中的細節,讓讀者得以瞭解攝影家掌握光線「色溫」的技巧。

何經泰曾任攝影記者,他以影像訴説人們受到壓抑與忽視的政治迫害記憶,以及社會底層哀歌;其具有高度張力的影像作品,傳達出深刻的社會批判意識。本書收錄何經泰三組著名攝影系列作品,以及近作《百年不斷的人神之約》系列,並探討何經泰攝影實踐與臺灣社會發展之間的關係,提供讀者更多元的觀看途徑。

本年度的三本專書,展現了三位攝影家在影像實踐上的執著與堅持:雷驤以多幅影像並陳的再創作,展現詩性的人文影像空間;張武俊關注自然環境的變遷,提出空間與影像的關係思考;何經泰則以攝影技術的別樣嘗試,叩問臺灣的弱勢議題。今年叢書在調研書寫、田野訪談、年表編纂以及作品圖版集成等方面,皆彰顯攝影家各自的影像關懷視野,期望本叢書新穎的攝影研究取徑和歷史線索,引領讀者進入攝影家的影像世界。

國立臺灣美術館館長

Foreword from the Director of NTMoFA

The *Photographers of Taiwan* series has already published 24 volumes, each featuring a different photographer, since it was first launched in 2017. To encourage more in-depth research on Taiwanese photographers, National Taiwan Museum of Fine Arts reorganized the series in 2020, appointing a research editor-in-chief to oversee the compilation. By gathering and analyzing historical materials, the series presents the creative processes of distinguished Taiwanese photographers and offers insights into the meaning behind their photographs. The three photographers featured this year are Lay Hsiang, Chang Wu-chun, and Ho Ching-tai. Through distinct camerawork, they have each established their own photographic style, and explored the changing relationships between images and nature, culture, and society.

Lay Hsiang is a talented writer who also uses imagery to recount personal and family memories as well as historic events. To compile his photographer's book, researchers combed through a large volume of historical documents and photographs. The book includes many previously unpublished manuscripts and images. Utilizing joint interviews, historic documents, and files, researchers show the underlying structure of Lay's creative image-making process while also exploring his profound humanism and cultural traits. Lay's ability to shift between literature, drawing, photography, and documentary filmmaking underscores the uninhibited, poetic nature of his creative achievements. Chang Wu-chun has long focused on the local scenery of Tainan. Through his camera lens, he explores the aesthetic style of everyday places and things. With a photographer's knack for seeing things in unique ways, Chang's photos use strong tones to reveal the special atmospheric settings of the badlands, bamboo forests, and gorges of southern Taiwan. This volume reveals to the public for the first time Chang's photographs taken after the year 2000, including the *Coastal Dunes* and *Fish Pond* series. In the interview, Chang also focuses on the details of his creative process, explaining his technical grasp of color temperature in lighting. Once a photojournalist, Ho Ching-tai uses his images to record instances of political persecution, including repression and neglect, as well as the sadness pervading the lower rungs of society. The high degree of tensions in his photographs expresses intense social criticism and awareness. Ho's photographer's book features three famed photograph series and the recent series *The Hundred-Year Covenant Between Man and God*, and explores the relationship between Ho's photography and Taiwan's social development, providing readers a greater diversity of perspectives.

The three books in the series published this year present the dedication and perseverance of these three photographers. Lay's juxtaposition of multiple images reimagines scenes in a way that shows the poetic nature of culture, images, and space. Chang pays attention to changes in the natural environment and deliberates on the relationship between spaces and imagery. Ho, meanwhile, experiments with unusual photographic techniques to examine the problems faced by the underprivileged in Taiwan. This year's books combine research-based writing, field studies and interviews, timeline compilations, and photographs to highlight the scopes of concern of the three photographers' works. We hope that our novel research approach can guide readers into these photographers' respective world of images.

Liang Yung-fei
Director of National Taiwan Museum of Fine Arts

攝影家自序

從消逝的昨日連結新生的明天

民國56年（1966）我和攝影結緣，超過半世紀至今。每每回看過往親自為家人和朋友拍攝的相片，深刻地凝視相片，年代雖已消逝，上頭的人事物仍然鮮活地在眼前展開，並觸動人心！攝影是透過時間、精神而得以流傳並且保存在心底，攝影之於我如同好友，知己如酒，愈沉愈香，靜默卻能抵過千言萬語。

民國76年（1987）我開始踏上草山月世界，時時刻刻凝視自然，以眼睛探究這片土地，理解家鄉的風貌，時間待得愈久愈發覺自然的多樣性，以及傳統臺灣土角厝房屋，顯現當地「人與環境」密切相關的訊息。多年來觀察月世界的管芒花、彩竹而逐漸體會到屬於臺灣人的性格：壓不倒、不被逆境所擊垮的精神。我想每個人一生中都應該找到一個時刻去凝視和體驗自然，因為凝視和體驗，加深對夢想的執著。

我的攝影道路養成大多是在原地攀登，因為不是藝術科班出身，要自己唸經、自己修行、打造自己的廟，因此我培養觀察的興趣，遇到困難而不斷突破自我，用心去體驗生命，做好攝影家自身的本分，帶來最真、善和美的體驗。

最後要謝謝出版計畫背後的專業研究與支持，花費長時間整理影像、集結成書，並撰寫精闢的作品評析，也期待影像的紀錄作一拋磚引玉，讓大家共同來欣賞。

張武俊

攝影家

Preface from the Photographer

From the Fading Days of Yesteryear to the New Life of Tomorrow

In 1966, I forged a connection with photography that has now lasted for more than half a century. When I look at pictures from the past that I took for my family and friends, I can't tear my eyes away. While that era has passed, the people and things in those photos remain vividly alive before my eyes, still touching my heart! Photography is transmitted through time, through the spirit, and preserved deep in the heart. Photography to me is like a good friend, as familiar as a good wine whose flavor deepens as it settles, its silence more powerful than a thousand words.

It was in 1987 that I began treading the ground of the Moon World at Caoshan, Tainan. Every moment there I was deeply absorbed, gazing at nature all around me; I explored the land with my eyes, trying to understand its features and its character. The longer I stayed, the more I became aware of nature's diversity, as well as the traditional earthen homes of Taiwan, which speak to us of the intimate relationship between man and environment in that locale. Over the years, observing the swordgrass and the colored bamboo at Moon World, I gradually came to understand the character trait that typifies the Taiwanese: an indomitable spirit, one that remains strong in adversity. I think everyone should take a few moments of their life to let themselves gaze at nature and experience it, because to gaze and to experience in that way will deepen your commitment to your dreams.

My path toward becoming an accomplished photographer has mostly been to struggle upward from where I started. I am not the product of an art department, so I have to chant my own sutras, practice cultivation on my own, and build my own temple. For that reason, I developed an interest in observation, and have continued to break through my own limitations when I encounter difficulties. I experience life wholeheartedly and I fulfill the task of a good photographer, which is to transmit the most genuine, good, and beautiful kind of experience possible.

Finally, I would like to thank the professional research and support staff behind this publishing project, who have spent so much time organizing these images and assembling them into book form, as well as the insight shown in the appraisal and analysis of my works. I also hope that documenting my work here may spur greater talents than mine to share their own work, for the enjoyment of all.

Chang

Photographer Chang Wu-chun

專文
ESSAYS

風景攝影的南方視角
張武俊的風土之眼

文 / 關秀惠

前言

1992 年 4 月 25 日在臺北市立美術館舉辦「夢幻月世界」展覽的張武俊，首度將臺南草山月世界種種奇美如仙境般的景色呈現於北部觀眾面前。展覽開幕活動不僅邀請到當時備受敬重的攝影大師郎靜山出席，郎氏更為展覽專輯提筆作序，其中揮毫所寫：「利用光線即可表達萬千情景 因其深解藝術之道 造詣湛深」，讚揚與肯定張武俊的攝影成就。[1] 展覽隨後巡迴至臺灣省立美術館（今國立臺灣美術館）、屏東縣立文化中心、臺南市立藝術中心、高雄市立中正文化中心等地，一時之間張武俊之名彷彿與月世界畫上了等號，張武俊成了月世界的最佳代言人。幾年後，他也不負所望，將長期深耕於臺南草山月世界所發掘到的第二寶——彩竹，化為鏡頭下另一亮麗的主角。1998 年同樣在臺北市立美術館舉辦的「彩竹的故鄉」個展中，讓人觀見在歲時變化中，另一生命旺盛的植物以其婀娜多姿的姿態，默默點綴著荒蕪貧瘠的丘陵、峭壁、山頭與低谷。

兩次北部的個人大展，以及 1995 年在臺北與故鄉臺南舉辦的「全臺首學」個展，奠基了張武俊身為風景攝影家的地位；然而知道他學習攝影歷程的人，卻不禁訝異於他為了記錄兒子身影，才購入第一台傻瓜相機，之後卻可靠著參加攝影社團、自行閱讀各類藝術書籍，而在各大小型攝影比賽中獲得如此優秀成績。張武俊在多次訪談中提到，攝影不外乎就是「用心觀察與多拍攝作品」，卻鮮少談及他人與學會對他的影響；也許是宥於攝影家心中自持的創作理念，但也可能來自他出生於臺南保安小鎮，生活除了拍

照、參與臺南在地攝影社團活動，每日即固守著必須開門作生意的務實個性使然。[2]

張武俊一開始的素人資歷，不論是對於八〇與九〇年代的臺南攝影發展，或是臺灣的風景攝影內容皆具有特殊的意義。一是他未受攝影學院訓練，長期深耕於在地風土人文的攝影背景，讓我們明瞭除了留學海外或經營攝影相關產業的經驗之外，若對攝影創作有興趣，往往只能藉由參加攝影學會、購買雜誌、與友人相互切磋自學而成。[3]二是在臺灣攝影比賽的評比機制與學會風格的相互習染之下，攝影家們如何苦思竭慮、突破創作樣式的過程。而後者尤其顯現出攝影家作品的重要性所在。

風景攝影的在地發展

當張武俊選擇以月世界作為他跳脫攝影比賽機制的攝影主題時，從此便沉浸於關於月世界種種特有景觀的拍攝。他自述並無受到郎靜山或其他攝影家的影響，而希望分享不同於高雄田寮月世界的臺南草山，也有世界級的雲海與日出，攝影家的言語反映出他對於家鄉土地之美的認同；他也自豪於自己的作品獲得政府認可，提及彩竹作品媲美於日本的櫻花，曾被當作市長赴日交流時贈送貴賓的伴手禮。[4]由此看出，風景攝影對觀看者來說，除了審美價值，也包含了建構國家認同的權力意味，如同視覺文化學者米契爾（W. J. T. Mitchell）所言，討論風景形成的模式，不僅是追問風景是什麼或意味著什麼，還有風景「做」了什麼，這個「做」，表示它如何在文化實踐裡作用，除了是象徵權力關係，還有它如何成為文化權力的工具。[5]

關於風景的再現，看似以抽離環境、社會與政治等種種現實的局部景觀，或瞬間美景素樸地呈現在我們眼前，實則在西方風景繪畫的研究領域裡，已就其多種敘述類型——田園（georgic）、牧歌（pastoral）、異域（exotic）、崇高（sublime）、如畫（picturesque）等，探討它們分別在文學、繪畫、攝影等媒介之中的美學形式，以及如何成為身分認同的焦點。攝影發明之初與繪畫關係的爭議，

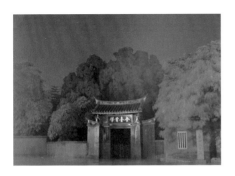

《全臺首學》系列作品 / 張武俊攝 / 臺南 / 1992-1999
A work from the *Confucian Temple* series / photo by Chang Wu-chun / Tainan / 1992-1999

在中西方已引起廣泛討論，無論是畫藝攝影（pictorialism）的興起，或是中國美術學界將攝影視為美術作品，風景攝影的定義也隨著相關論述的累積逐漸地被建構。[6] 去除了人存在的風景攝影，以其自然甚至如畫般的面貌向觀者進行審美邀請的同時，鏡頭下框取的景色卻可能是攝影家個人意志下的成果。一幅杳無人煙的廣袤地景，或是被高度抽象化的幾何線條所體現的多幅美國優勝美地國家公園（Yosemite National Park），其中超脫物質世界的山脈與荒野所展現的是攝影家對於自然精神境界的高度崇仰；又或，臺灣著名的集錦攝影家郎靜山，透過中國山水畫的構圖，傳達人如何坐臥於自然與山水合一的境界。即便郎靜山提出攝影應像中國繪畫的理念，在當時招致了膚淺與僵化的批評，他在臺創立的中國攝影學會，卻造成臺灣沙龍攝影的興起，全盛時期更成為戰後臺灣攝影發展的主流。[7]

不論是亞當斯的山脈風景或郎靜山的集錦攝影風格，我們卻無法簡單地將張武俊歸類為兩者其中之一。張武俊曾自述，因為顧及白天米行的生意，拍攝完的照片只能調好色彩數據後交由相館或彩印公司沖印，之後才在所沖印的毛片上框取沖洗的範圍，再次重新沖印或放大作品。[8] 對於攝影取景的重視所標示的框線就如同繪畫上對構圖的要求，而作品中種種抽象線條、光影對比、彩度明暗種種形式美感的表現，特別是早期《荷花》系列作品，更引人聯想當時盛行於攝影競賽或業餘團體的沙龍攝影。這或許與張武俊早期曾加入攝影團體、積極參與各項競賽、投稿《攝影天地》等雜誌，屢獲國際攝影榮銜的創作經驗相關。[9]

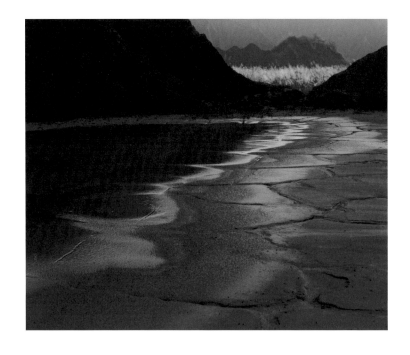

《月世界》系列作品，高雄市美術館典藏。張武俊自述拍攝當時，因為前一晚下過大雨，腳踩在泥沼般的河床，曾經跌了個跤，落得滿身泥巴 / 張武俊攝 / 臺南金馬寮 / 1991
A work from the *Moon World* series / Kaohsiung Museum of Fine Arts Collection / Chang notes that a heavy rain fell the night before he took this photo, and he lost his footing in the swampy ground of the riverbed, covering him with mud./ photo by Chang Jinmaliao, Tainan / 1991

然而撇除與當時所盛行的沙龍風格相近作品，張武俊其他大量、具有個人創作意志，並且重新開創畫意風格且極具在地色彩的影像，卻是那些經由長時間曝光等待、深入踏查以及全副武裝進入月世界險境才取得美景的作品。他自述：「每天清晨獨自穿梭在月世界的刺竹林中，卻常流血流汗，忍受肌膚之痛；還常受長蟲的驚嚇」[10]，以及半夜幾次夢到被月世界蛇群包圍而跳起猛烈搖晃棉被的事蹟等等，這些伴隨作品的驚險軼事，讓他的攝影作品於體現優美風景外，還隱含著攝影家如何冒險進入荒地、用鏡頭記錄荒土自然與風土人文的文化意涵。

帝國之眼與現代之眼

當八〇年代獲得國內各項攝影大獎後的張武俊，開始困窘於攝影內容的侷限，進而意圖尋找其他攝影題材時，他第一個想到的是童年時期曾經在保安坐糖廠車到龍崎遠足，之後長遠跋涉所看到的那一座吊橋。[11] 吊橋建築對於小孩而言，不僅是一座高大與稀奇的存在，同時也象徵了交通建設進入鄉野的現代性意義。位於鄉野之中吊橋雄偉的姿態，對於張武俊幼小心靈的衝擊，不禁令人遙想到第一位拍攝臺灣月世界地區的英國攝影師湯姆生（John Thomson）。湯姆生曾於1871年受馬偕醫生邀請，由廈門渡船抵達打狗港口，短暫停留三天後即從臺南府城轉道拔馬（今臺南左鎮），預計沿著山路前往高雄甲仙；在前往木柵（今高雄內門）的中途，湯姆生記錄了臺灣現存的第一張月世界特殊地形的照片。湯姆生因未在照片上題字，這張照片普遍被後來者認為是左鎮草山的月世界，然依據游永福的研究，拍攝地應是高雄內門附近。[12] 無論是否真的是與張武俊同樣拍攝了臺南草山月世界，張武俊與湯姆生同樣經歷了由左鎮到高雄內門的這段旅程；後者是為了尋找內地的原住民，替帝國記錄遠東地區的原始影像，前者則是為了尋找童年記憶所繫之處。

與湯姆生飄洋過海至遠東地區進行攝影紀錄的帝國目光不同，張武俊進入月世界除了尋找題材，還包含著童年回憶與對鄉土的關照。他於八〇與九〇年代初期所拍攝臺南草山地區的月世界，並

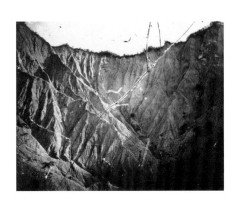

約翰 · 湯姆生，〈月世界〉，攝影，數位輸出，1871，61.5×76公分。高雄市立美術館典藏
John Thomson, *Moon World*, Photograph, Digital Output, 1871, 61.5×76cm. Kaohsiung Museum of Fine Arts permanent collection

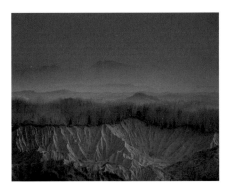

《月世界》系列作品 / 張武俊攝 / 臺南金馬寮 / 1991
A Work from the *Moon World series* / photo by Chang Jinmaliao, Tainan / 1991

非全部聚焦於月世界山脈各種大大小小雨溝所形成的童山濯濯景象，畫面強調的是整體氣氛的營造；因而我們可以看到接近日出時分，月世界遠方山脈的重巒層疊，以及近景中竹林扶疏生長於雲氣之中的特殊美感。原來海拔僅 204 公尺的月世界也有雲海壟罩、霧氣縹緲的世界級美景。由於臺灣戰後實施戒嚴與沙龍攝影的流行，風景攝影成為學會或業餘攝影團體的大宗題材；然，對於臺灣風景的藝術再現，其實不僅止於風景攝影類別。戰前因為現代西畫與寫生概念的倡導，臺灣戰後的畫家們也以寫生的方式到各個知名景點留下精彩作品，例如臺南知名畫家蔡草如，即曾在 1960 年代留下多幅關於草山月世界的速寫作品。這些作品起初著力於描繪月世界地形的險惡，隨後轉化成山脈下方開始出現屋舍、綠林相伴的寧靜田園風景；顯現畫家們對於月世界並非是視作奇景般的單純描繪，而是逐漸摻雜對於鄉土的情感與認同。

不停巡遊鄉土的目光

隨著長期月世界主題的拍攝，張武俊注意到此地容易讓人忽略卻永遠是山頭那一抹最美顏色的竹子，還有每到初秋一片盛開的芒花即景，以及最富人文寓意的月世界土角厝。以稻草攪泥、經過日曬後所製成的土角磚堆疊成牆壁的土角厝，是當地居民早期的住屋形式；張武俊認為這住起來冬暖夏涼的屋舍是先民智慧，必須有人為其留下紀錄，因而他一方面拍攝月世界，另一方面也企圖將此地特有的建築以影像保存下來。不同於純粹外觀式的調查紀錄，張武俊接觸當地人民，與他們閒話家常，最後他與每一戶人家皆十分熟稔。他透過與他們聊天的過程，了解到每一戶居住者的生活故事，進而拍攝其屋內的構造、擺設、物品與器具等，他的作品已不只是單純的風景攝影，而是具有風土與文化勘查的意義。在他《月世界土角厝》系列作品中，經常可見在長鏡頭與廣角鏡頭的交互運用下，屋內的家居擺設比例更趨放大，甚而成為畫面的重心，實際上侷促狹窄的屋內景致，更有了文化上的縱深涵義。

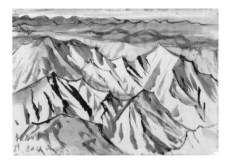

蔡草如，〈岳浪〉，1961
圖片來源：國立臺灣美術館
Cai Cao-ru, *Hills Like Ocean Waves* / 1961
Source: *National Taiwan Museum of Fine Arts*

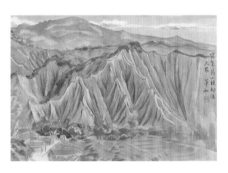

蔡草如，〈部落人家〉，1961
圖片來源：國立臺灣美術館
Cai Cao-ru, *Tribesmen's House* / 1961
Source: *National Taiwan Museum of Fine Arts*

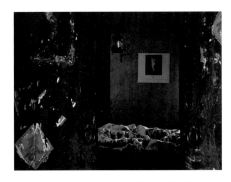

《月世界土角厝》系列作品 / 張武俊攝 / 臺南龍崎 / 2000
A work from the *Earthen Homes at Moon World* series
photo by Chang / Longqi, Tainan

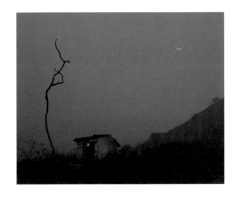

《月世界土角厝》系列作品 / 張武俊攝 / 臺南動員
1989.12.21
A work from the *Earthen Homes at Moon World* series
photo by Chang Dongyuan, Tainan / 1989.12.21

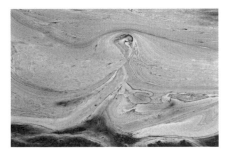

《魚塭》系列作品。張武俊於作者訪談時提到這張作品就像是身穿白衣的觀音大士，乘海而來 / 張武俊攝
2004
A work from the *Fish Ponds* series. Chang said this photo looked to him like the goddess Guanyin, wearing a white robe and striding across the seas. / photo by Chang

張武俊並非以觀光或窺視的心態拍攝土角厝影像，他深入當地居民的生活所拍攝的影像，饒有韻味；例如一幅傳達土地公廟默默守護當地居民的作品裡，趁黎明未曉時分，攝影家刻意拿了一盞燈籠掛在廟內，配合月亮高掛天空的角度，營造出枯樹、老廟、荒月的三角式構圖，並透過晨曦未露時高度色溫的深藍色彩，更增添了土地公廟亙古深遠的存在。攝影家謝震乾曾言，心象攝影難以被模仿的理由，是因心象攝影需經由作者個性、學識、生活環境、想像、與在季節性的氣氛下產生。[13] 換句話說，為了表現被對象物所觸動的心靈，攝影家往往透過攝影來傳達自己想像的意境。在一幅老翁痀僂的身影出現在毀壞門裡的作品，張武俊提及，照片裡的李先生因為兒子賺了大錢要重新改建居住多年的土角厝，本是喜事一椿，老先生卻不捨於自己所建造的老房子即將被移除改建。[14] 張武俊捕捉因為屋頂沒了，老翁喜憂參半的身影恰巧被映照在頹圮門裡的影像；畫面中影子背後的月世界山頭，與門上仍未斑駁的春聯相互對映著，彷彿訴說著老翁久居於月世界的各種物換星移。

張武俊將自我心境投射於攝影景物之中，還包括他每年於梅雨季節來臨前，到三股沿海地區拍攝的《魚塭》系列作品。他聚焦拍攝魚池表面中的各種生態現象，魚池菌種的光合作用與各種漂浮的物品，成了他鏡頭下所捕捉的奇異景觀與幻化色彩；然並非流於個人心境抒發，張武俊更以所見的各種人物形象與故事，將作品分別命名與類比，讓影像的內容扣連著攝影者個人的記憶與文化背景。同樣著迷於拍攝物體色彩與線條變化，張武俊的《萬年峽谷》系列，更加放大靜止於湍流之中的岩石紋路與峽谷奇景。臺灣美術史學者蕭瓊瑞提到，張武俊並不以獵奇作為藝術創作手段，他從不追求長程遠征之類的攝影活動，因他認為「一個藝術家應該拍他最熟悉的鄉土」，也由於他對於色溫精確的掌控，才能為這個只有岩石、流水，沒有樹木、天空、生物的臺灣風景，留下壯麗的樂章。[15] 因為長年觀察自然與氣候關係而練就的精準色溫控制技巧，讓張武俊不必到其他國家或甚至更遠的縣市，只要用心探尋腳下的土地，任何大千世界即在他的鏡頭下展現出來。

結語

張武俊開始拍攝專題攝影的八〇年代，正是臺灣紀實攝影蓬勃發展的時代，張武俊雖不是進行社會現實或是遠方弱勢族群的身影紀實主題，卻以在地的南方視角，展現了自身對於家鄉風土的長期投入與深刻觀察。與其他風景攝影不同，他對於攝影技巧與造型美感的要求，隱含其後的是對於偏遠地區的地域踏查，與專注地方景觀變遷的文化書寫。曾任中國攝影學會理事長的周志剛，在為其展覽所作序文裡，寫道：「在此十二年間，他走遍了月世界地區的每一角落，包括臺南、高雄兩縣的三十餘處的村鎮，通稱草山月世界、田寮月世界和燕巢月世界三大區域，總里程超過二十萬公里。」[16] 無論是花費了幾千個日子、幾萬個小時的長期巡遊與用心觀察，從月世界、孔廟、三股魚塭、海邊沙洲、安平古宅、澎湖咾咕石老屋、乃至草嶺萬年峽谷等一系列作品的創作軌跡之中，我們都無法忽略張武俊作品拍攝背後的艱辛歷程。攝影學者郭力昕曾提出國民黨統治時期的沙龍風景照片，多少被處理成帶有中國山水畫風味的景觀，然而近年來的臺灣風景中，攝影者扛著同樣昂貴的器材不辭辛勞地上山下海，意欲捕捉紀錄的卻不折不扣是「本土臺灣」的各地美景。[17] 張武俊也並非對於這些美景背後的環境變遷或生態破壞視而不見，在「夢幻月世界」的展覽序言裡，便已提到，拍攝月世界時可看到遠方高雄工業區的空氣汙染，經常使月世界呈現灰濛濛一片。[18] 張武俊作品給我們的啟發是：攝影家如何從生長的環境著手，在與大臺南地區的風土人文、自然地景息息相關的作品中，將自身對鄉土的感情與投射實踐出來；而我們又如何從他以月世界作品為起點所開摺、輻射出的南方視角，推導出臺灣風景攝影外其他更積極、深刻的意義。

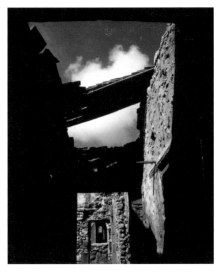

除了《月世界土角厝》系列，張武俊也曾前往澎湖拍攝咾咕石老屋 / 張武俊攝 / 澎湖西嶼二崁村 / 2000
In addition to his *Earthen Homes at Moon World* series, Chang traveled to Penghu to photograph the coral-stone houses there/ photo by Chang / Erkan Historic Village, Xiyu Township, Penghu / 2000

1. 郎靜山，〈序〉，收入張武俊著，《夢幻月世界：張武俊攝影作品集》（臺北：臺北市立美術館，1992），頁2。

2. 張武俊最早於1970年加入臺南市攝影學會，之後陸續參加點點攝影俱樂部（1976），臺南美術研究會攝影部會員（1989）；參考自許淵富，《1860-2006聚焦府城——臺南市攝影發展史及史料》（臺南：臺南市政府，2008）。

3. 參考自李欽賢，〈臺南地景的表情——攝影家張武俊〉，《鹽分地帶文學》第55期（2014.12），頁30-31。

4. 攝影家自述見本書「口述訪談」。

5. W.J.T. Mitchell, "Introduction," *Landscape and Power* (Chicago: The University of Chicago Press, 1994), pp. 1-2.

6. 當時中國美育學家蔡元培發表〈美學的研究法〉一文肯定攝影為美術作品，畫家豐子愷也曾於〈美術的照相——給自己會照相的朋友〉提到像繪畫的照相就是「美術的照相」，引自王雅倫，〈隱匿的風景——郎靜山「風景攝影」作品與西方的第一次接觸〉，《年代風華——郎靜山逝世13週年紀念展》座談會論文（臺北：國立歷史博物館，2008），頁28。

7. 當時批評可見盧施福，〈我的藝術攝影觀〉，《中國攝影》第11期（2017），頁91，原載於《攝影周刊》第1卷第3期（約1930年），頁17-18。攝影學者郭力昕提到，郎靜山在臺北成立的中國攝影學會，分會遍及全臺，這個民間攝影組織控制了臺灣的攝影生態，將臺灣整個攝影文化導向去政治、非現實的業餘沙龍攝影實踐，而捕捉畫意風格的風景攝影，則是沙龍攝影的大宗。見郭力昕，〈地景攝影〉，《再寫攝影》（臺北：田園城市，2014），頁36-37。

8. 見本書口述訪談。

9. 依據簡永彬的分析，沙龍展與沙龍攝影等詞彙的產生與早期攝影向當時印象畫派靠攏，所成立的畫意主義攝影團體「兄弟輪會」（Linked Ring Brotherhood）相關，該團體舉辦的「沙龍展」（salon），以及後來以「國際沙龍攝影展」名義舉辦的各項展覽，成為各國業餘沙龍攝影的濫觴；隨後的各國攝影榮銜的考核更以沙龍入選的成績為考量。見簡永彬，〈何謂沙龍？何謂寫實？——臺灣攝影文化發展的一段艱辛〉，《夏門攝影企劃研究室》網址：
https://zh-cn.facebook.com/media/set/?set=a.478035122219539.104311.386967567992962&type=1，2021.7.14瀏覽。

10. 張武俊，《彩竹的故鄉》（臺北：臺北市立美術館，1998），頁8。

11. 見本書「口述訪談」，經筆者再次向張武俊確認為李德興吊橋。

12. 游永福，〈照見臺灣的容顏——1871年英國攝影家約翰‧湯姆生南臺灣驚艷〉，《高雄文獻》第4卷第3期（2014.12），頁178-180。

13. 謝震乾，〈心象風景〉，《台灣攝影》第22期（1966.8.25）。

14. 張武俊，〈由攝影看鄉土-醫學生自我成長系統-張武俊老師-20060411〉
網址：https://www.youtube.com/watch?v=g6csQxWSHnk，2021.6.9瀏覽。

15. 蕭瓊瑞，〈鄉土的色溫——張武俊的萬年峽谷攝影〉，《藝術家》第458期（2013.7），頁256-259。

16. 張武俊，《彩竹的故鄉》，頁2。

17. 郭力昕，〈地景攝影〉，《再寫攝影》，頁38。

18. 張武俊，《夢幻月世界》，頁4。

何以見山
從臺灣攝影史出發看張武俊
《月世界》系列作

文 / 郭懿萱

前言

出生於臺南車路墘地區（今臺南仁德區保安里）的張武俊（1942-），
畢業於成大附工，接觸攝影的過程，如同他所選擇的題材一樣，
總是從「厝邊」著手，與日常生活密不可分。接觸攝影前，張武
俊家中經營米店與販賣寵物飼料。[1]因為想要記錄孩子的成長，才
開始著手「拍照」，也漸漸地對「拍照」產生興趣；後又因朋友
的推薦，購買了第一台美能達單眼相機，並加入攝影學會，觀摩
其他人如何攝影。張武俊在耳濡目染之下，也開始像其他會友一
樣參加攝影比賽，但因不得要領，始終無法入選。在請教林茂繁、
陳金元等攝影同好後，藉由觀摩書籍、展覽以及審查委員的評選
內容，調整自己的創作，終於接連入選、獲獎。直至 1980 年代，
「張金牌」的外號便開始在張武俊周圍出現。[2]

在接連獲獎之後，張武俊思考的是下一階段的創作課題。1980 年
代，張武俊開始以專題攝影的方式進行創作。最初的《荷花》系
列作品，取景於臺南鹽水溪、白河等地，並以此申請臺灣攝影學
會的會員資格。[3]1986 年，在創作上面臨瓶頸的張武俊，回想起幼
時至龍崎遠足的記憶，開始往龍崎尋找創作題材，而「月世界」
至此開始與張武俊的名字再也密不可分。

過去針對張武俊的討論，除早期《攝影天地》期刊在張武俊舉辦
展覽時刊登作品之外，許汝玉在 1998 年曾為張武俊撰寫報導，簡
介張武俊拍攝月世界與彩竹的概況，此篇報導主要為宣傳 1998 年

至 1999 年在臺北市立美術館與各地文化中心的巡迴展。[4] 之後較有論述性的文章為李欽賢於 2014 年的介紹，他根據訪問張武俊以及對臺灣 1980 年代攝影發展的概況作一比對，指出張武俊的攝影歷程，與 1980 年代臺灣攝影主體性的自覺年代重疊，加上自身對於土地的關懷心情，因而創造出藝術性極高的月世界影像。[5] 近年則以臺南市美術館在 2020 年出版《覓南美》雙月刊第 9 號為代表，本號以「捕捉月世界的萬種風情——張武俊」為題，收入余青勳與黃華安對其創作的解說，以及地景專家楊宏裕對月世界地貌的介紹。[6]

然而，至今較少討論《月世界》系列在臺灣攝影藝術史上的地位為何。故本文試圖藉由攝影史中月世界的形象出發，首先探討十九世紀末期以來月世界的探勘狀況與留下的影像紀錄，說明月世界在戰前如何被世人們看待。接著，列舉以月世界作為創作題材的視覺影像作品，並討論張武俊在主題取向和技法建構的特殊性，來說明此系列在臺灣攝影史上的地位。

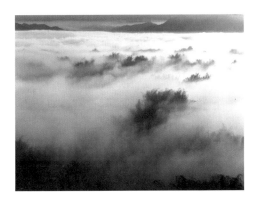

《夢幻月世界》系列作品 / 張武俊攝 / 二寮 / 1999.5.7
A work from the *Dream of Moon World* series / photo by Chang Erliao / 1999.5.7

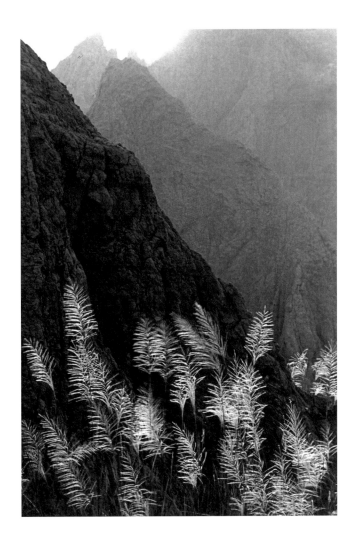

《芒花》系列作品 / 張武俊攝 / 臺南 / 2004-2011
A work from the *Swordgras* series / photo by Chang Tainan 2004-2011

尋山者：臺灣攝影史中的月世界影像

有關對於月世界一區的影像，目前最早可知為 1871 年約翰·湯姆生（John Thomson, 1837-1921）來臺的南臺灣之旅所留下的一張作品（參見本書頁 15）。關於拍攝地點的說法或為左鎮草山月世界、或為高雄內門溝坪。[7] 此時「月世界」的名稱尚未出現，而是被稱作「溪窪，環境的破壞者」或是「深泥坑」。除影像之外，湯姆生亦留下拍攝這張照片的紀錄：「經過一夜的沸騰，我的硝酸銀液恢復了令人滿意的品質，但是用來稀釋硝酸銀液的水實在太偏鹼性，只好用大量的中國醋將它調為弱酸。」、「我在這地區拍了一張深泥坑相片，可是我必須要多走十英哩的路，才能弄到一點水來沖洗玻璃感光片以得到底片。但不管怎樣，這張相片是我的好作品之一。」[8] 從湯姆生的自述，可知 19 世紀末期，若使用濕版攝影技術拍攝月世界地區，是十分困難留下影像的。這張照片中，湯姆生主要拍攝月世界山脊陵線以及雨蝕地形造成的溝紋；取景由下而上，地景據畫面五分之四，將僅 308 公尺高度的月世界景觀，展現出連綿高聳的群山環繞感。這樣以外來者的視角拍攝、具有強烈的紀錄性質方式拍攝的月世界影像，同樣出現於日治時期。

日治時期對於臺南、高雄一帶的泥岩惡地的探勘，起於博物學界、礦物學界對於バッドランド（badland，惡地）的研究。1913年臺灣博物學會出版的《臺灣博物學會會報》就有關於滾水坪庄（今燕巢區）附近泥火山的報導與照片。[9] 對於此處惡地形的介紹，也多出自於油田地質的調查報告，或是《日本地理大系·臺灣篇》等介紹地質的書籍。這些1930年代的官方報告書在介紹這些地形時，照片的圖說多是地名，或是「惡地地域樣貌」這樣的名詞。不過在1929年的《臺灣日日新報》上，一篇關於編輯同人們前往南部旅遊的報導，則明確地在標題處指出〈世上稀有 值得一看的泥火山—彷彿漫步在月世界的奇觀〉（世に珍しい　泥火山見物　恰も月の世界をさまよふ如き奇観），可知「月世界」的名詞在昭和4年已經出現，並從報導內文了解，他們所前往的正是現今的高雄地區的月世界。[10]

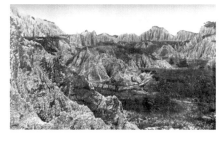

〈螺底山〉，1930-31，國立臺灣大學圖書館藏。
圖片來源：《日本地理大系·臺灣篇》，臺灣舊照片資料庫
Luodishan, / 1930-31 collection of National Taiwan University Library. Source: *Geographical Survey of Japan, Taiwan Edition.* Historical Taiwan photo database

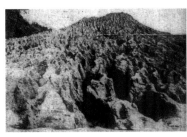

圖左：被雨水侵蝕的谿谷，圖右：泥火山噴出口痕跡。
圖片來源：《臺灣日日新報》1929.4.5，版 5。
Erosion-formed ravines(Left) ; Markings at the mouth of a mud dome (right).
Source: *Taiwan Daily News*, 4 May 1929, p. 5.

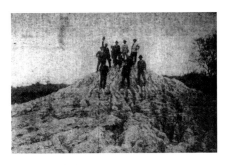

泥火山頂的一行人
圖片來源：《臺灣日日新報》1929.4.5，版 5。
Group photo on top of a mud dome.
Source: *Taiwan Daily News*, 4 May 1929, p. 5.

同篇報導刊出幾張照片，照片的下方説明文指出此處為雨水侵蝕的谿谷、泥火山噴出口、淤泥的痕跡。由此可見此時的月世界照片，仍是以記錄地貌，或是出遊紀錄相關。值得注意的是，除了地景紀錄外，報導中附上一張出遊的人物合影，拍攝的角度同樣是由下往上，但報社的編輯同人站在高地上，一名男子手舉高帽，除了具有紀念出遊意義外，更帶有征服高地，或是獨特地景之感，這樣的拍攝方式應與此時旅行與山岳攝影的視覺文化相關。

日治時期因近代文化的移入，日本官方將國土的視覺形象建立，與人民的愛國心與對鄉土的認同感連結，推廣國土旅遊或是票選「八景」的活動時，常結合畫家或是攝影師對於風土的描繪與拍攝。[11]1926 年 11 月，臺灣山岳會成立，主張「登山」可謂國民運動，用以強健身心，提升國民競爭力。除了休閒活動的面向外，登山活動的舉辦亦成為日本征服險地的象徵。臺灣因多擁高山，登山過程或是登頂的照片都成為象徵國民踏查國土，展現日本領土多樣性與國家實力的證明。因此與編輯同人們登頂的照片一般由下往上的拍攝視角，以及高舉手臂的合照形象，在此時的登山旅遊照中屢見不鮮。

臺灣山岳會初期的活動當中，又可見主辦許多學術調查活動。[12]值得注意的是，在創會會員的名單中，出現了惡地地形的研究專家齋藤齋的名字；[13]且在臺灣山岳會會報中，亦可見到以「月世

界探勝」為名的出遊活動，到了 1942 年時已出遊 19 回，並有許多地形專家一同出行導覽。[14] 可知月世界的探勘到了昭和時期，旅遊的行程與專家的調查活動往往同時並行。在前述《臺灣日日新報》編輯同人的報導中，除了照片外還出現一幅插畫，插畫中前景的一人拿著紙筆、一人俯身觀察地形，表現出同人們對於惡地地形的研究興趣。

值得一提的是，這些山岳會的活動地點如同編輯同人所前往的一樣，多集中於高雄地區的月世界，這可能是因為此處可從橋頭糖廠搭乘輕鐵前往，交通較臺南月世界便捷之故。

戰前的月世界觀光活動以及拍攝作品，往往是從外來者視角出發，結合學術研究的調查，記錄性質頗高。到了戰後，經濟型觀光的發展越趨蓬勃，且攝影器材的研發更趨便利，使此地的視覺作品不再僅止於寫實層面或記錄面向，而是開始成為追求畫面形式實驗與表達個性的媒介。

守山人：戰後月世界影像作品與張武俊《月世界》系列

1950 年代，起初因政治上的文藝政策使得符合國家外交形象的沙龍攝影風格占主導地位，這種情況 1960 至 70 年代開始有所轉變。此時因為現代攝影思潮以及本土文化意識的興起，開啟主觀性的紀實攝影表現，同時各個影會也相繼成立。[15] 這些影會為表達與推廣自我的理念，常舉行例會或外拍教學活動，其中，月世界便在此時成為藝術家們教學外拍與尋求靈感創作之處。

關於月世界的攝影，臺南點點攝影俱樂部於 1970 年成立的合影，應是最具有代表意義的照片之一。俱樂部成立者之一的攝影師王徵吉（1946-）提到：田寮的月世界因有農村與放牧趕羊的活動，故成為一處適合拍攝的觀光地區；[16] 而 1962 年蘇明全（1929-）所拍攝的〈荒山野牧〉即為這個說法的見證。作品中 S 型的蜿蜒道路從遠景延伸至前景，羊群沿著道路向前行，碎石子的道路與兩旁斑駁的山壁，展現出荒野的原始感。蘇明全拍攝此作的時間點，

報導插圖，圖片來源：《臺灣日日新報》
1929.4.5，版 5。
Newspaper illustration. Source: *Taiwan Daily News*,
4 May 1929, p. 5.

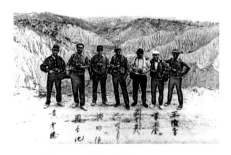

點點創會七員合照 / 洪碩甫提供 / 1970
Group photo of seven members of the Tainan Dian Dian
Photography Club / photo provided by Hong Shou-fu
1970

為蘇明全遷居高雄後不久，故應是取材於高雄地區的月世界。另外，1960 年代起正值臺灣藝術圈關注周遭土地文化時期，蘇明全的創作本以庶民生活寫實地呈現做為特色，故這張取景於月世界的作品，較偏向人文紀實，而非風土樣貌。

另外，點點俱樂部創會成員之一的周全池（1929-2015）的〈荒山歸牧〉，同樣以月世界的放牧作為創作主題。周全池以簡潔的構圖拍攝兩幅連作，一幅彩色作品表現牧者行走於泥溝之上，近距離地從旁拍攝，觀眾與攝影師彷彿與牧者一同前行；另一幅黑白的作品則以遠距角度出發，一人二牛的組合行走於山路上，相較於彩色照片的即時紀錄感，黑白作品更呈現幽遠的詩意。

與蘇明全〈荒山野牧〉同年拍攝的〈月世界，臺灣〉一作是柯錫杰（1929-2020）早年的經典佳作之一。月世界的地景做為攝影的

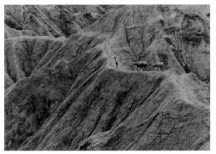

周全池，〈荒山歸牧〉，年代不詳，銀鹽相紙，32 × 49
公分，34.5 × 49.5 公分。臺北市立美術館典藏
Zhou Quan-chi, *The Herders Return*, date unknown, Silver
salt photo paper, 32 × 49cm, 34.5 × 49.5 cm. Taipei Fine
Arts Museum permanent collection

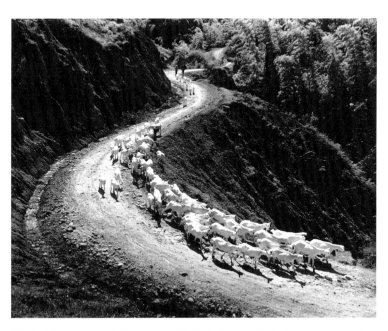

蘇明全，〈荒山野牧〉，攝影，FB 纖維紙基相紙，1962，48.3×60.8 公分。高雄市立美術館典藏
Su Ming-quan, *Wild Mountain Herdsmen*, Photograph, Fiber Base Photographic Paper, 1962,
48.3×60.8cm. Kaohsiung Museum of Fine Arts permanent collection

主題，占據畫面的中段，黑白色彩讓峻峭的山石更加冷峻、蒼茫。然畫面上端與前景分別佈排積雲以及湖水，湖水的倒影模糊不清，表現動態。一靜一動、一虛一實的交互，讓畫面中出現蒼茫的永恆感之外，更帶有一種活力。

除了庶民活動與地景攝影，1960 年代晚期郭英聲（1950-）〈高雄月世界〉的創作已經出現臺灣現代攝影啟蒙運動的影子。山脊嶙峋的月世界代表樣貌，出現在畫面的右上角，泥流沖刷的痕跡占據前景並向後延伸。在後方一位人物的小型身影矗立著，整體作品的荒蕪感不僅是透過自然粗曠的地景表達出來，更是透過小型身影獨立出現，傳達出的寂靜感更帶有一種孤獨的韻味。

這些作品多取材於高雄地區的月世界，根據張武俊的自述可知，雖然他也曾前往田寮月世界拍攝牧羊，但為了突破創作瓶頸，且田寮月世界的拍攝風潮在 1980 年代已盛，故張武俊選擇了人煙稀少，尚未有人拍攝過的草山月世界作為目標，這樣的取捨可能與他不喜於人物入鏡的偏好相關。[17]

郭英聲，〈高雄月世界〉，1969。圖片來源：國家攝影文化中心
Guo Ying-sheng, *Moon World, Kaohsiung* / 1969
Source: National Center of Photography and Images

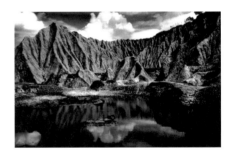

柯錫杰，〈月世界，臺灣〉，1962。
圖片來源：國家攝影文化中心
Ko Si-chi, *Moon World, Taiwan*. / 1962
Source: National Center of Photography and Images

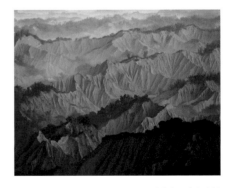

日出前拍攝的月世界，色溫較高 / 張武俊攝 / 臺南大林頂 / 1991.12.26
A photo of Moon World taken before sunrise, with a relatively high color temperature / photo by Chang Dalinding, Tainan / 1991.12.26

張武俊與前述的攝影作品最為明顯的不同之處在於其畫面中的色彩安排,以及他對月世界拍攝時間的選擇。攝影作品的色彩由老天決定,光影的變化著實為攝影師的「顏料」。張武俊所拍攝的時間多為凌晨三點半至八點,[18] 此時的光照不足,故張武俊常使用小光圈拍攝,以長時間的曝光與倒易律失效的機制,利用色溫的差別與變化作為其作品的「調色盤」。[19] 同時畫面中色彩並不會過於繽紛,往往呈現同色系的樣貌。在尚未日出前作品色溫較高,畫面上往往呈現黑色與寒色系的漸層搭配;日出後的作品,畫面轉為低色溫的紅、橘色,加上不同光源方向的角度,使有時可見以側逆光角度拍攝、較為清晰的地景形象,有時張武俊會利用黑卡遮擋明暗反差,讓畫面集中於片幅的中央,且利用正逆光的角度,讓地形起伏宛如剪影般出現。[20]

除了色彩的呈現方式與前人不同外,張武俊的月世界作品所要表現的,既非地景紀實,亦非受現代主義影響下的創作。雖然系列作品中仍可見其拍攝出月世界遍佈溝紋的景觀樣貌,但這些作品與前述紀錄的照片相比,除利用前後景光影明暗的差距表達深邃之外,或將地景的特殊性占據更多的畫面比例,如同在金馬寮所拍攝的作品一般,以片幅的七分之六呈現冷色調的地溝紋路。月世界的惡地景觀雖如湯姆生的紀錄照片一樣地被記錄下來,但在張武俊的鏡頭下,透過明暗的差距與構圖的鋪排,呈現的是荒地的冷冽感。

在構圖上以地景作為主角外,前述提及張武俊更利用光照使得地形以剪影的效果出現畫面上。有時月世界的山形並非作品要表達的重點所在,張武俊將這些山脊置於畫面一角,利用特殊的稜線起伏襯托出天空的景緻。他也善於利用早晨或是黃昏之際,光線照射雲霧帶來的顏色變化,搭配起伏的剪影山線,成為作品的焦點。

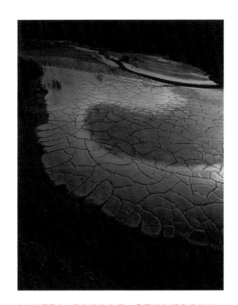

〈大地讚歌〉:日出後的作品,畫面轉為低色溫的紅、橘色 / 張武俊攝 / 鹽水坑 / 1989
Ode to the Earth: a photo taken after sunrise, with red and orange tones at lower color temperatures / photo by Chang / Yanshuikeng / 1989

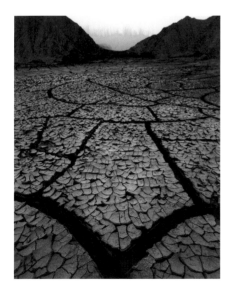

冷色調的地溝紋路 / 張武俊攝 / 臺南金馬寮 / 1991.3
Veins and cracks photographed in cool tones / photo by Chang / Jinmaliao, Tainan / 1991.3

大自然的變化是剎那的，攝影師按下快門的動作也是瞬間的，但為了拍攝出這些色澤的變化，張武俊經常長時間且長年地守在鏡頭前面，利用自然的氣候與地景的搭配，將月世界的色澤與氣韻皆「守」在作品之中。而在《夢幻月世界》拍攝六年後，張武俊將目光轉向月世界中生長季節短促的彩竹。除了記錄彩竹本身色彩一季的轉變之外，張武俊也會等待天色的變化，為的是在拍攝彩竹時，達到有意境的畫面。例如在拍攝因環境險惡而無法發芽的竹子時，張武俊希望以日出的太陽作為生命的象徵共同出現在鏡頭裡，為了等候太陽移動至鏡頭的相對位置，等了一個禮拜才達到目的，可見其恆心與毅力。[21] 與相較於前人拍出月世界的樸實、人文、活力，從張武俊的色彩選擇與構圖模式，可知他的創作是帶有「繪畫性」的概念，[22] 這也就說明了張武俊的《月世界》系列在臺灣攝影史上是如此有意義的原因所在。

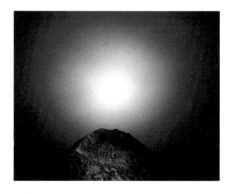

冬季清晨於草山月世界拍攝作品 / 張武俊攝 / 臺南草山
1992
A photo shot in winter in the early morning at Moon
World / photo by Chang / Caoshan, Tainan / 1992

結論：見山還是山

張武俊《月世界》的系列作品，將月世界的題材在攝影史上開拓了另一個境界。本文回顧月世界最早的視覺影像到戰前的攝影，可見多為外來者開闢新疆域的壯遊紀錄，這些尋山者多將月世界實體樣貌直白地記錄下來。戰後，寫實的紀錄移向人文活動，或是心象攝影家們利用月世界的景致反射內心的情緒世界。張武俊的《月世界》作品，則全然以地景與天色的搭配完成，並非詳實地記錄地理景觀或是人文活動，在當時獨樹一格；極具詩意的畫面來自於顏色變化、構圖取景，山景地貌有時僅為襯托，簡單的線條搭配色溫的變化，成就觀看月世界的獨特視角。這是須對月世界地景長期經營且十分瞭解的「守山人」才能達成的挑戰。臺灣攝影史上的月世界，彷彿經歷「見山是山」、「見山不是山」的歷程，而到了張武俊的鏡頭下，成了「見山還是山」的樣貌，使得草山月世界的形象，是如此夢幻卻又直觀地出現在世人眼前。

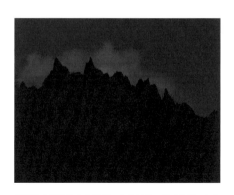

利用特殊的稜線起伏襯托天空的景緻 / 張武俊攝 / 高雄
古亭 / 1990.7
Chang uses the unusual outline of a ridge to set off the
sky / photo by Chang / Guting, Kaohsiung / 1990.7

1. 許汝玉，〈背著相機彩繪天地——記月世界中的痴人張武俊〉，《鄉城生活雜誌》第55期（1998.8），頁67。

2. 關於張武俊早年創作動機，參見許汝玉，〈背著相機彩繪天地——記月世界中的痴人張武俊〉，頁64-71；李欽賢，〈臺南地景的表情——攝影家張武俊〉，《鹽分地帶文學》第55期（2014.12），頁29-39。

3. 見本書「口述訪談」。

4. 許汝玉，〈背著相機彩繪天地——記月世界中的痴人張武俊〉，頁64-71。

5. 李欽賢，〈臺南地景的表情——攝影家張武俊〉，頁29-39。

6. 潘（福）總編輯，《覓南美9——捕捉月世界的風情萬種 張武俊》（臺南：臺南市美術館，2020）。

7. 此說法參見游永福，〈照見臺灣的容顏：1871年英國攝影家約翰．湯姆生南臺灣驚豔（上）〉，《高雄文獻》第4卷第3期（2014.12），頁178-179。

8. John Thomson著，黃詩涵譯，《從地面到大空　臺灣在飛躍之中》（臺北：Editions Rene Vienet，2006），頁76、78。轉引自游永福，〈照見臺灣的容顏：1871年英國攝影家約翰．湯姆生南臺灣驚豔（上）〉，《高雄文獻》第4卷第3期（2014.12），頁179-180。

9. 作者不詳，〈臺灣之自然界〉，《臺灣博物學會會報》第3卷第11期（1913），頁113。

10. 作者不詳，〈世に珍しい　泥火山見物　恰も月の世界をさまよふ如き奇観〉，《臺灣日日新報》（1929.4.5）版5。

11. 關於臺灣八景在日治時期的圖像意涵的轉變，可參見宋南萱，〈臺灣八景從清代到日據時期的轉變〉，國立中央大學藝術學研究所碩士論文，2000。

12. 例如〈臺灣山岳會の科學的の使命 調查部の內容を充實せよ〉，《臺灣日日新報》（1927.8.23）版2；〈本島學界の權威者連　南湖大山を踏破　學術的の深究を行ふ　臺灣山岳會の主催〉，《臺灣日日新報》（1928.10.19）夕版1。

13. 作者不詳，〈臺灣山岳會設立趣意書〉，《臺灣山岳》第1期（1927.4），頁3。齋藤齋，生卒年不詳，福島出身。根據《臺灣總督府職員錄》，1918年已到臺灣，曾任教於臺北師範學校、高等學校，並於1926年擔任殖產局商工課技師，1929年後亦擔任殖產局鑛物課技師。在《臺灣鑛業會報》、《臺灣博物學會會報》與《臺灣地學記事》等刊物上，發表過關於不同地質鑛物的相關論述。曾在《臺灣山岳彙報》上發表〈火焰山與泥火山〉一文說明兩種地形的成因。參見齋藤齋，〈火炎山と泥火山〉，《臺灣山岳彙報》第15卷第3期（1943.3），頁1。

14. 社團法人臺灣山岳會，〈月の世界探勝（徒步第十九回）〉，《臺灣山岳彙報》第14卷第6期（1942.6），頁5-6。

15. 關於1950年代至70年代成立影會可參見簡永彬，《看見的時代——影會時期的影像追尋1940s-1970s》（臺北：夏綠原國際，2014），頁326-327。

16. 關秀惠，〈臺南市攝影學會的記憶溯源——訪問攝影家王徵吉〉，《南美館月訊》（2018.4）版2。

17. 見本書「口述訪談」。

18. 見本書「口述訪談」。

19. 見本書「口述訪談」。

20. 有關利用黑卡遮擋的說法，參見黃華安，〈三十年磨一劍的月世界守護者〉，《覓南美9——捕捉月世界的風情萬種 張武俊》，頁21。

21. 關於等候日出之事蹟，取材自張武俊演講，〈夢幻月世界：張武俊老師〉（2004.01.22），https://www.youtube.com/watch?v=v9oTuh-Dl94，2021.7.11瀏覽。

22. 有關「繪畫性」參見Heinrich Wolfflin著，曾雅雲譯，《藝術史的原則》（臺北：雄獅美術，1987）。

A Southern Perspective on Landscape Photography: Chang Wu-chun's Eye for Local Lands and Customs

Kuan Hsiu-hui

Preface

On April 25, 1992, Chang Wu-chun's *Dream of Moon World* exhibition opened at the Taipei Fine Arts Museum, giving viewers in northern Taiwan their first glimpses of Tainan's Caoshan Moon World and its wonderland-like scenery. The highly respected photographer Lang Jing-shan was in attendance, and further, had written the preface to the exhibition album, in which he praised Chang's achievements: "Chang expresses a myriad of scenes and feelings through his profound artistic feeling and deep understanding of the photographic medium." Chang continued to uphold this reputation when, several years later, another treasure he discovered during his long period of work at Moon World—colored bamboo—was also beautifully transformed through his lens.

Those two major solo exhibitions in the north, and the 1995 *Confucian Temple* solo exhibitions in Taipei and Tainan, cemented Chang's status as a landscape photographer. In interviews, he claimed that photography was just "observing carefully and taking lots of photos," and he rarely talked about the influence of other photographers or photographers' associations. Perhaps that represents his actual creative concepts, or perhaps being born in the small town of Baoan, Tainan, meant that, aside from taking pictures and participating photography club activities, his pragmatic side was emphasized by the routine of engaging in business each day.

Chang's status as a non-professional held special meaning, both for the development of photography in Tainan in the 1980s and 1990s, and for the nature of Taiwan's landscape photography. First, he was not academically trained, but instead, was a photographer steeped in local customs and culture. His example makes clear that, beyond studying abroad or operating a photography-related business, an interest in creative photography can only be cultivated by learning from photography groups, magazines, and friends. Second, we can see how, influenced by the type of judging in Taiwanese photo contests and the styles of the photography societies, he strove to achieve stylistic breakthroughs, and this latter point in particular illustrates the importance of Chang's work.

The Local Development of Landscape Photography

Believing that the Moon World theme would help him escape from the system of competitions, Chang became immersed in capturing every aspect of its unique landscapes. He has said that he was not influenced by Lang Jing-shan or other photographers, but simply hoped to share the beauty of the land around his hometown in Tainan's Caoshan region. While different than the Moon World at Kaohsiung's Tianliao, the Caoshan Moon World, with its seas of clouds and sunrises, also possesses world-class views. Chang was proud that the government recognized his work. His *Colored Bamboo* works were considered comparable to Japanese cherry blossoms, and Tainan's mayor presented works by Chang as gifts when meeting dignitaries in Japan. This shows the aesthetic value photography holds for its viewers as well its power to construct a national identity.

Reproducing a landscape might seem a matter of selecting a specific view, removed from the realities of the environment, society or politics, or simply presenting a moment of beauty at a particular scene. But Western research has shown that landscape painting can present many different types of narratives— georgic, pastoral, exotic, sublime, or picturesque—and it has discussed how these appear in literature, painting, photography and other media, and how they can become a focus of identity. Controversy about the relationship between photography and painting, which arose upon the invention of photography, has been rife in both East and West. Whether in the rise of pictorialism in photography or the view of photography as an art in Chinese academic circles, a definition of landscape photography has gradually been constructed through this discourse. Landscape photography eliminates human presence and exerts an aesthetic appeal through its natural and picturesque features. But at the same time, the scene framed by the camera lens often reflects the photographer's own will. A photographer's reverence for nature as a spiritual realm may be shown in vast landscapes devoid of humanity, such as Ansel Adams' famous photos of America's Yosemite National Park, their mountains and wilderness seemingly detached from the physical world in their abstract linear geometry. There is also the work of Lang Jing-shan, a well-known Taiwanese photographer working in a "composite" style, whose compositions reflect traditional Chinese landscape paintings and evoke a sense of humanity couched within nature and the landscape. While Lang incurred superficial and narrow-minded criticism due to the relationship of his art to Chinese painting, he founded a Chinese photography society in Taiwan that helped produce Taiwan's salon photography, which in its heyday represented the mainstream of Taiwan's photography development in the post-war period.

Chang Wu-chun cannot be easily classified as similar to either Ansel Adams, with his mountain scenery, or Lang Jing-shan and his composite style of photography. Chang once said that, being busy during the day with his rice business, all he could

do was adjust the color data of the photos he had taken, submit them to the photo studio, and then, after development, mark the negatives to show the areas to be developed or enlarged. Chang's concern for scene selection, as shown by those framing lines, is similar to the concern for composition in painting. The expression of beauty in Chang's work, through various abstract lines, contrasts of light and shadow, and color saturation and value, especially in his early *Lotuses* series, suggested the kind of salon photography popular at the time in competitions and amateur groups. This may have been related to Chang's early experience in photography groups, his participation in various competitions, his contributions to magazines such as *Photography World*, and the international photography titles he won.

But Chang produced many works, besides those similar to the salon style of the time, in which he exhibits a personal creative drive, a newly created, painterly style, and a great sense of local color. Those beautiful photos were only made possible by waiting for long exposures, doing on-site studies, and delving deep into the risky territory of Moon World loaded down with equipment. Chang once said, "Early every morning, I walked alone in the thorny bamboo groves of Moon World, sweating and sometimes bleeding, enduring painful scrapes and being frightened by the snakes." A number of times he would be startled awake by nightmares of being surrounded by snakes at Moon World. The anecdotes surrounding Chang's photos of beautiful scenery speak to his adventurousness in entering these wild, desolate areas and the cultural meaning behind the scenes of nature and human customs he captured through his lens.

Imperial Eye, Modern Eye

After winning various domestic photography awards in the 1980s, Chang felt restricted in his choice of subjects. In a search for new ideas, he recalled how as a boy he took the sugar factory train from Bao'an to Longqi to go hiking, and how on one such trip he saw a suspension bridge. For him, the bridge was both a strange, grand structure, and a symbol of modernity coming to the countryside. The majestic, imposing form of the suspension bridge had an impact on his young mind, and one is reminded of the British photographer John Thomson, who first photographed the Moon World region in Taiwan. At the invitation of Dr. James Maxwell in 1871, Thomson arrived at Dagou harbor by ferry from Xiamen. After a short stay of three days, he diverted from Tainan's Fucheng to Bama (now Tainan's Zuozhen), planning to take the mountain road to Kaohsiung's Jiaxian. On the way to Muzha (now Kaohsiung's Neimen), Thomson took Taiwan's earliest surviving photo of Moon World's unusual terrain. The photo bears no inscription, and was later assumed to show the Zuozhen Caoshan Moon World, but investigation by You Yong-fu has shown it was likely taken near Kaohsiung's Neimen. Regardless of whether it was the same Moon World as in Chang's photos, it is certain that both

Chang and Thomson made the same journey from Zuozhen to Neimen. Thomson was searching for the aborigines of the interior to record "primitive" scenes of the Far East for the British empire; Chang was searching for ties to his childhood memories.

Thomson crossed the seas to photograph the Far East from an imperial point of view. Chang, too, entered Moon World in search of new subjects, but it was early memories and concern for his native countryside that were on his mind. His photos from the Caoshan area in the 1980s and '90s are not all focused on treeless ridges and rain-carved ravines. Instead, they evoke an overall atmosphere in which we see, around sunrise, a distant cascade of mountain ridges and the special beauty of lush bamboo groves hiding in the nearby mists. Moon World, while only 204 meters above sea level, provides world-class views with seas of clouds and mist-enshrouded mountains. The imposition of martial law after the war and the popularity of salon photography meant that landscapes were a safe, staple subject for academic or amateur photography groups. Depictions of Taiwan's landscapes were not limited to photography, however; prior to the war, the promotion of Western painting and painting from life meant that after the war's end, painters continued to paint from life at famous locations. One example is the well-known Tainan painter Cai Cao-ru, who left a number of sketches of Caoshan's Moon World from the 1960s.

Gazing Across His Native Land

During the long period in which he worked at Moon World, Chang took note of the beautiful colored bamboo there—easily overlooked, yet always growing on the mountaintops. There were also expanses of flowering swordgrass, and human interest to be found in its old earthen homes. Earthen bricks, made of mud or clay mixed with grass and dried in the sun, make up the walls of these homes, which were early forms of shelter for the residents here. Chang believed these houses, warm in winter and cool in summer, embodied the wisdom of the ancestors, and that someone should make a record of them. Unlike surveys focusing only on their physical appearance, Chang met the people who lived there and chatted with them until he was familiar with each family and understood their individual stories. He was able to photograph the interiors of their homes and their furnishings and utensils. These works are no longer pure landscape photography, but gain significance as an exploration of local culture and customs.

Photographing these homes, Chang was neither tourist nor prying outsider; the appeal of his work derives from access to the occupant's lives. Photographer Xie Zhen-qian once said that photos of mental imagery are unique because of what they reflect: a photographer's personality, technical knowledge, living environments, and imagination, as well as the mood of the season. That is to say,

a photographer's conceptions will express what touches them in a particular subject. In one photo, the bent figure of an old man appears within a crumbling doorframe. Chang explained that the old man was Mr. Li, whose son was going to rebuild his house. While that was a welcome event, Mr. Li found it hard to accept that the house he had built himself would soon be torn down. Chang captures the mixed emotions in this figure, the roof above him gone, his silhouette appearing against the backdrop of the crumbling door, and the mountain seen through the doorway mirrored by the Chinese New Year decoration above it. These details all speak of the many changes seen by the old man in his years living in Moon World.

Chang projected his state of mind into the scenes he photographed, including the *Fish Pond* photos he shot along the coast near Sangu each year before the rainy season. Chang's photos transform the photosynthesis of microorganisms and other natural phenomena on the ponds' surfaces into strange visions and fantastic colors, but without reducing them to expressions of his own individual mood. He named and compared his works with characters he had seen and their stories, linking the content of his images to his personal memory and cultural background. The *Wannian Canyon* series likewise displays his fascination with the changing colors and lines of his subjects; he magnifies the veins of the canyon rocks, frozen amid the turbulence and the visual wonder of the canyon. Taiwanese art historian Xiao Qiong-rui notes that Chang did not need to hunt for novelty in order to be creative. He did not go on long expeditions to distant places since he believed that "an artist should photograph the land he is most familiar with." Chang's precise control of color temperatures helped produce his magnificent account of a Taiwanese landscape composed only of rocks and flowing water, without trees, sky, or living creatures. He had learned the techniques for such control over many years, observing relationships between nature and climatic conditions. Rather than travel far afield, he simply explored the land beneath his own feet, finding grand new worlds and revealing them through his lens.

Conclusion

Documentary photography was developing rapidly in Taiwan when Chang Wu-chun took up thematic photography in the 1980s. While not focusing on social realities or disadvantaged groups, Chang did document his native land, his presentation of it based on long-term involvement and observation. His works contrasted with other landscape photography, in that implicit in any of his photographic techniques or aesthetic approaches was personal study of the regions he photographed and the cultural aspects of changing landscapes. We cannot ignore the hardships of his creative processes, the thousands of hours and days spent roaming *Moon World* and gazing attentively at what he saw there—and at the Confucian temple, the Sangu fish ponds, the seaside sandbars, the ancient houses at Anping, the coral-stone houses of Penghu, and Wannian

Canyon. Photographic scholar Guo Li-xin once suggested that the salon landscape photos of the Kuomintang era were processed to inject a flavor of Chinese landscape paintings. Today, while photographers still shoulder their expensive, heavy gear among the mountains and along the seashores, what they seek now is the real scenic beauty of their native Taiwan. Chang did not turn a blind eye to environmental changes or ecological degradation occurring in any landscape he photographed. In the preface to his *Dream of Moon World* exhibition, he mentioned that pollution from Kaohsiung's industrial zone frequently blackened the skies at Moon World. From Chang's work we gain insights into how a photographer can begin from the environment in which he grows up, and then materialize his personal feelings for the land in works closely tied to its customs, culture, and natural environment. Even more, we can learn how, based on the southern perspective that he opened up and that radiates from all of his works after the *Moon World* series, we can derive a kind of Taiwanese landscape photography with a deeper and more positive meaning.

How to Look at Mountains:
Moon World Series in the Historical Context of Photography in Taiwan

Kuo Yi-hsuan

Preface

Chang Wu-chun (1942-) was born in Baoan, in the Rende District of Tainan, and graduated from the affiliated industrial vocational school of National Cheng Kung University. Before taking up photography, he managed a rice shop from his home and sold pet food. His interest in taking pictures developed out of photographing his children as they grew up. At a friend's recommendation, he bought his first Minolta single-lens camera and joined the Photography Society of Tainan. Like its other members, he entered photography competitions, but having not yet grasped the fundamentals, his work was never recognized. He changed his approach after consulting fellow photographers Lin Mao-fan and Chen Jin-yuan and learning from books and exhibitions. His works were finally chosen for exhibition and began to win awards, and in the 1980s, the nickname "Gold Medal Chang" began to be heard around him.

Having won multiple awards, Chang began to think about the subject of his next creative phase, and in the 1980s he turned toward thematic photography. His early *Lotuses* series was shot at locations around Tainan such as the Yanshui River and Baihe, and based on those works, he obtained membership in the Photographic Society of Taiwan. In 1986, feeling creatively stymied, Chang recalled hiking in Longqi as a child and returned there to look for new subjects. From that point on, the name "Moon World" became virtually synonymous with Chang's own.

Past discussions of Chang's works include an early *Photography World* periodical that published some of his works when he held an exhibition, and a report by Xu Ru-yu promoting an exhibition that appeared at the Taipei Museum of Fine Arts and other cultural centers in 1998 and 1999. Later, a more analytical essay by Li Qin-xian in 2014, based on an interview with Chang, introduced his works against the backdrop of photography's development in Taiwan in the 1980s. Li pointed out that Chang's development overlapped with the growing awareness of photography's subjectivity in contemporary Taiwan, resulting in his exceptionally artistic *Moon World* images. More recently, Chang was featured in Vol. 9 of the Tainan Art Museum's bimonthly publication, *Seeking the Beauty of the South*, in which Yu Qing-xun and Huang Hua-an discuss Chang's work, while the landforms of Moon World are introduced by Yang Hong-yu.

Yet there has been little discussion of Chang's Moon World series relative to the history of photographic art in Taiwan. This essay will begin with views held historically of the Moon World region, discussing first its exploration from the end of the 19th century on and images from that period, to illustrate how it was seen in the pre-war era. Later photographs that take Moon World as a creative subject will show by contrast just how unique Chang was in his choice of subjects and his techniques, making clear the position his *Moon World* series holds in the history of Taiwanese photography.

Seekers of Mountains:
Images of Moon World in the History of Taiwanese Photography

The earliest known image of Moon World was taken by John Thomson (1837-1921) during his travels in southern Taiwan in 1871 (see page 15 of this book). Some say the photo was taken at Caoshan Moon World at Zuozhen, Tainan; others say at Neimen Gouping, near Kaohsiung. The name "Moon World" had not yet come into use; the area was instead called "Xi Long, Destroyer of the Environment," or simply, "the deep dry clay-pits." Thomson left a record describing how he took the photo: "After the night's doctoring, my nitrate-of-silver bath gave every satisfaction; only the water which I used to dilute it, was so extremely alkaline that I had to employ a goodly supply of Chinese vinegar to turn it—slightly, to the acid side." And: "I took a picture of one of the deep dry clay-pits of this region, and had to proceed ten miles farther on before I could get a drop of water to wash the plate and finish the negative. It turned out one of my finest pictures, nevertheless." From Thomson's report, we can see how difficult it would have been, in the late nineteenth century, to produce an image at Moon World with wet-plate photography. Thomson mainly photographed the ridgeline of Moon World and the gullies washed out by erosion; his photo is composed from the bottom up, evoking a sense of the surrounding range of towering mountains. Similar images of Moon World, taken from an outsider's perspective and with a strong documentary meaning, also appeared during the period of the Japanese occupation.

During the Japanese occupation, exploration of these shale badlands near Tainan and Kaohsiung began with naturalists and mineralogists. In 1913, the Journal of the Natural History Society of Taiwan published reports and photos of mud domes near Gunshuipingzhuang (now the Yanchao District). In such official reports, the photo captions for these landforms were usually place names or titles such as "View of the Badlands." In 1929, however, a *Taiwan Daily News* report on a trip by its editorial staff to the south of the island was titled, "Rare Mud Domes Well Worth Seeing—Like Walking Amid the Strange Sights of the Moon World." Thus, we know that the term "Moon World" was already used in the fourth year of the Japanese Showa era, and we know that they refer to the present-day Moon World near Kaohsiung.

The photos published in that report were mostly tourist or landscape photos, but the inclusion of a group photo, taken with an upward perspective, is notable. The editorial staff stand on a protruding high point, with one member raising his cap high in the air. Beyond being a simple memento, it also suggests the conquest of a highland or an unusual landform, a style of photography likely related to the visual culture associated with the era's tourism and the photographing of mountainous terrain.

With the introduction of modern culture during Japanese colonization, the colonial authorities associated the creation of a visual image of the national territory with patriotic feelings and the people's identification with the land. Paintings and photos of local scenes were connected with the promotion of domestic tourism or with voting to choose Taiwan's "eight scenic spots." In November 1926, the Taiwan Mountaineering Society was established; it urged that mountain climbing be considered a national sport so as to enhance physical fitness and national competitiveness. Mountain climbing became not just a leisure activity, but a symbol of Japan's conquest of dangerous places. The upward perspective of the newspaper staff photos reflect such trends, and the upraised arms of the photos were often seen in mountain climbing or tourist photos in this period.

Early activities of the Taiwan Mountaineering Society included a number of academic surveys. It is worth noting that Hitoshi Saito, an expert in badlands terrain, was a founding member, and its bulletin lists outings described as "Exploring Moon World." In 1942, it held 19 such outings, frequently with topographers as guides, and during the Showa era, tourism was often combined with specialist surveys. In the aforementioned *Taiwan Daily News* report on the travels of its staff, an illustration showed one person taking notes with pen and paper while another studies the terrain, suggesting a shared interest in understanding the badlands topography.

Sightseeing activities and photography at Moon World prior to the war often reflected the viewpoints of outsiders, and in combination with academic research, they were highly documentary in character. Tourism developed rapidly after the war, and photographic equipment became more convenient to use. This meant that visual depictions of the area were no longer always oriented toward realism or documentation; they became a medium for experiments with visual presentation and personal expression.

Keeper of the Mountains:
Postwar Images of Moon World and Chang Wu-chun's *Moon World* series

In the 1950s, salon-style photography, which accorded with the desired diplomatic image, became dominant under governmental policies regarding art and literature. That situation began to change in the 1960s and '70s, in line with a modernist approach to photography and the rise of nativist cultural consciousness. Documentary photography became more subjective in expression, and numerous photography associations were formed. To express and promote their respective ideas, they often held regular meetings and outdoor photography instruction; Moon World became a favored site for instruction and creative inspiration.

A group photo of the Tainan Dian Dian Photography Club from 1970 exemplifies photography at Moon World at this time. One of the group's founders, Wang Zheng-ji (1946-), said that Tianliao's Moon World, with its rural villages and livestock herding, had become a suitable area for tourist photography. A Su Ming-quan (1929-) photo, *Wild Mountain Herdsmen*, corroborates that statement. The road that winds between the foreground and the far background shows the primitive nature of the wasteland. Shot shortly after Su moved to Kaohsiung, that photograph should be of the Moon World near that city. As Taiwanese artistic circles in the 1960s were giving greater attention to the land and culture of surrounding localities, and Su Ming-quan's work features a realistic presentation of the lives of ordinary people, it should perhaps be considered humanistic documentary photography rather than landscape photography.

The Herders Return, by Zhou Quan-chi (1929-2015), another founding member of Dian Dian, also centers on livestock grazing at Moon World. Zhou shoots a diptych employing simple compositions. The first photo, in color, is shot at close range from the side and shows herders walking along a muddy ravine; both photographer and viewer seem to be walking alongside. The second, in black and white, shows a man and two cows, traversing a mountaintop path, from a distant perspective. The color photo has an immediate, documentary feel, while the black and white work seems more distant and poetic.

Moon World, Taiwan, taken the same year as Su Ming-quan's *Wild Mountain Herdsmen*, is a classic work by Ko Si-chi (1929-2020), its black and white tones lending the rugged rocks of Moon World a more forbidding appearance. But cumulus clouds appear in the upper part of the photo and a lake below, while blurred reflections in the lake suggest movement. The combination of static and active elements in the scene, and its solid and ethereal aspects, add great vitality to this view of a grand, enduring landscape.

In addition to humanistic and landscape photography, aspects of the movement toward photographic modernism in Taiwan appear in *Moon World, Kaohsiung*, a late-1960s work by Guo Ying-sheng (1950-). Craggy ridges typical of Moon World appear in the upper right, while a small human figure stands alone in the distance. The barren wildness of the place is communicated through the rugged terrain, while the small, solitary figure conveys a poetic sense of stillness and loneliness.

Most of these photos were taken at Kaohsiung's Moon World. Chang Wu-chun has said that he also once went there to shoot sheepherding scenes. But, facing creative difficulties, and with the trend toward filming at Tianliao, near Kaohsiung, already peaking, he ultimately settled on the Moon World at Caoshan instead. It was more sparsely populated and seldom, if ever, photographed; moreover, it may have suited his preference for avoiding human figures in his landscapes.

The differences between Chang's work and the photographs above lie mostly in his handling of color and the time of day at which he worked. The colors in a photo are ultimately determined by the almighty, and changing lights and shadows become a photographer's "pigments." Chang mostly shot his photos with small apertures between 3:30 and 8:00 a.m., creating a "palette" out of the different, changing color temperatures, making use of long exposures and reciprocity failure. Photos taken before sunrise showed higher color temperatures, with a gradation of tones between black and cool colors; after sunrise, they display more reds and oranges, with lower color temperatures. In addition, light arriving from multiple angles helped the topography to stand out more clearly in the side lighting, and occasionally Chang used a black card to reduce bright-dark contrasts and center the image on the film. The angles of the front and back lighting in his works sometimes presented the Moon World's undulating terrain in stark silhouettes.

Chang presented colors differently than those earlier photographers, and if his Moon World photos were uninfluenced by modernism, neither were they mere documentation of the landscape. While in the *Moon World* series we can still see the deep ravines characteristic of that landscape, what makes them different from earlier documentary photos is their depth, created by contrasts of light and shadow in the foreground and background, and the large proportion of the pictorial space occupied by the landscape's unusual features. While these photos record the badlands landscapes just as Thomson's did, the strong dark-light contrasts in Chang's photos and their compositional arrangements present a much chillier view of this barren region.

Landscape features were the subjects of Chang's photographs, and as noted above, the illumination of those topographical features made them stand out in silhouette. Sometimes Chang's focus was not on the shape of the mountains; their ridges might instead appear in the corners, where their outlines could set off the sky. He also excelled at capturing the changing colors of fog or clouds in the

early morning or at dusk, which, against the undulating outlines of the mountains, became the focal point of certain works.

Nature can change in an instant, and the snap of a photographer's shutter is likewise an instantaneous motion. Yet capturing Moon World's changing colors, for Chang Wu-chun, meant long days and long years behind the lens. Six years after shooting his *Dream of Moon World* series, Chang turned his gaze toward the colored bamboo he found growing there. Sometimes, to artistically highlight the bamboo's changing colors during its brief growing season, Chang might wait until the sky also changed color. Once, trying to shoot some bamboo that wouldn't germinate in the harsh environment, he was determined to capture the rays of the rising sun as a symbol of life; he waited a full week until the sun moved into the right position. Earlier photographers at Moon World showed simplicity, humanism, and vitality in their work, but Chang's focus on color and composition exhibits a much more "painterly" kind of conception, a fact that explains why his *Moon World* series of works hold such significance in the history of photography in Taiwan.

The Mountain is Once Again a Mountain

Chang Wu-chun's *Moon World* series of works opened up an entirely new realm in the history of photography with his approach to that subject. This essay, looking at early images of *Moon World* and photos from the pre-war era, shows that most were made by outsiders on a grand mission to open up new territory, wanderers creating straightforward records of its physical appearance. After the war, realistic documentation of the area turned toward human activities, and photographers also created mental imagery in which Moon World scenery symbolized an inner emotional world. Chang's Moon World photographs, rather than detailing the region's geographical features or human activities, employed a simple pairing of landscape and sky, and were unique to the era. The poetry of his work derives entirely from scene selection, composition, and changing colors; the mountainous landscape was sometimes just a backdrop, and the simple lines and shifting color temperatures of his photos provide a unique perspective on his Moon World subject. Only a "keeper of the mountains" such as Chang, who truly understood the region through working there so many years, could meet the challenge of creating such works. Photographic history in Taiwan, like the parable of enlightenment in Zen Buddhism, seems to have undergone phases in which the mountain is, first, "just a mountain," after which "the mountain is no longer a mountain." Finally, through the lens of Chang Wu-chun, "the mountain is once again a mountain," presented to us as both a dreamlike reverie and a direct visual presence.

作品
WORKS

風景映照

晨曦／夕照・霞海／雲霧・大地景觀

Reflections of the Landscape

Dawn / Dusk - Sea of Clouds / Floating Mists - Landscape Views

作品內容：《夢幻月世界》、《彩竹的故鄉》系列

Includes works from the *Dream of Moon World* and The Hometown of Colored Bamboo series

文／關秀惠　Author / Kuan Hsiu-hui

自1987年張武俊投入臺南草山月世界專題攝影，

此系列作品儼然為攝影家最負盛名的代表作品；攝影家亦自述，

前六年的拍攝歷程幾乎每日皆於凌晨3時30分出發前往。

不同於高雄田寮燕巢地區常見的拍攝手法，

張武俊將鏡頭聚焦於月世界惡地形所襯托的種種氣候變化之下的日出、雲海、夕照與地形景觀，

其中變化萬千的色彩成了他鏡頭中特殊的色溫表現。

由月世界視角延伸出的焦點另有無謂惡劣生長環境、容易被人忽略的竹子；

它們或以獨傲之姿雄踞山頭，或交落叢聚於嶙峋山脈之間，

於貧瘠的地貌裡呈現另一種旺盛的生命力。

本分類作品除了精選包含《夢幻月世界》與《彩竹的故鄉》展覽專輯中重要作品，

亦挑選攝影家未曾出版以及2000年之後的作品。

After 1987, Chang devoted himself to his most representative series of works, which portrays Tainan's Moon World at Caoshan. According to Chang, he typically set out at 3:30 a.m. each day during his first six years there. Chang's techniques here differ from those he used near Kaohsiung's Yanchao Tianliao area; views of the harsh topography and changing weather at Moon World set off its sunrises, low clouds, sunsets, and scenic views, all expressed with his unique sensitivity to color temperature. His work at Moon World led him to other subjects too, such as the bamboo within this absurdly harsh environment, easily overlooked but standing proudly on the mountaintops and adding its vitality to the craggy terrain.

Works in this category include important works from the *Dream of Moon World* and *The Hometown of Colored Bamboo* exhibition catalogs, as well previously unpublished works or works dating from after 2000.

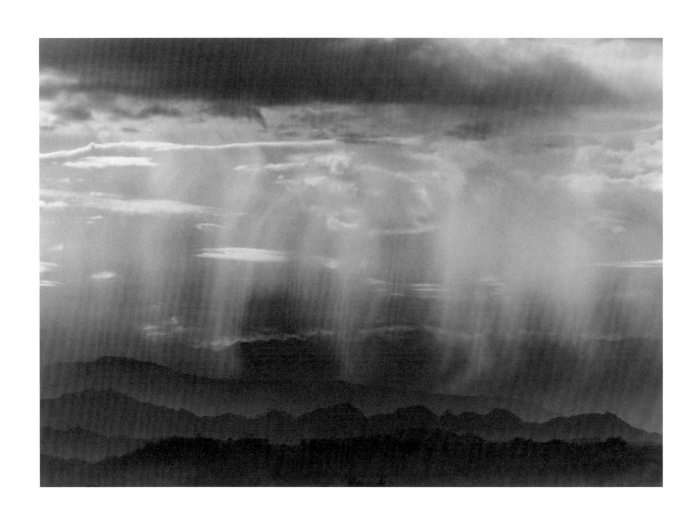

《夢幻月世界》/ 龍崎大坪 / 1988.5
Dream of Moon World / Daping, Longqi / 1988.5

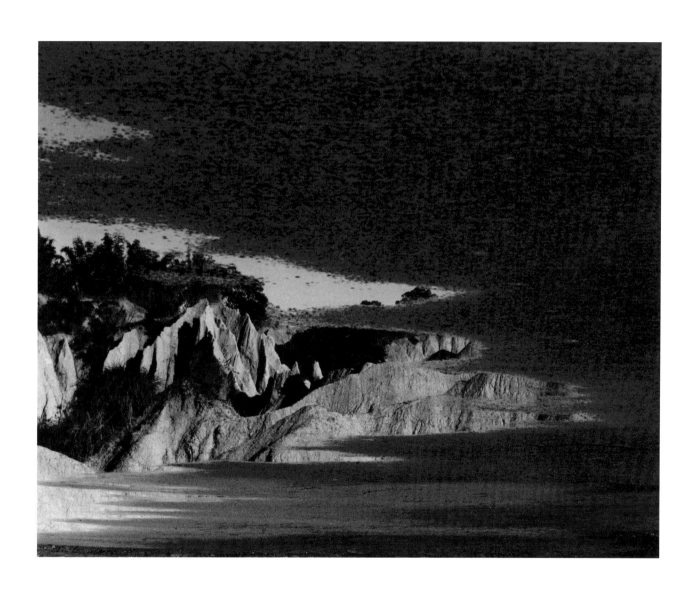

《夢幻月世界》/ 金馬寮 / 1990.12
Dream of Moon World / Jinmaliao / 1990.12

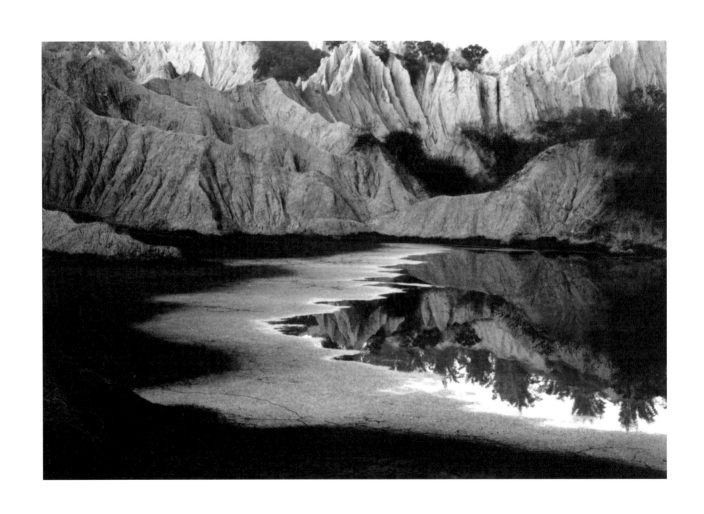

《夢幻月世界》/ 心仔寮 / 1990.12.24
Dream of Moon World / Sinzihliao/ 1990.12.24

《夢幻月世界》/ 青瓜寮 / 1990.12.8
Dream of Moon World / Qinggualiao / 1990.12.8

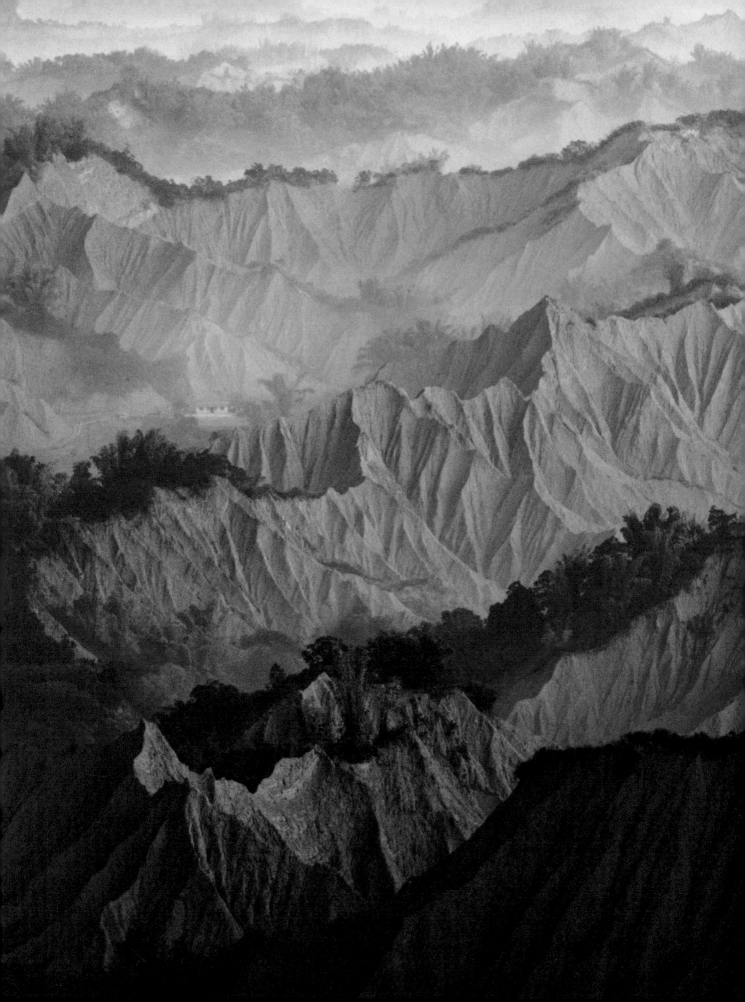

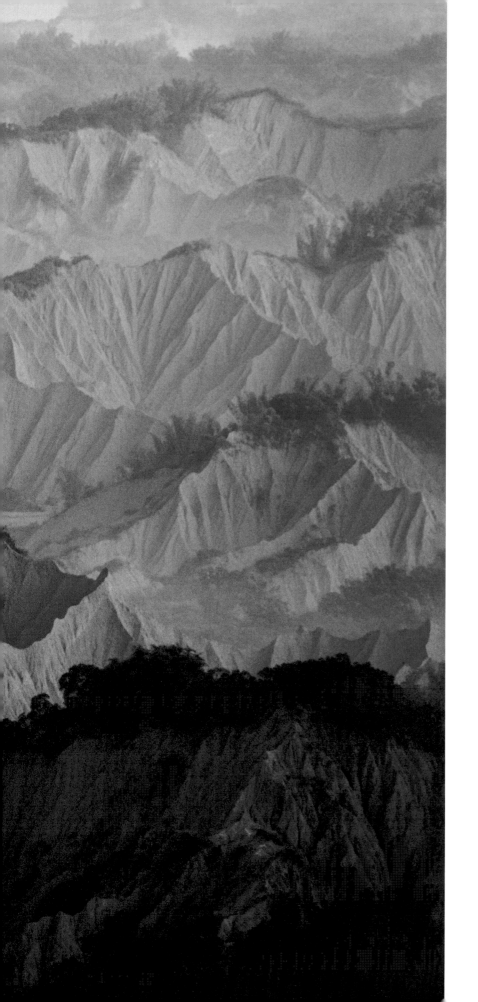

《夢幻月世界》/ 大林尾 / 1991.12.26
Dream of Moon World / Dalinwei / 1991.12.26

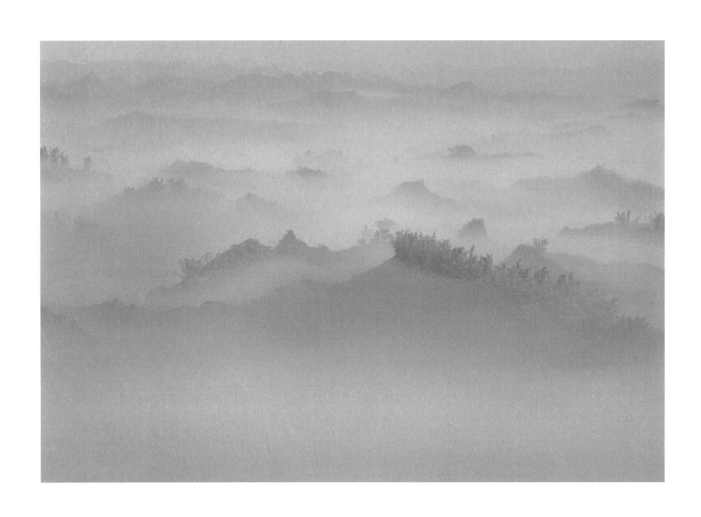

《夢幻月世界》/ 大林尾 / 1988.8.5

Dream of Moon World / Dalinwei / 1988.8.5

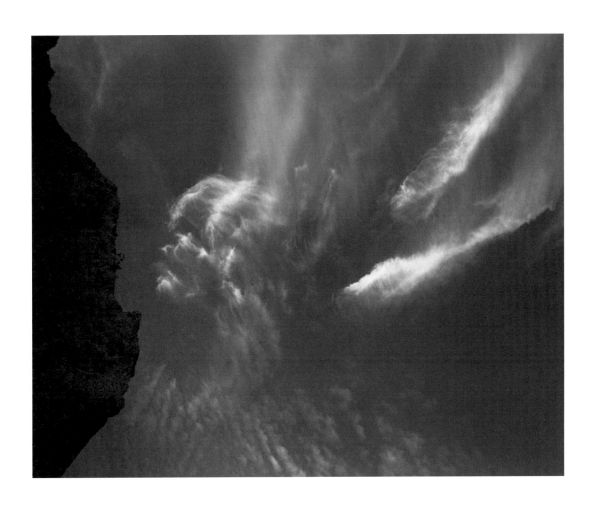

《夢幻月世界》/ 茵夢湖 / 1990.5.17
Dream of Moon World / Yinmeng Lake / 1990.5.17

《夢幻月世界》/ 二寮 / 1989.10
Dream of Moon World / Erliao / 1989.10

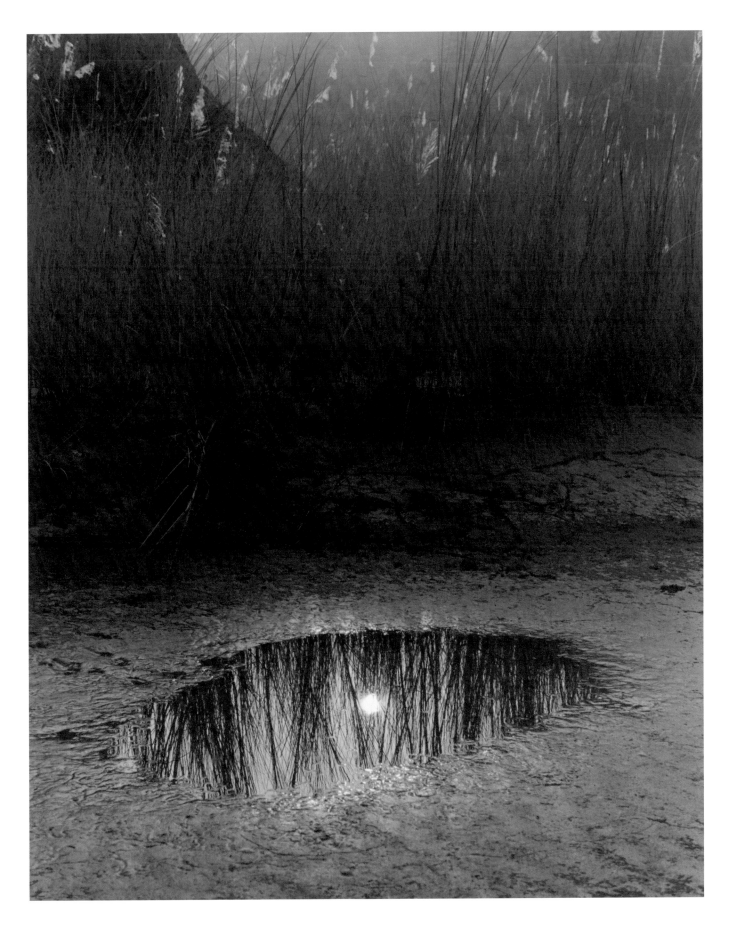

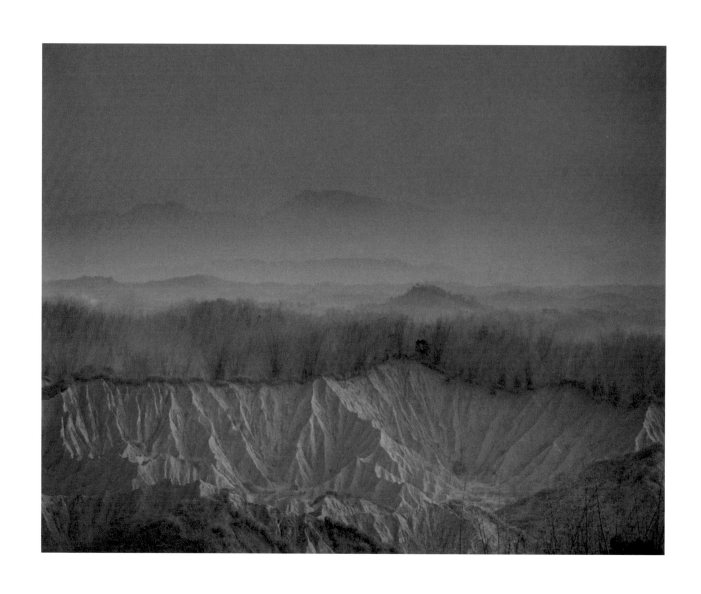

《夢幻月世界》 / 金馬寮 / 1991.3.24

Dream of Moon World / Jinmaliao / 1991.3.24

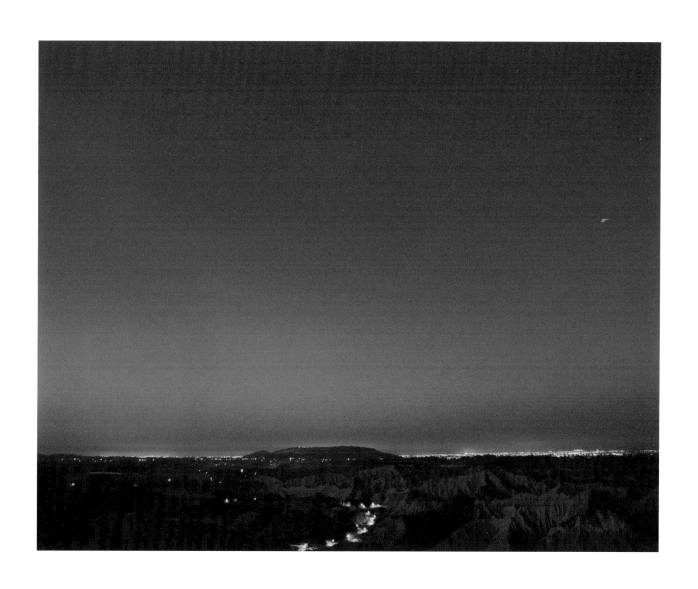

《夢幻月世界》/ 龍崎烏山頭 / 1993.1
Dream of Moon World / Wushantou, Longqi / 1993.1

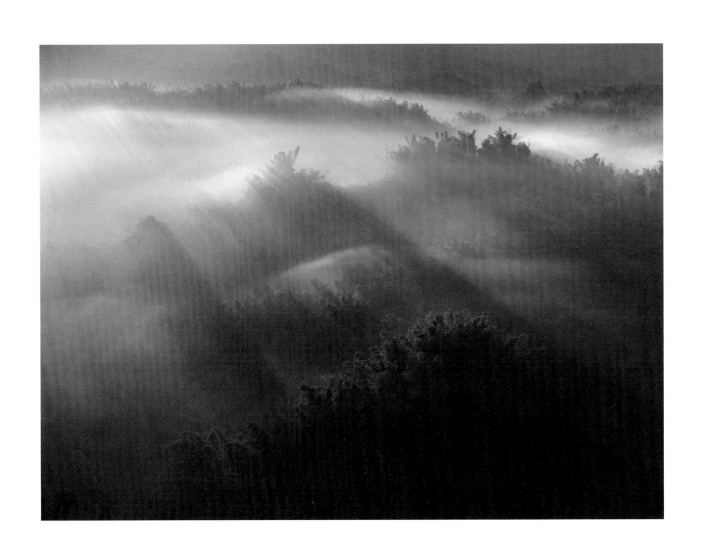

《夢幻月世界》 / 二寮 / 1998.7.26

Dream of Moon World / Erliao / 1998.7.26

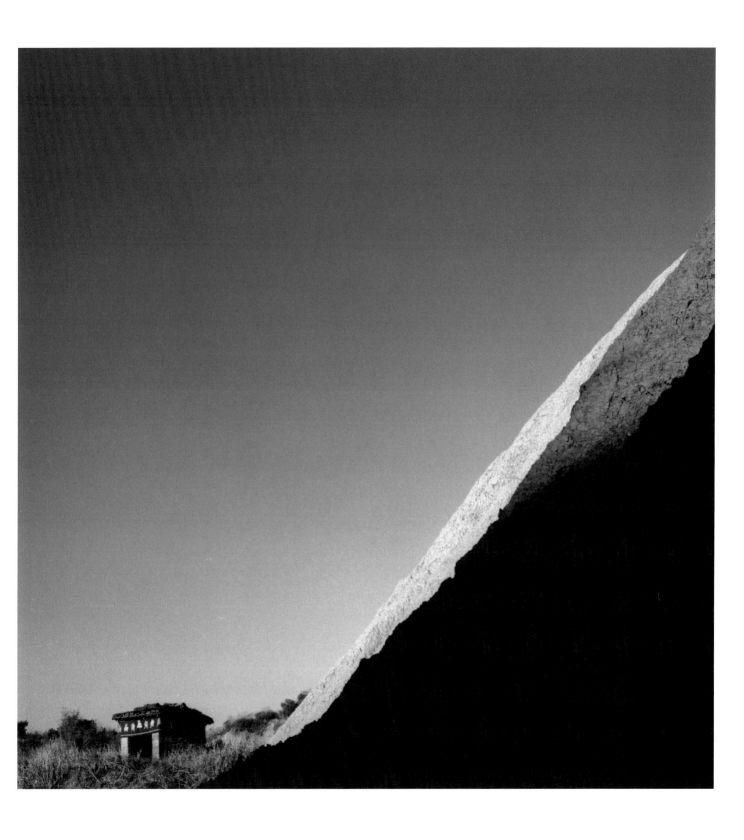

《夢幻月世界》/ 動員 / 1991.3.8
Dream of Moon World / Dongyuan / 1991.3.8

《夢幻月世界》/ 二寮 / 1996.8.6
Dream of Moon World / Erliao / 1996.8.6

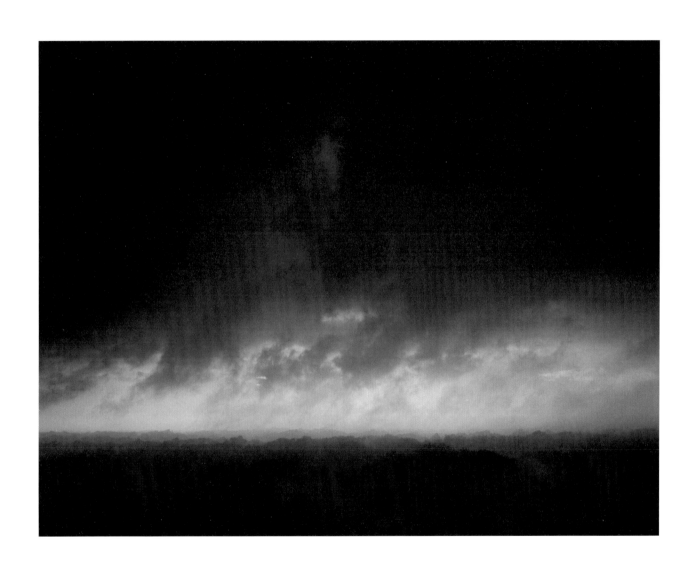

《夢幻月世界》 / 二寮 / 1997.6.27
Dream of Moon World / Erliao / 1997.6.27

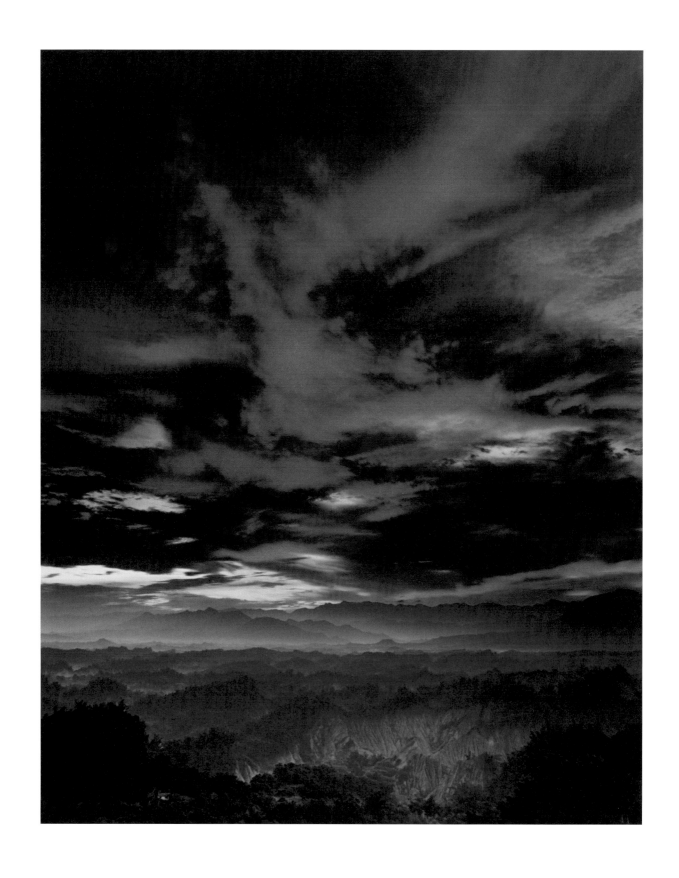

《夢幻月世界》／二寮／1998.6.22

Dream of Moon World / Erliao / 1998.6.22

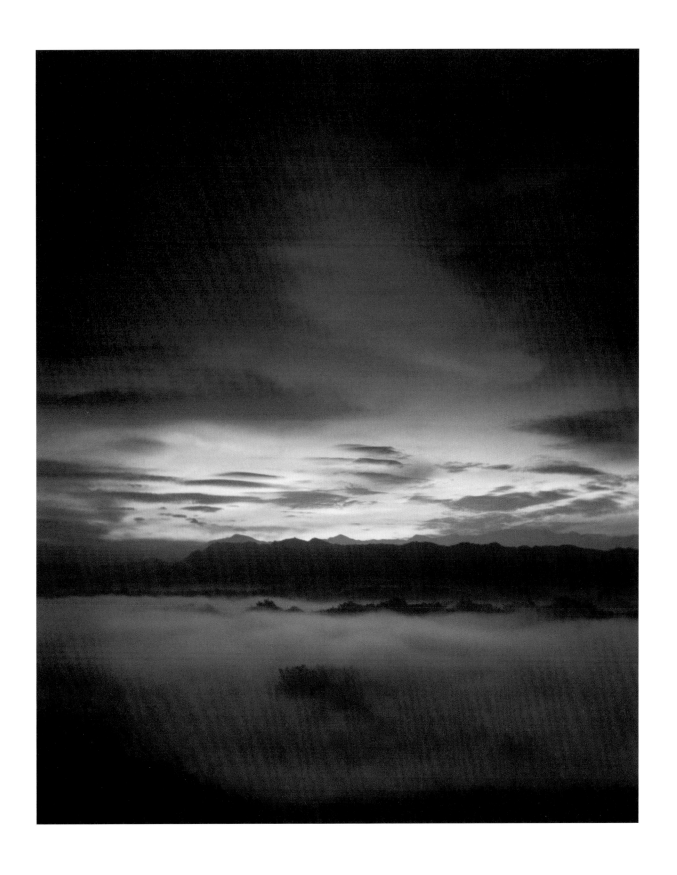

《夢幻月世界》/ 二寮 / 2001.6.19
Dream of Moon World / Erliao / 2001.6.19

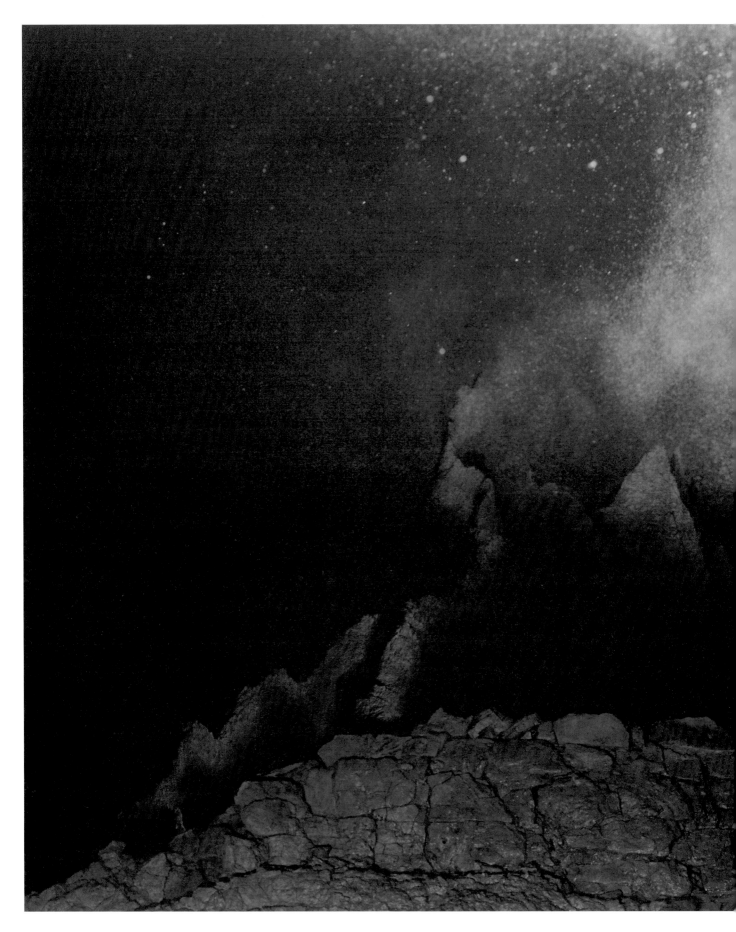

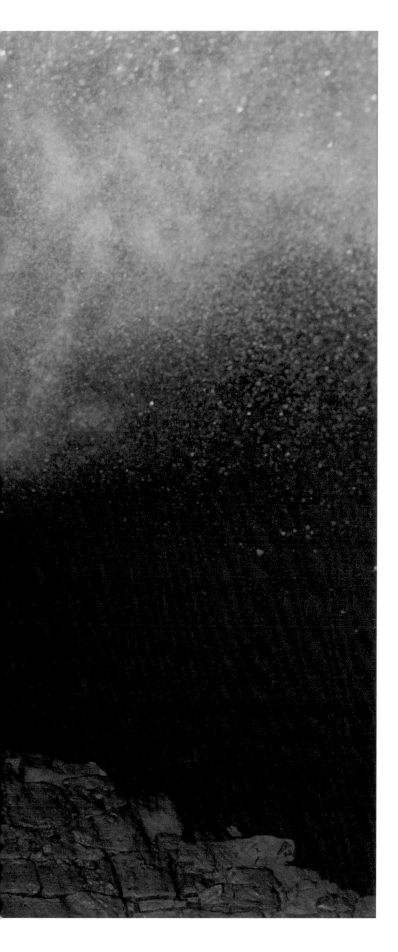

《夢幻月世界》 / 金山 / 1990.1
Dream of Moon World / Jinshan / 1990.1

《夢幻月世界》/ 金山 / 1990.1
Dream of Moon World / Jinshan / 1990.1

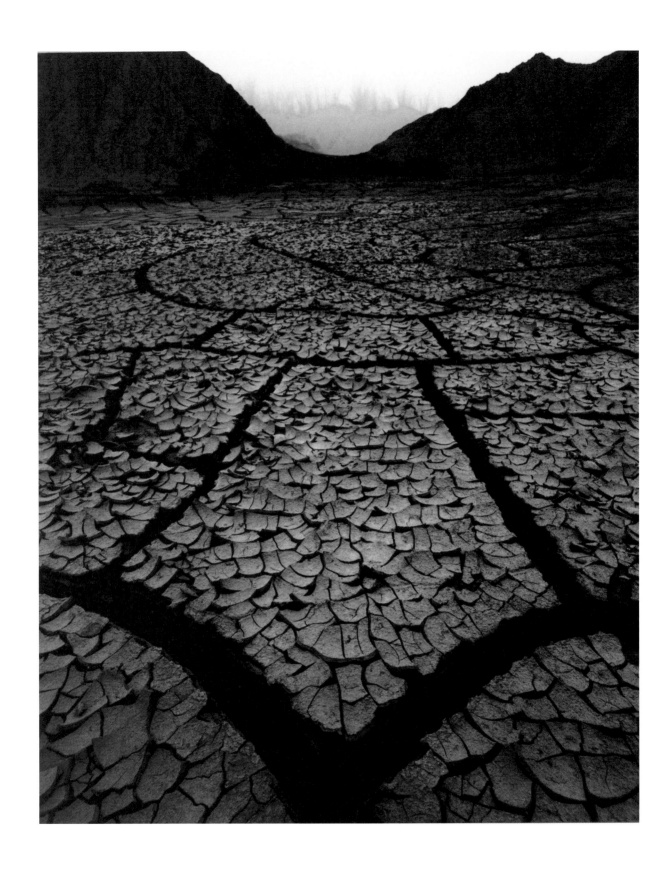

《夢幻月世界》 / 金馬寮 / 1991.3
Dream of Moon World / Jinmaliao / *1991.3*

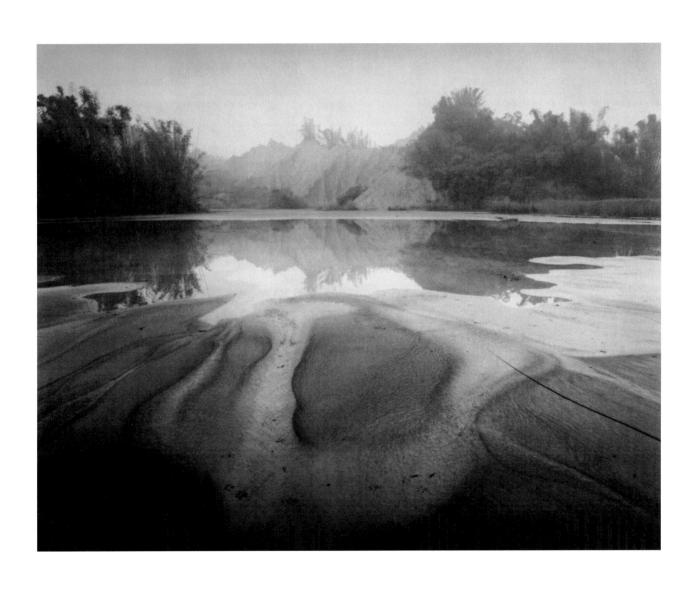

《夢幻月世界》 / 青瓜寮 / 2007.10.25
Dream of Moon World / Qinggualiao / 2007.10.25

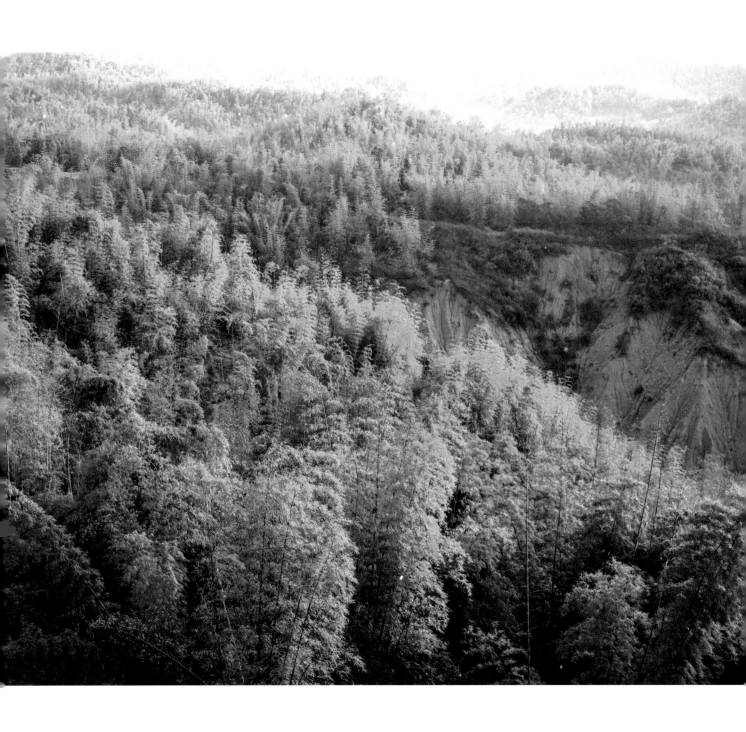

《彩竹的故鄉》/ 烏山頭 / 1994.1.6
The Hometown of Colored Bamboo / Wushantou / 1994.1.6

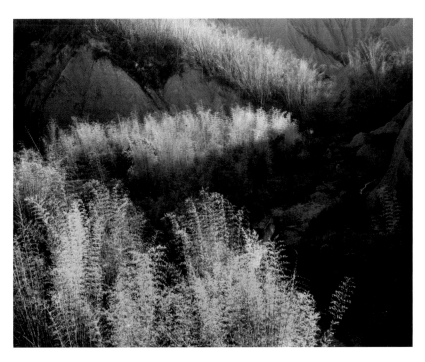

《彩竹的故鄉》/ 丘園 / 1996.3.17
The Hometown of Colored Bamboo / Qiuyuan / 1996.3.17

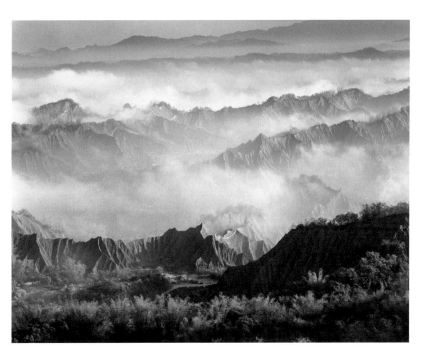

《彩竹的故鄉》/ 308 高地優美山莊 / 2001.3.27
The Hometown of Colored Bamboo / Beautiful Villa / 2001.3.27

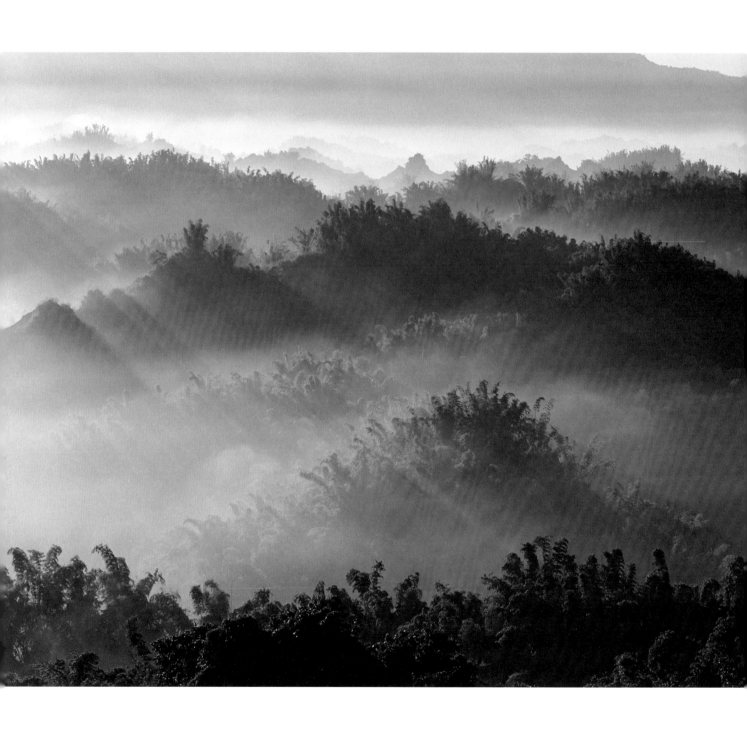

《彩竹的故鄉》/ 二寮 / 1996.6.6
The Hometown of Colored Bamboo / Erliao / 1996.6.6

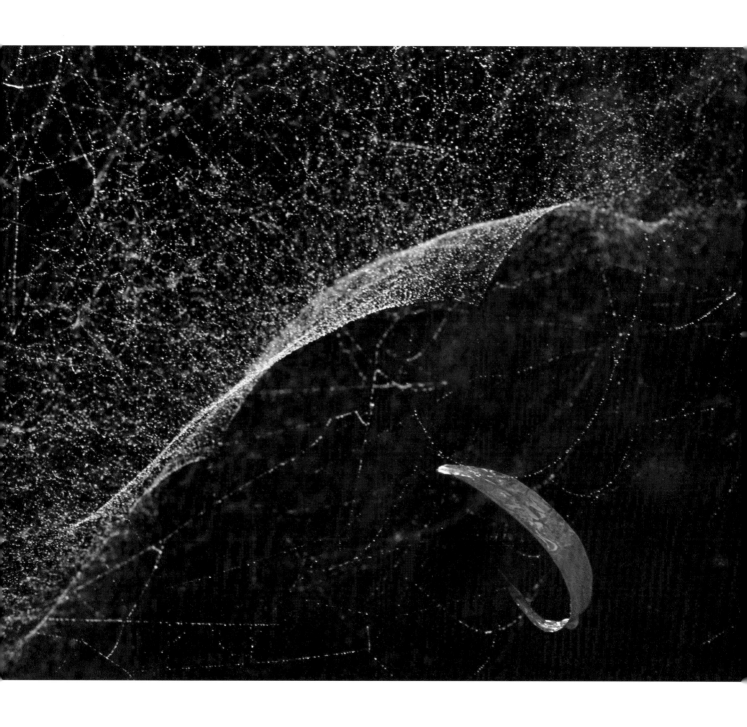

《彩竹的故鄉》／ 大林尾 / 1996.10
The Hometown of Colored Bamboo / Dalinwei / 1996.10

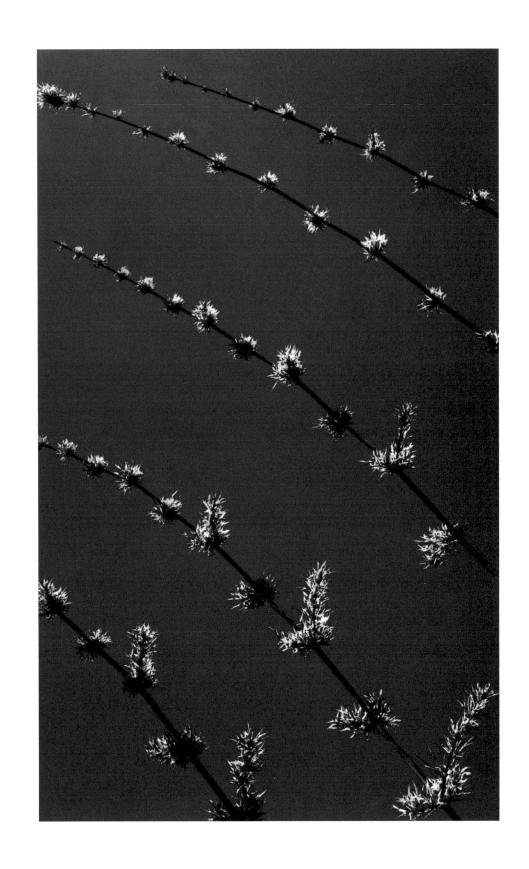

《彩竹的故鄉》／ 龍崎石嘈 / 1996.10
The Hometown of Colored Bamboo / Shicao, Longqi / 1996.10

《彩竹的故鄉》/ 山月湖 / 1994.2
The Hometown of Colored Bamboo / Mountain Moon Lake / 1994.2

《彩竹的故鄉》/ 龍崎龍船窩 / 1997.2
The Hometown of Colored Bamboo / Longchuanwo, Longqi / 1997.2

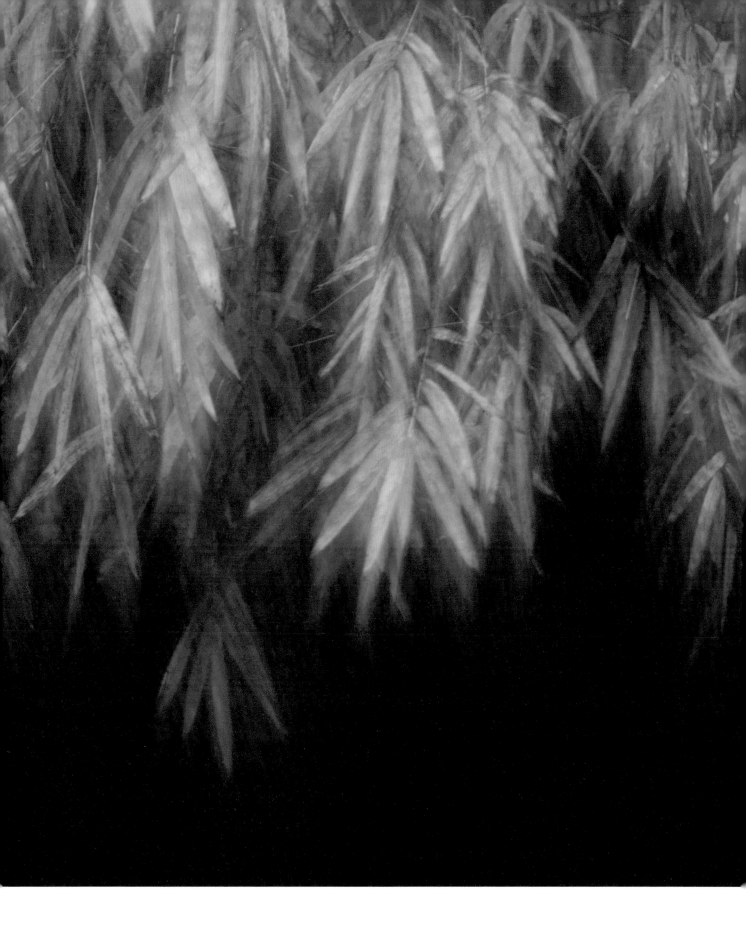

《彩竹的故鄉》/ 龍崎 / 1996.9
The Hometown of Colored Bamboo / Longqi / 1996.9

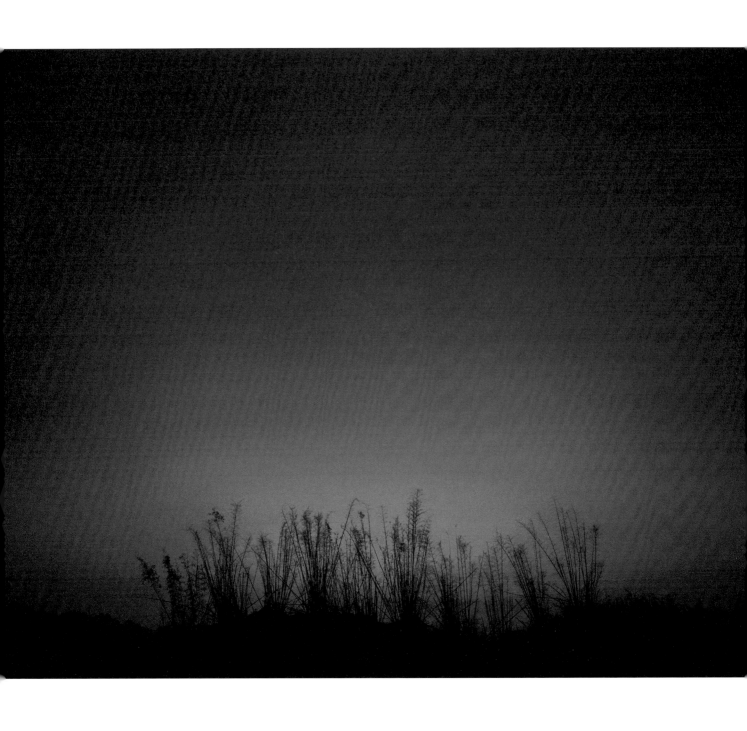

《彩竹的故鄉》/ 玉井後坑 / 1995.12
The Hometown of Colored Bamboo / houkeng, Yujing / 1995.12

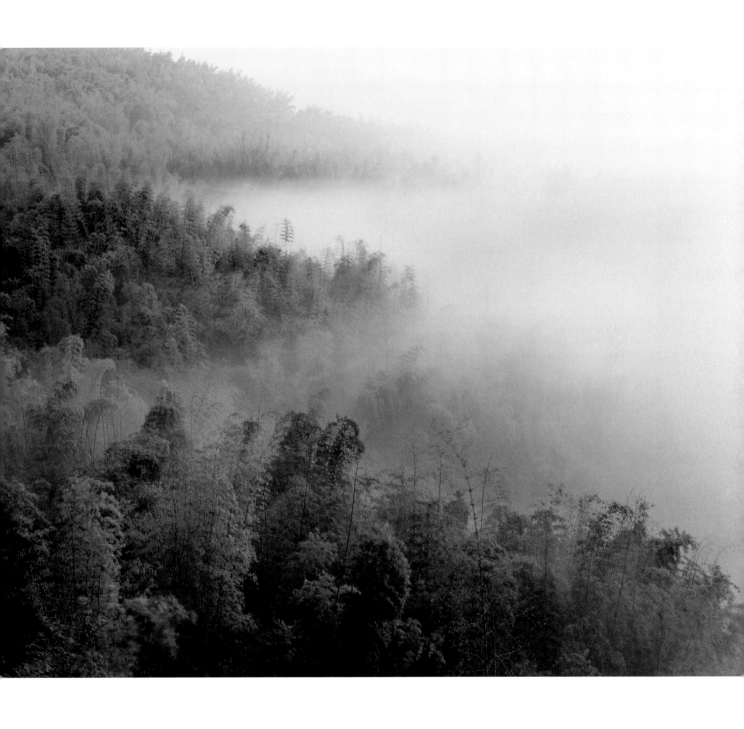

《彩竹的故鄉》/ 烏山頭 / 1997
The Hometown of Colored Bamboo / Wushantou / 1997

厝影流光

孔廟 · 古宅 · 民居

Age-Worn Homes in Time's Wake

Confucian Temple / Early Houses / Common Homes

作品內容：《全臺首學》、《月世界土角厝》、《安平》系列

Includes works from the *Confucian Temple, Earthen Houses at Moon World and Anping* series.

文 / 關秀惠　Author / Kuan Hsiu-hui

此系列是攝影家除了自然地景之外，最接近人文風土色彩的作品。
家鄉的百年古蹟孔廟建築、安平古宅的靜謐與深遠，還有月世界重要的第三寶——土角厝，
競相成為攝影家鏡頭下深刻的文化記憶。攝影家用他最擅長的造型構圖與光影對比，
留下浮塵微光中歷史靜止的一刻；是藍天與紅瓦對映之下的幾何之美，
也是試圖保存先人文化的自我意志使然。

This is the photographer's most humanistic series after his work with natural landscapes. Powerful cultural memories vie for our attention in views of the centuries-old historic site of the Confucian Temple in his hometown, the tranquility and agelessness of ancient homes at Anping, and Moon World's third treasure—its earthen homes. Excelling at compositional shapes and contrasts of light and shadow, Chang is able to freeze historical moments in time; the geometric beauty of red tiles against blue skies displays his determination to preserve his ancestral culture.

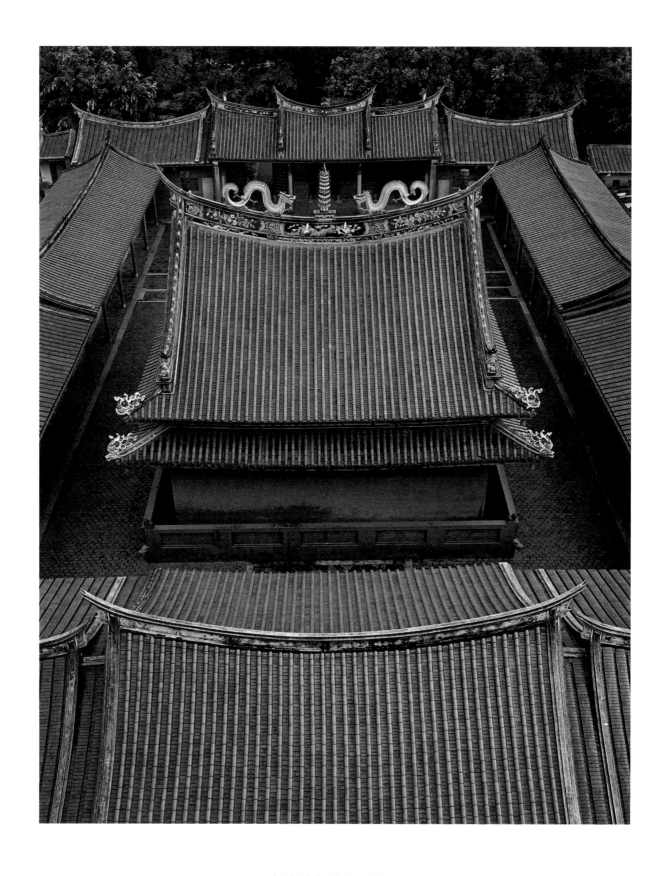

《全臺首學》/ 臺南 / 1994.8.6
Confucian Temple / Tainan / 1994.8.6

《全臺首學》/ 臺南 / 1993.8.15
Confucian Temple / Tainan / 1993.8.15

《全臺首學》/ 臺南 / 1994.5.15
Confucian Temple / Tainan / 1994.5.15

《全臺首學》/ 臺南 / 1994.8.23
Confucian Temple / Tainan / 1994.8.23

《全臺首學》/ 臺南 / 1999.1.19
Confucian Temple / Tainan / 1999.1.19

《全臺首學》/ 臺南 / 1994.4.8
Confucian Temple / Tainan / 199s4.4.8

《全臺首學》/ 臺南 / 1994.4.20
Confucian Temple / Tainan / 1994.4.20

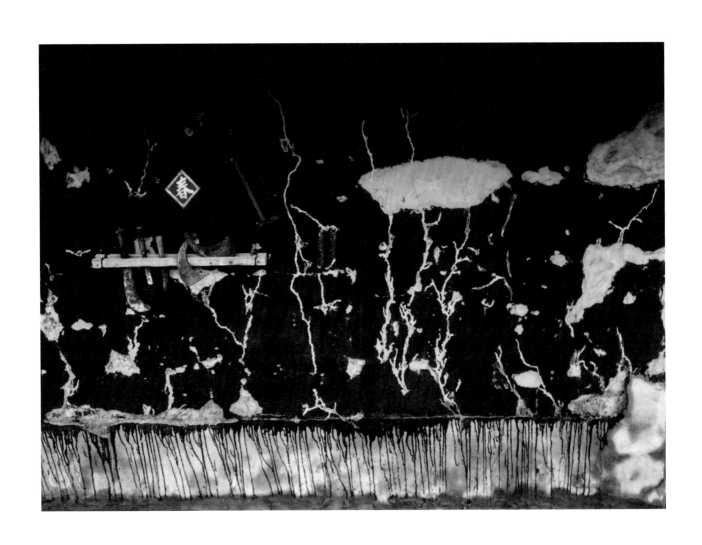

《月世界土角厝》/ 龍崎大坪 / 1999.10.23
Earthen Houses at Moon World / Daping, Longqi / 1999.10.23

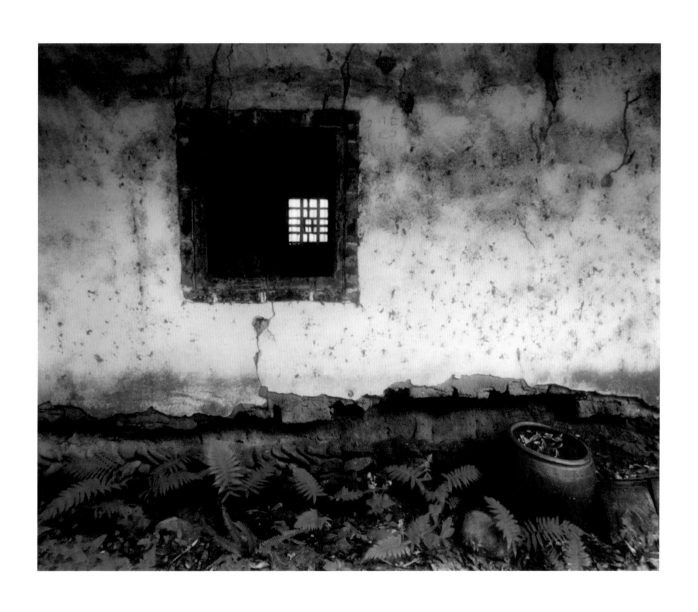

《月世界土角厝》/ 龍崎大坪 / 1999.10.30
Earthen Houses at Moon World / Daping, Longqi / 1999.10.30

《月世界土角厝》/ 龍崎牛埔 / 2000.2.7
Earthen Houses at Moon World / Nioupu, Longqi / 2000.2.7

《月世界土角厝》/ 內門 / 2000.12.17
Earthen Houses at Moon World / Neimen / 2000.12.17

《月世界土角厝》/ 龍崎大坪 / 2000.5.14
Earthen Houses at Moon World / Daping, Longqi / 2000.5.14

《月世界土角厝》/ 龍崎土崎村 / 1999.12.10
Earthen Houses at Moon World / Tuchi Village, Longqi / 1999.12.10

《月世界土角厝》/ 龍崎烏樹林 / 1999.11.26
Earthen Houses at Moon World / Wushulin, Longqi / 1999.11.26

《月世界土角厝》/ 龍崎牛埔 / 2000.12.21
Earthen Houses at Moon World / Nioupu, Longqi / 2000.12.21

《月世界土角厝》 / 龍崎蜈蜞埔 / 2000.4.30
Earthen Houses at Moon World / Wuqipu, Longqi / 2000.4.30

《月世界土角厝》 / 新光村 / 2010.9.10
Earthen Houses at Moon World / Xinguang Villiage / 2010.9.10

《月世界土角厝》/ 二寮楊春安宅 / 1999.12.9

Earthen Houses at Moon World / Yang chun-an's home, Erliao / 1999.12.9

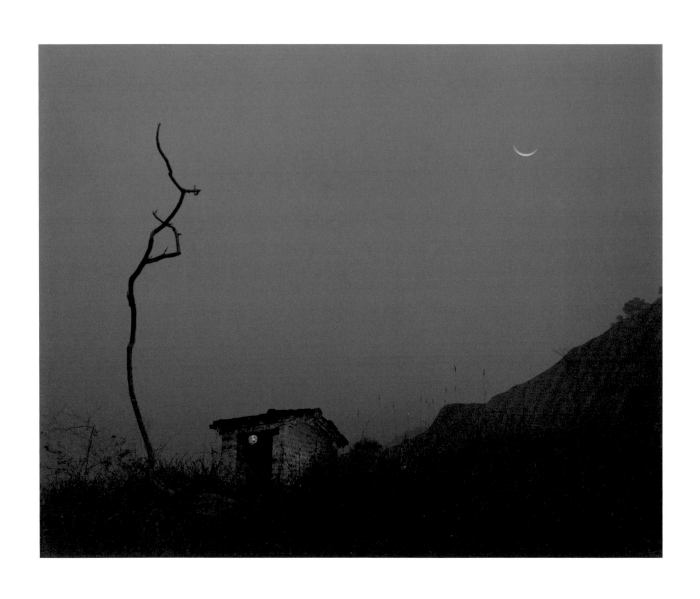

《月世界土角厝》/ 動員 / 1989.12.21
Earthen Houses at Moon World / Dongyuan / 1989.12.21

《安平》安平夜色 / 臺南 / 1992-1995
Anping, Night in Anping / Tainan / 1992-1995

微物自然
芒海・荷語・木榮・花綻

Nature in the Smallest of Things
Seas of Swordgrass / Lotus Talk / Thriving Trees / Plum Blossoms

作品內容：《菅芒花》、《荷花》、《鳳凰木》、《梅花》系列

Including works from the *Swordgrass, Lotuses, Royal Poinciana* and *Plum Blossom* series

文 / 關秀惠　Author / Kuan Hsiu-hui

花卉主題是臺灣沙龍攝影常見的題材，從張武俊早期曾加入臺南攝影社團，

並且曾以荷花系列作品申請台灣省攝影學會員資格，足見他對於花卉題材攝影的專精。

張武俊拍攝荷花始於臺南鹽水溪與鄭仔寮溪一帶，

之後曾至臺南中山公園、沙崙、新營、白河等地，拍攝時不單純以盛開的花朵為焦點，

也捕捉了它們隨季節更迭由含苞、盛開、枯萎乃至凋零的種種細節面貌。

他進行月世界主題攝影時即注意到

該地老屋旁古老的鳳凰木，以及他所謂的「月世界第四寶」──菅芒花，

拍攝取景特側重於植物與相鄰環境的依傍關係，

梅花系列作品亦可見以枝幹為重心撐起繁梅綻放的特殊構圖。

本分類以花卉系列為題，

意圖呈現攝影家如何用其獨特細微的心眼，捕捉自然更迭興替的變化。

Floral themes are common in Taiwan's salon photography. Chang's special skill with floral themes can be seen in his early period when he joined the Photographic Society of Tainan and in the lotus-themed works with which he applied to join the Taiwan Provincial Photographic Society. He first photographed lotus flowers in Tainan's Yanshui and Zhengziliao Rivers, and later in Tainan's Zhongshan Park and at Shalun, Xinying, and Baihe. He showed them not just at full bloom, but also captured how they bud out and blossom, then wilt and wither with the seasons. He took note of the ancient poinciana trees next to the old houses at Moon World, and what he called its "fourth treasure"—swordgrass. In his unusual compositions, the center of gravity is not the spray of plum blossoms, but the branches that support them.

This category, taking the floral series as its main theme, presents the unique and subtle vision of the photographer as he captures nature's changes.

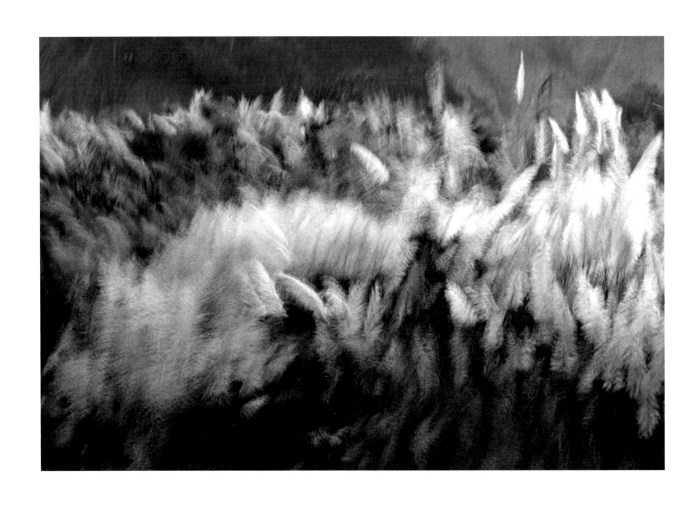

《菅芒花》 / 五里坑 / 2004.9.26
Swordgrass / Wulikeng / 2004.9.26

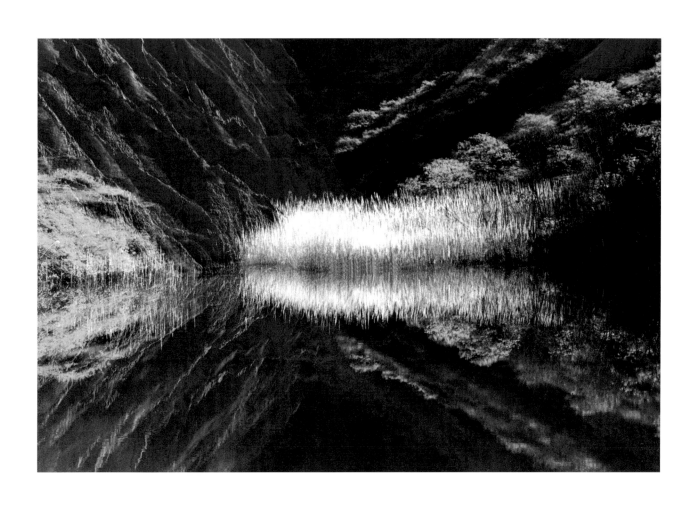

《菅芒花》／臺南／2004-2011
Swordgrass / Tainan / 2004-2011

《菅芒花》/ 燕巢金山 / 2006.9.18
Swordgrass / Jinshan, Yanchao / 2006.9.18

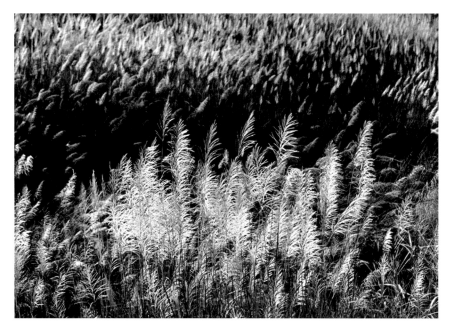

《菅芒花》/ 臺南 / 2004-2011
Swordgrass / Tainan / 2004-2011

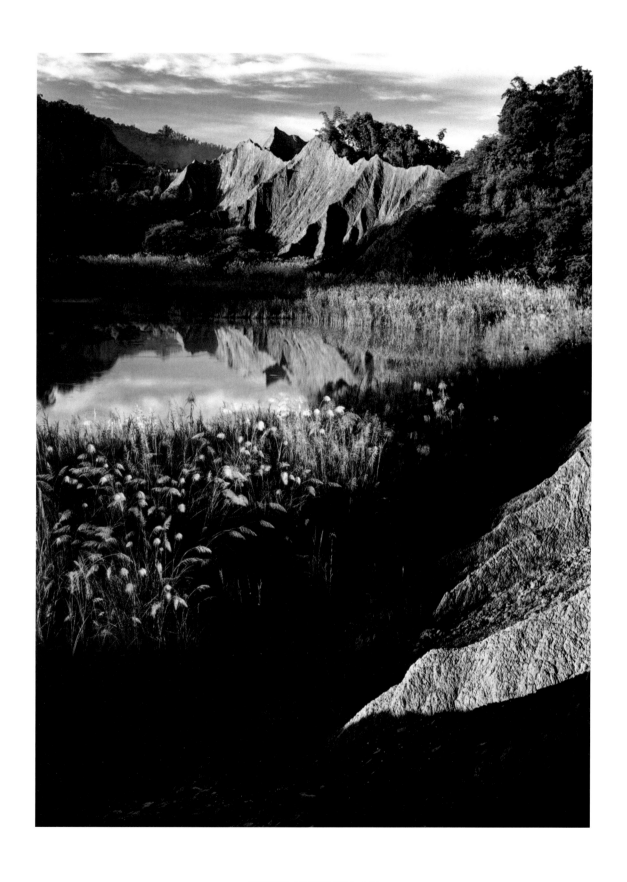

《菅芒花》/ 青瓜寮 / 2011.9.29
Swordgrass / Qinggualiao / 2011.9.29

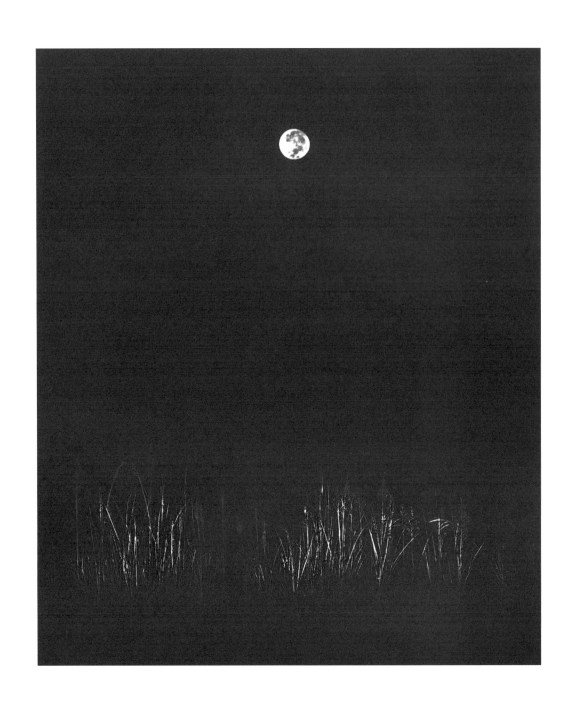

《菅芒花》 / 臺南 / 2004-2011
Swordgrass / Tainan / 2004-2011

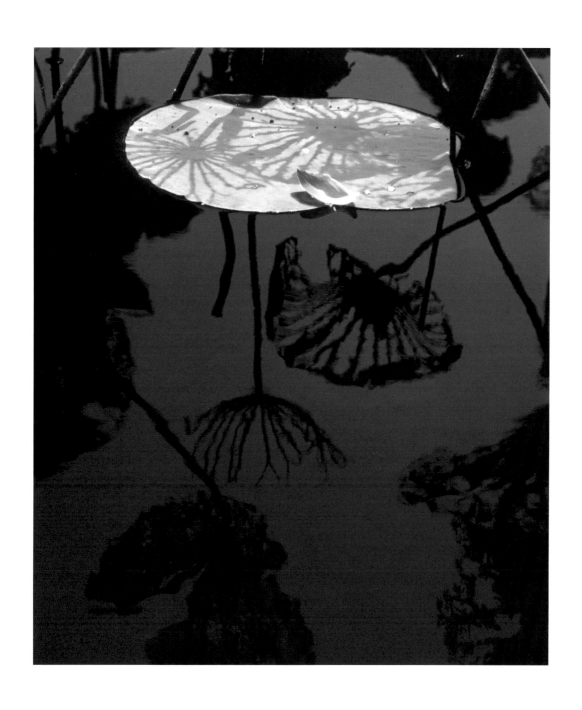

《荷花》 / 臺南 / 2009-2013
Lotuses / Tainan / 2009-2013

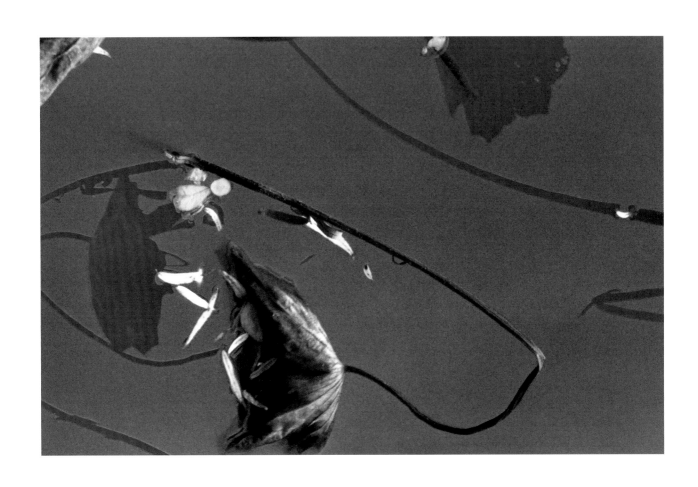

《荷花》 / 新營天鵝湖 / 2013.9
Lotuses / Swan Lake, Xinying / 2013.9

《荷花》/ 臺南永康公園 / 2011.6.25
Lotuses / Yongkang Park, Tainan / 2011.6.25

《荷花》/ 沙崙 / 2009.8.15
Lotuses / Shalun / 2009.8.15

《荷花》/ 沙崙
Lotuses / Shalun
上 (above) 2010.4.18; 下 (below) 2010.4.23

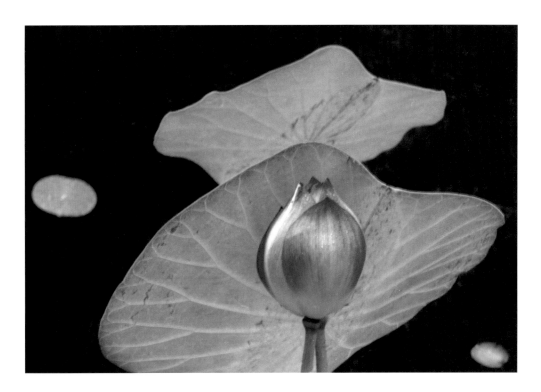

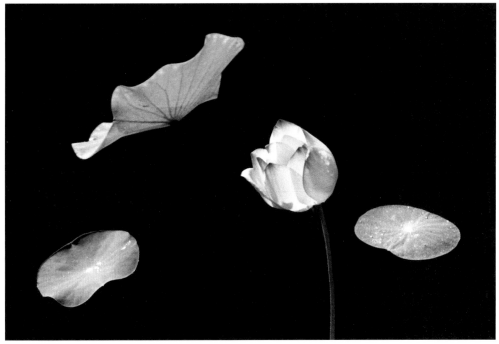

《荷花》/ 沙崙
Lotuses / Shalun
上 (above) 2010.7.25; 下 (below) 2010.7.15

《鳳凰木》/ 大湖
Royal Poinciana / Dahu
上 (above) 2008.5; 下 (below) 2007.5.21

《鳳凰木》/ 大湖 / 2012.5.19
Royal Poinciana / Dahu / 2012.5.19

《梅花》/ 風櫃斗 / 1998-2011
Plum Blossom / Fengguidou / 1998-2011

《梅花》/ 南投信義 / 1998-2011
Plum Blossom / Xinyi, Nantou / 1998-2011

《梅花》/ 嘉義阿里山 / 1998-2011
Plum Blossom / Alishan, Chiayi / 1998-2011

萬象即景

沙丘・魚塭・峽谷

Natural Phenomena

Sand Dunes / Fish Ponds / Canyons

作品內容：《濱海沙丘》、《魚塭》、《萬年峽谷》系列

Including works from the *Coastal Dunes*, *Fish Pond* and *Wannian Canyon* series

文 / 關秀惠　Author / Kuan Hsiu-hui

2000年後，張武俊拍攝足跡延伸至臺南沿海與其他縣市。
攝影家在三股以沙丘與魚塭為主題拍攝一系列作品；
2007年則與友人共同驅車至雲林草嶺地區著名的萬年峽谷景點尋找題材，
此處成為月世界之後，攝影家另一個探險秘境。

此類作品中，可觀察到攝影家更得心應手地將自然萬象轉化為片刻之美；
廣角、高反差與刻意去除多餘景物干擾的構圖方式，使得畫面更臻至於純然的視覺符號。
三股地區的沙丘地形被高度抽象化彷彿具有神秘力量，
《魚塭》系列中千奇百怪的漩渦與色彩變化也被賦予各種故事想像。這些不同時間、
地點或光線所構築的萬象風景也隱含了攝影家對於家園斯土的記憶與情感。

After 2000, Chang photographed along the coast at Tainan and in other counties and cities, and shot photos of the sand dunes and fish farms around Sangu. In 2007, he drove with friends to the famous Wannian Canyon in Yunlin's Caoling region, which became another area for exploration after his *Moon World* works.

In these works, Chang's transformation of natural phenomena into moments of beauty is even more accomplished. Deliberately removing unnecessary scenic elements allows his pure visual motifs to emerge with startling clarity in these wide-angle, high-contrast compositions. His highly abstracted views of sand dunes take on a mysterious power, while narrative imagination fills the strange vortexes and shifting colors in his *Fish Pond* series. These varied scenes, constructed at different times, locations, and under different lighting conditions, suggest the memories and emotions that the photographer connected with his homeland.

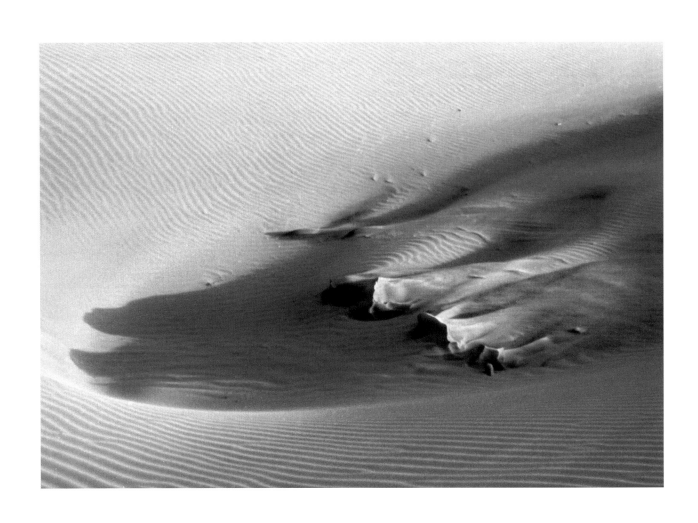

《濱海沙丘》 / 三股 / 2011.1.18
Coastal Dunes / Sangu / 2011.1.18

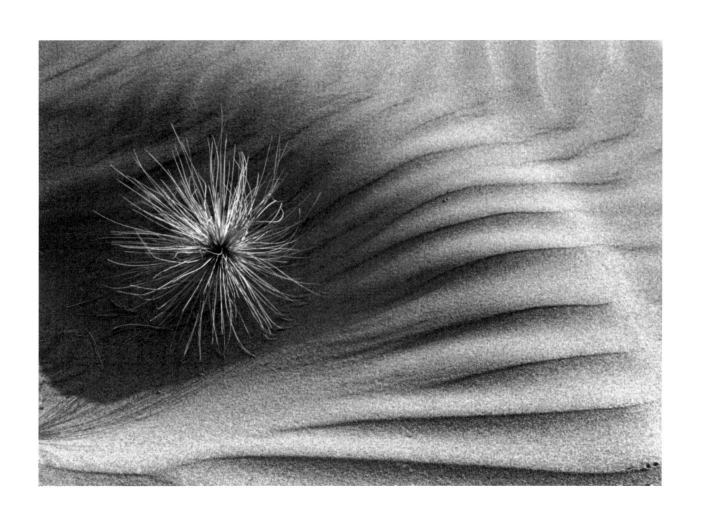

《濱海沙丘》/ 三股 / 2011.8.26
Coastal Dunes / Sangu / 2011.8.26

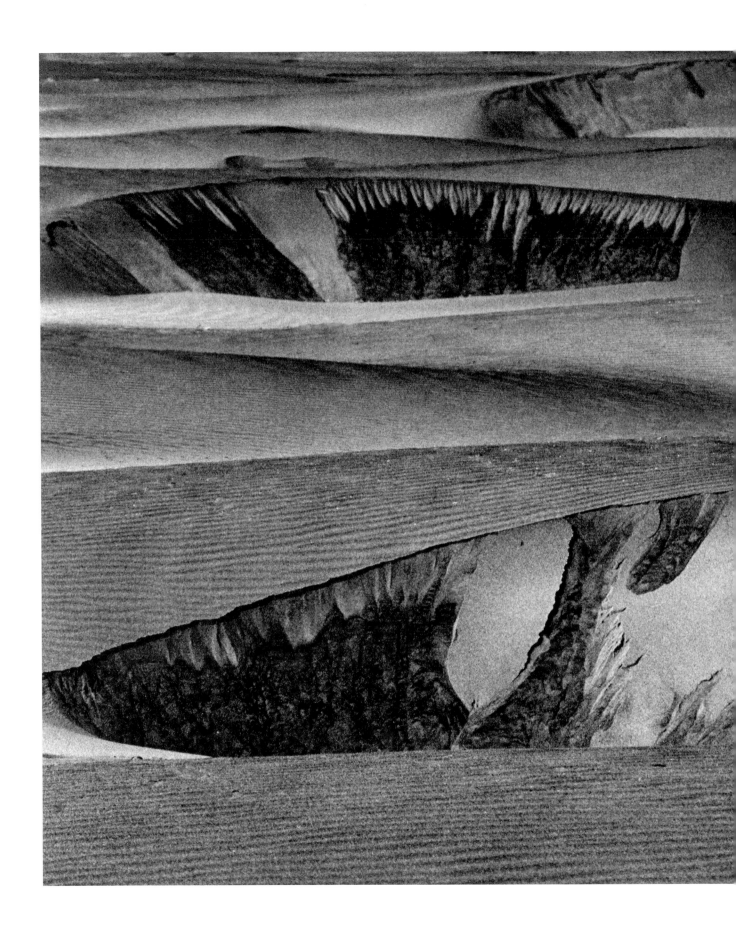

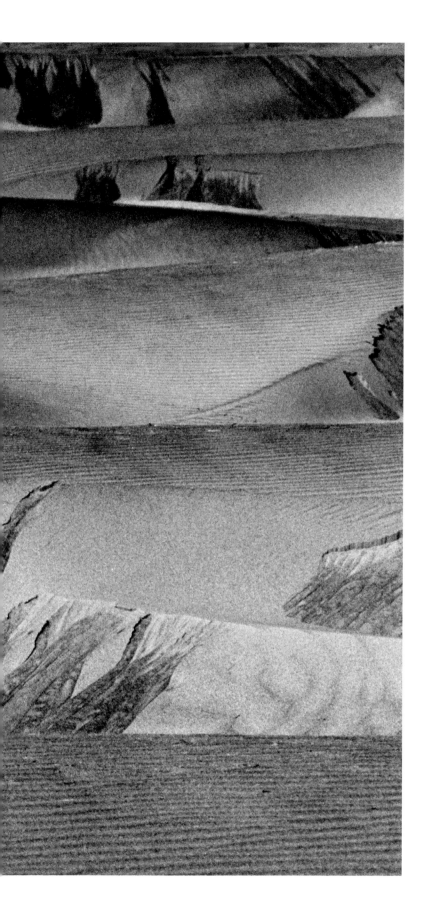

《濱海沙丘》 / 三股 / 2011
Coastal Dunes / Sangu / 2011

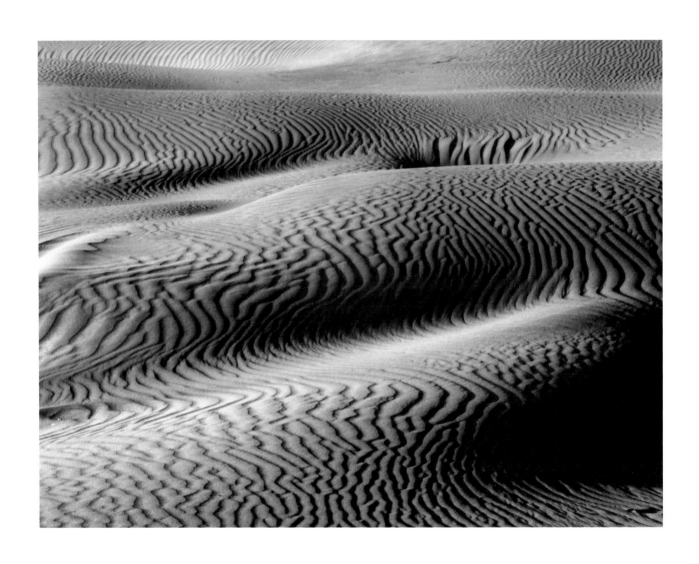

《濱海沙丘》 / 三股 / 2011
Coastal Dunes / Sangu / 2011

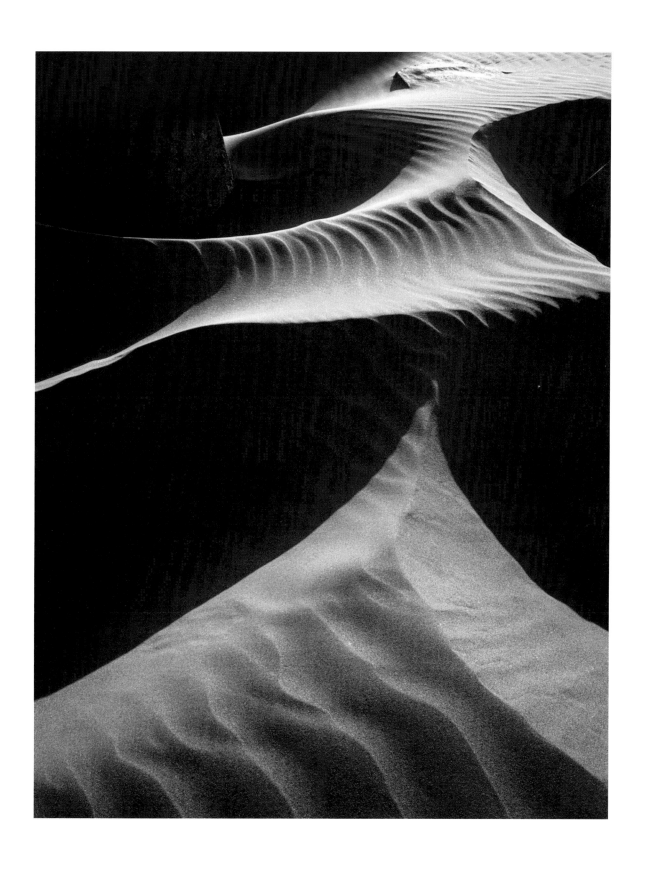

《濱海沙丘》 / 三股 / 2011
Coastal Dunes / Sangu / 2011

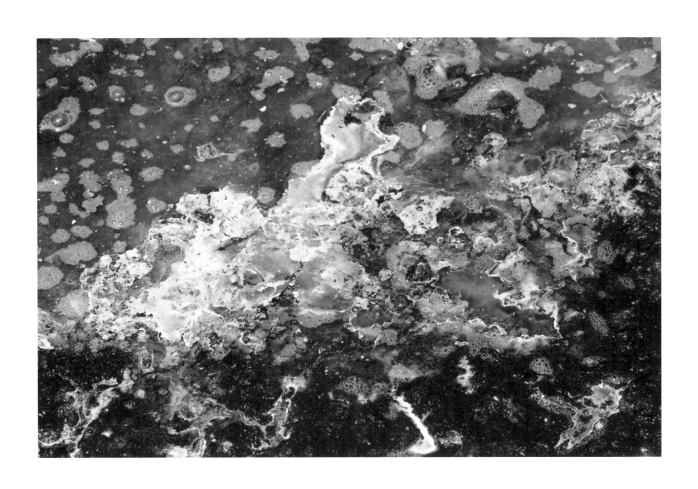

《魚塭》狂歡 / 三股 / 2009.7.12
Spree form the *Fish Pond* series / Sangu / 2009.7.12

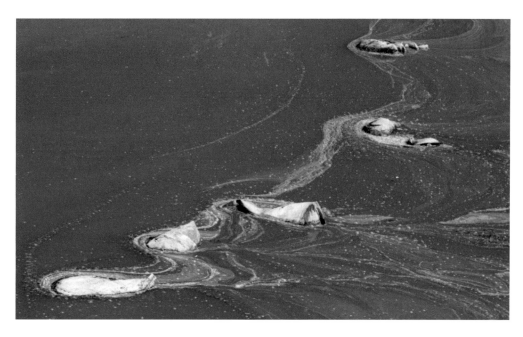

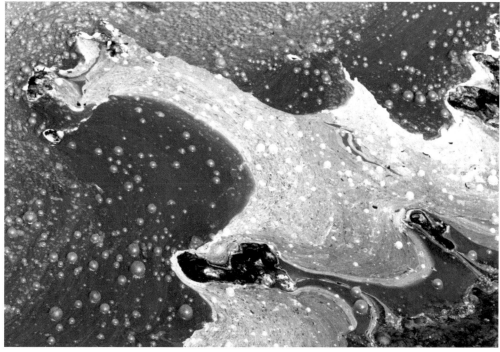

《魚塭》/ 十份

Fish Pond / Shifen

上 (above) 2008.6.19；下 (below) 2008.10.25

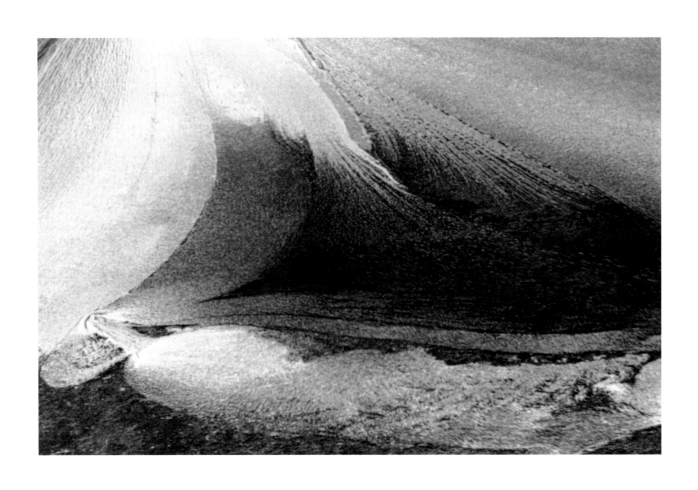

《魚塭》 / 七股 / 2004-2013
Fish Pond / Qigu / 2004-2013

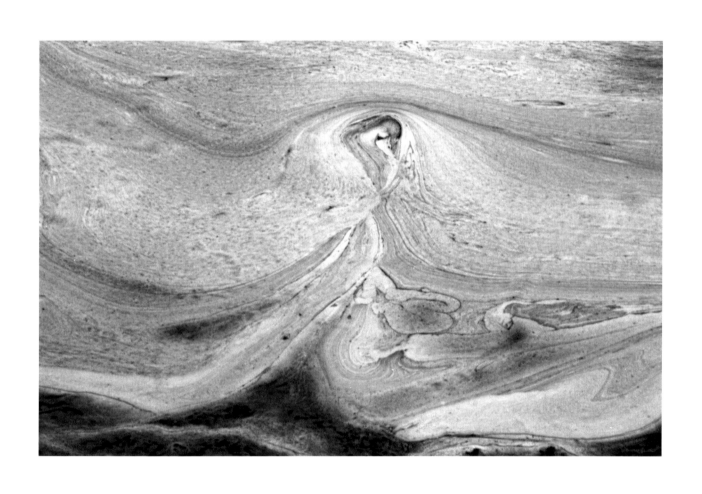

《魚塭》／七股／2004-2013
Fish Pond / Qigu / 2004-2013

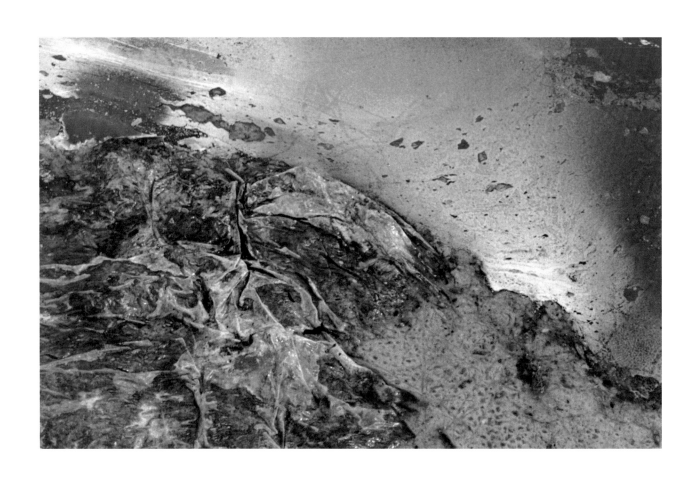

《魚塭》/ 七股 / 2004-2013
Fish Pond / Qigu / 2004-2013

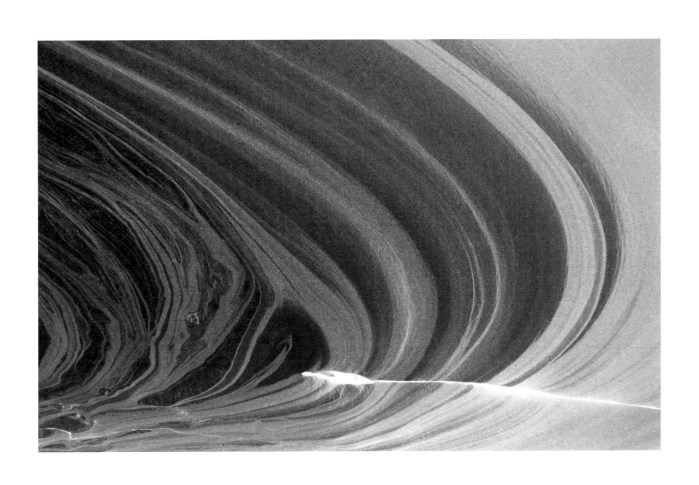

《魚塭》／七股／2004-2013
Fish Pond / Qigu / 2004-2013

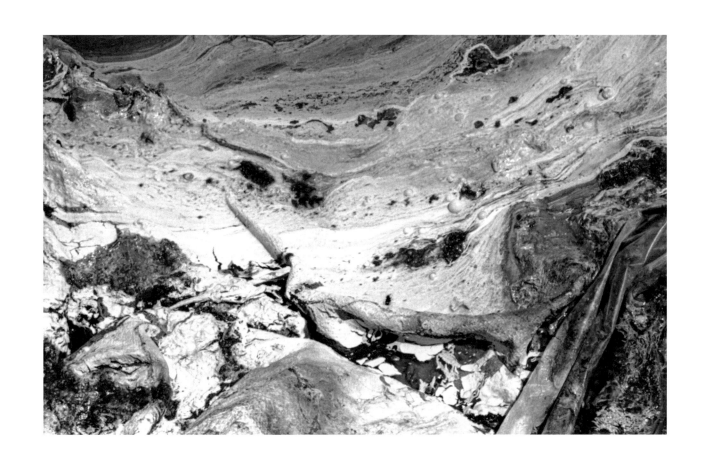

《魚塭》/ 海埔 / 2011.7.26
Fish Pond / Haipu / 2011.7.26

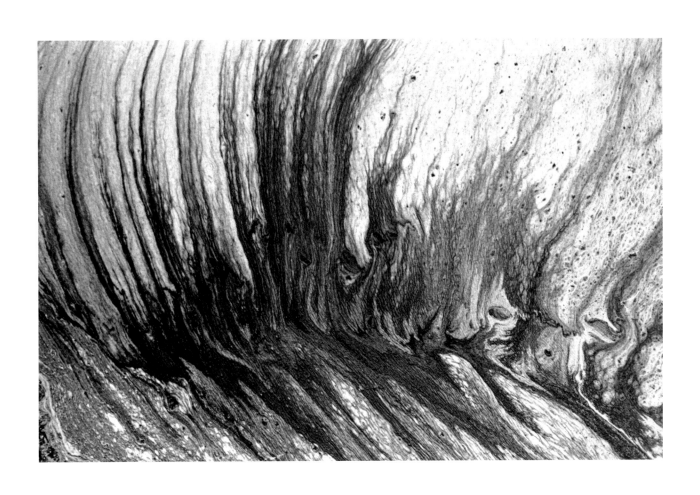

《魚塭》/ 七股 / 2004-2013
Fish Pond / Qigu / 2004-2013

《魚塭》/ 七股 / 2007
Fish Pond / Qigu / 2007

《魚塭》/ 三股 / 2009.5.30
Fish Pond / Sangu / 2009.5.30

《魚塭》/ 三股 / 2012.5.14
Fish Pond / Sangu / 2012.5.14

《魚塭》/ 七股 / 2004-2013
Fish Pond / Qigu / 2004-2013

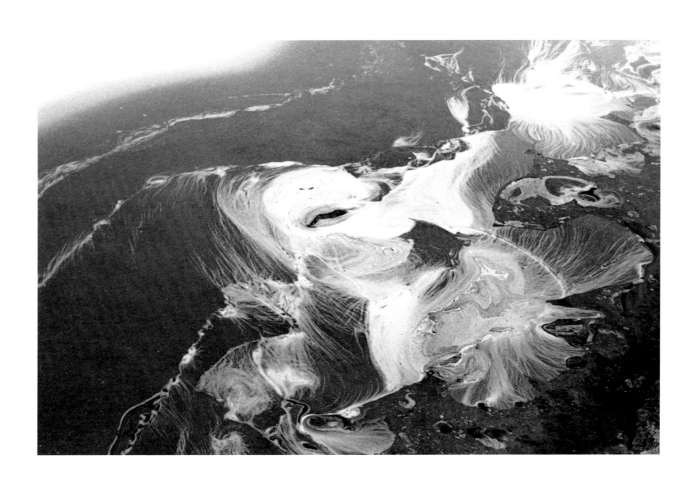

《魚塭》/ 七股 / 2004-2013
Fish Pond / Qigu / 2004-2013

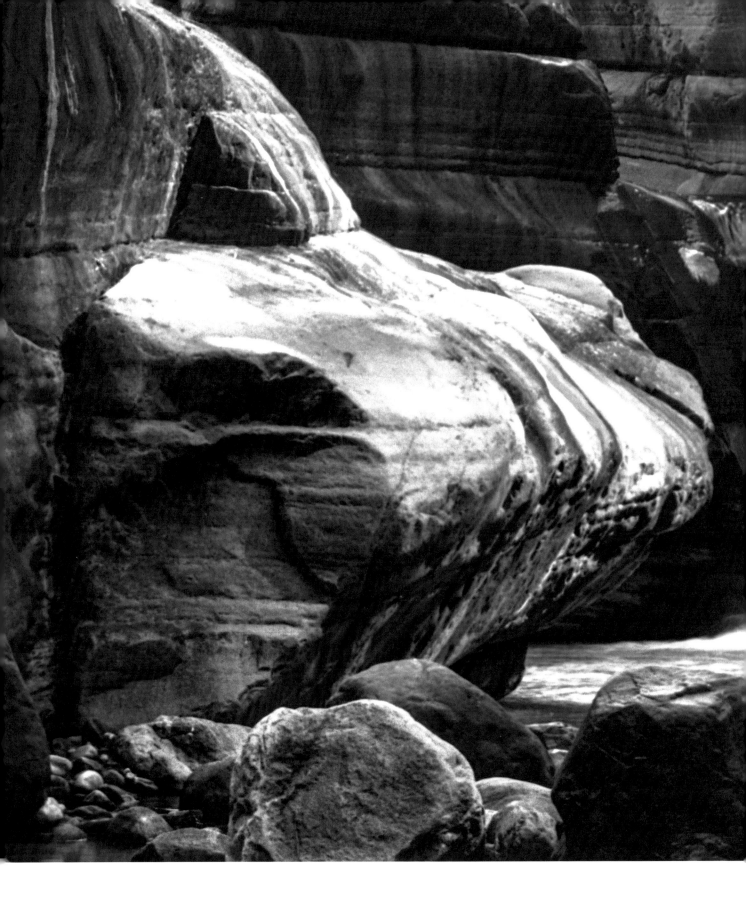

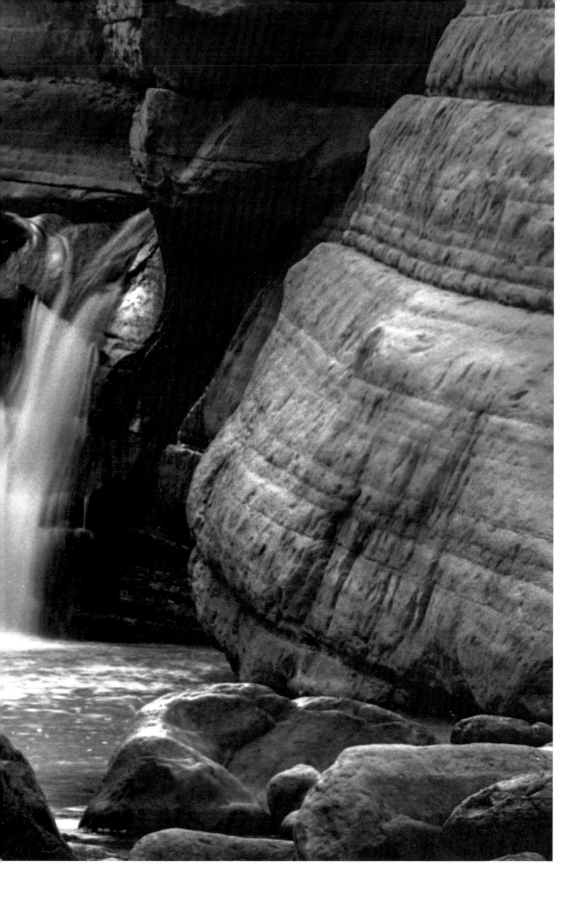

《萬年峽谷》/ 雲林草嶺 / 2007
Wannian Canyon / Caoling, Yunlin / 2007

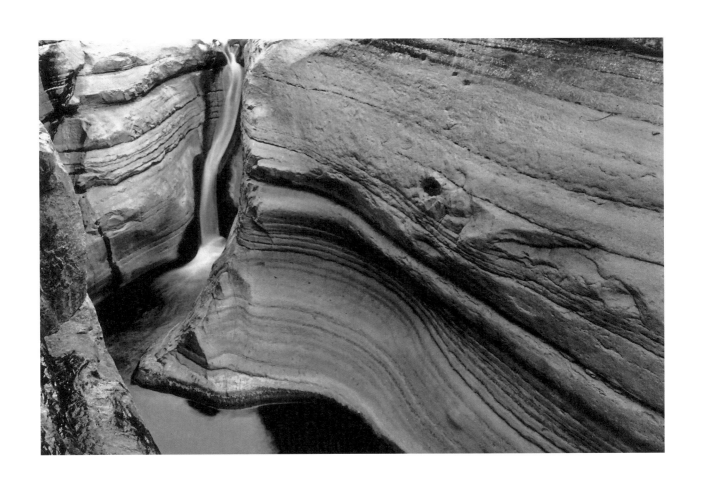

《萬年峽谷》/ 雲林草嶺 / 2007.12.21
Wannian Canyon / Caoling, Yunlin / 2007.12.21

《萬年峽谷》/ 雲林草嶺 / 2009.10.31
Wannian Canyon / Caoling, Yunlin / 2009.10.31

《萬年峽谷》／雲林草嶺 / 2009.11.22
Wannian Canyon / Caoling, Yunlin / 2009.11.22

《萬年峽谷》 / 雲林草嶺 / 2007.12.28
Wannian Canyon / Caoling, Yunlin / 2007.12.28

口述訪談
INTERVIEWS

張武俊訪談紀錄 [1]

接觸攝影的緣起與早期學習歷程

關秀惠（以下簡稱關）：您曾提到，剛接觸攝影時是透過多看別人作品、聽取評審意見，進而參加各項比賽而增進攝影能力，能否談談您學習攝影的歷程。

張武俊（以下簡稱張）：我拍照一開始是為了替小孩做紀錄，民國57年的事了。當時用的是雙眼相機，聽朋友建議要買單眼的比較好，後來就去買一台Minolta單眼相機。接著有朋友看到我的相機，他說既然買這麼好的相機，就建議我去參加攝影學會，後來被他說服，參加臺南市攝影學會。有一次學會通知有攝影活動，要去臺南公園（舊名中山公園）拍攝少女人像，我開心地揹著我的單眼相機到公園，一到現場看到其他人揹著大包小包，裡頭有各種鏡頭，反觀自己只有一顆鏡頭，心想：這要怎麼拍？相機也不敢拿出來，鼻子摸一摸就回家。之後人家跟我說哪個鏡頭好，我就買哪個鏡頭，哪個鏡頭不好，就把它賣掉，那個時候學習拍照的階段是這樣。

一開始只為記錄孩子成長而拍照 / 張武俊攝 / 臺南
1970 年代
In the beginning, only taking photos to record the growth
of the child / photo by Chang / Tainan / 1970s

加入攝影學會後，就去參加活動和比賽，我參加了三年的比賽，都不曾入選，曾經拿著作品去問朋友林茂繁，結果他說我拍人像後面還有人，這樣不行，他只教我這一個技巧，接下來我用這個技巧繼續拍攝少女人像，背景有人的時候我就不拍，但是單單因為有人而不拍還是不夠，無法入選。三年後遇見攝影界的前輩陳金元，向他請教為什麼無法得獎的理由，他便問我評選時我會不會從旁觀察？我說不曾，他又問我有沒有在看攝影雜誌和相關書籍？有沒有常常參觀別人的展覽？他問的這三個問題，我都不曾做過，從此之後只要知道哪裡在辦比賽，我一定去看評審過程，這也算我的轉捩點。因每個比賽一定都去看評選，觀察別人作品，之後參加攝影比賽我都得獎，得過的大獎包括櫻花、柯達、富士或Konika等軟片公司所舉辦的大型攝影比賽金牌獎，從1980年代起，我的一些同好朋友看到我，便開始叫我張金牌。[2]

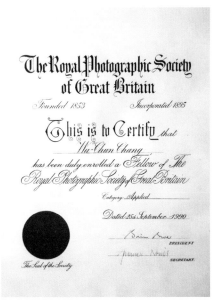

關： 您曾加入哪些攝影社團？可否談談您加入的過程以及離開的理由？

張： 我國內、國外都有參加，最早參加的是台南市攝影學會，也有參加臺南美術研究會的攝影部。接下來是台灣省攝影學會（2005年改名臺灣攝影學會）、台北市攝影學會，國外則是美國紐約攝影學會、香港旺角攝影學會、中華藝術攝影家學會、世界華人攝影學會、英國皇家攝影學會、中國攝影學會。我參加的攝影學會都有得到最高榮譽的博學會士，會士資格取得不易，需要拿照片去考試，尤其是英國皇家榮選更不容易。[3]現在（2021年）有些學會雖然沒有繼續參加活動，但我仍繼續擔任理事，沒有退出。

關： 您曾榮獲英國皇家攝影學會高級會士、香港旺角攝影學會高級會士等會員資格，從早期參加臺灣攝影比賽的自我磨練到獲得國際會員資格的歷程，能否談談其中創作過程的改變與想法，以及您又是如何申請國際攝影會員資格？

張： 我學習攝影的階段一直參加各項攝影比賽，也一直得獎，但到後來卻對得獎沒有太大的興趣，也逐漸感到疲乏，因此開始思考自己拍照的下一階段是什麼，後來決定嘗試專題攝影。第一個專題攝影選擇拍攝荷花，嘗試拍攝的時間大約是民國70年左右。荷花系列作品一開始是在鹽水溪、鄭仔寮溪邊等地拍攝，之後也有去著名的臺南白河景點。當時我是用20張《荷花》作品去申請臺灣攝影學會的會員資格，考香港的英國皇家攝影學會資格則是用《月世界》系列作品去申請。2000年之後，也有繼續拍攝荷花主題。

關： 為何選擇荷花、月世界這些自然的題材做為您的專題攝影？七〇年代的攝影團體曾經時興一陣拍攝臺灣知名景點的熱潮，例如高雄田寮的月世界十分有名，是一處熱門的觀光景點與適合外拍的勝地，洪碩甫與王徵吉等人成立的臺南點點攝影俱樂部便是以高雄月世界的背景為創社起點。請問您拍攝月世界的美景，是否也有受此波攝影風潮的影響？

英國皇家攝影學會博學會士證書 / 1990
Doctoral Fellow certificate from the Royal Photographic Society of Great Britain / 1990

張： 開始拍攝月世界是因為我那個時候遇到瓶頸、找不到題材可拍，回想起小學六年級時，曾經搭糖廠的五分車坐到關廟，再從關廟走路到龍崎國小，到那邊去遠足。小時候遠足的事都忘記了，只有一件事忘不了，就是那邊有一座吊橋。當我找不到拍攝題材時，想起那一座吊橋，想到要去那邊挖寶，後來去那邊每一次探險就每一次愈陷愈深，最後我幾乎走遍（臺南）龍崎。[4]

我從民國76年開始專注拍攝臺南月世界，我拍的是草山月世界，不是王徵吉他們拍的田寮月世界——當時那個地區的月世界已經很有名了，雖然我也曾去那邊拍過羊。我拍的左鎮草山月世界，在當時從沒有人聽過，也沒有人去拍過，那邊以前都沒有路，是個鳥不生蛋的地方。在月世界拍了21年多，起初15年內我每一天都到，我用最笨的方法走遍月世界，就是為了抓住任何景觀的變化，沒想到後來漸漸帶動了大家拍攝草山月世界的熱潮，它從1990年代變成了一個熱門的景點，有時我晚到也會找不到位置拍了。

攝影拍攝過程與技巧訓練

關： 您曾於1992年個展的展覽專輯裡提到，拍攝月世界的六年光陰裡，每日都「三時三十分準時出擊」[5]，在現場用小光圈、長時間曝光的方式拍攝日出、霞海。面對瞬息萬變的天氣，您如何表現您所「見」景色，是否也與您經常提到作品中的「色溫」表現有關？

張： 月世界對我來說就像是一座寶山，朋友都笑我說那邊是不是有粉味，不然我怎麼每天都去。因為從臺南開車到月世界最快只要25分鐘內就可抵達，我通常前一天看完氣象報告（但電視報導只能當作參考），知道大概的天氣狀況後，就會透早就出門，從3點半到8點之間四處尋找拍攝的題材；後來拍久了發現到，如果前一晚下過雨，隔天清晨月世界地區就是一片雲霧縹緲、如同仙境一般。1992年辦完第一次月世界個展後，報紙說我是月世界的魔術師，其實不是，我是利用色溫的變化。畫家可以利用調色盤來調色，但我們攝影家只能靠老天來補色，藍色調就是高色溫的表現，低色溫就是呈現紅色的顏色。[6]

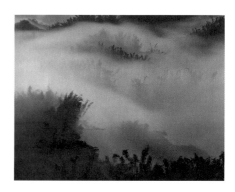

《月世界》系列作品 / 張武俊攝 / 二寮 / 1996.8
A photo from the *Moon World* series / photo by Chang Erliao / 1996.8

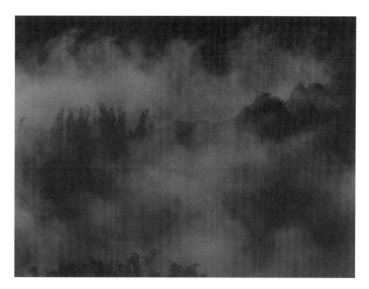

《月世界》系列作品 / 張武俊攝 / 左鎮 / 1996.8
A photo from the *Moon World* series / photo by Chang / Zuozhen / 1996.8

例如下過雨後的早晨，月世界必然是雲海翻騰的景象。雲海太多會把山頭壟罩，所以拍攝時要注意雲海移動的速度。日出前後的色溫變化也都是看老天爺的安排。這張作品，實際上在日出前是藍色，後來太陽升起、照射陽光後，紅色加上藍色拍出來就變成紫色了，這就是「色溫」的變化（左圖）。而有些照片中的雲霧看起來像是被火燒，其實是因為受到太陽照射後的結果（上圖）。

關：您拍攝的月世界與古厝、孔廟等系列作品，曾被視為具有沙龍攝影風格特色的作品，您對此評語有何想法？談到沙龍攝影特別重視的技術層次與美感的追求，您認為您的作品除了具有此特色外，還有其他人文寓意嗎？

張：攝影就是一種藝術，要表現美感。當年我在北美館（臺北市立美術館）辦展覽時，曾遇到一位參觀民眾對我說道：從一樓逛到三樓都是令人心情沉悶的作品，只有看到你的展覽，你的作品才讓我感到心情是舒服、快樂的。我的作品就是表現美，讓人心情感到單純、愉快。我不大會去理會那些評論，只有儘量多觀察、多看別人的作品。

在月世界找尋攝影題材時，除了拍攝月世界的特殊地形、日出景觀，我也開始注意到當地早期蓋的土角厝。我認為月世界重要的人文風景就是這些土角厝，它是先民的智慧，住起來冬暖夏涼，但是這些先民以前蓋的土角厝、竹籠厝如今卻慢慢地不是自然的倒塌，就是被破壞改建，看到這些房子當下覺得應該要有人替這些古厝留存影像。攝影人要有社會責任，不然下一代的人就看不到了。[7]

關：在先前他人訪問您的檔案中，您曾說，您會刻意用手電筒補光、或是準備一桶水灑向空中，捕捉其他的攝影畫面。[8]請談談過程中您的想法，此舉是否為您想追求攝影的另一種「美」的表現？

張：在拍月世界題材作品時，曾經遇到幾個月找不到題材可拍，心裡著急之下，就想刻意製造一些效果，表現不同的美感。我不會想拍純粹的紀實攝影，有時為了營造畫面的美感，會刻意地加一些東西，譬如拍這張古厝時（如圖），我一直在等天空的一朵雲經過，但它就是不動，最後是請屋子的主人去生起爐灶，營造炊煙裊裊的美感，也表現屋子仍有人居的感覺。[9]

關：除了月世界系列作品，《彩竹》系列也是您重要且知名的作品，如何想到拍攝月世界地區的彩竹？請談談拍攝彩竹的過程。

張：我在月世界拍了六年後，辦了一個夢幻月世界的展覽，是全臺巡迴的展覽，第一站是在北美館，再來是創價學會新竹藝文中心、國美館（國立臺灣美術館），以及臺南、高雄、屏東、嘉義等地文化中心。展完後，我開始思考下一步怎麼走下去。我拍照的那六年是天天拍照，夏天一定三點出門，如果題材需要，會更早出門，都差不多在日出前一個鐘頭到達目的地。後來那個地方因為我去拍，變成很多人也去，每天都客滿，所以後來也不去了，準備另尋新的地點拍照。《月世界》作品展完後，在思考中無意間發現新的寶，就是彩竹。雖然竹子在臺灣很常見，但月世界的彩竹就是不一樣，它會變色，我形容它是臺灣的楓葉，它的生態跟別種植物不一樣，一般楓葉變色是秋天，

《月世界土角厝》系列作品／張武俊攝／臺南內門／1990年代
A photo from the *Earthen Houses at Moon World* series photo by Chang / Neimen, Tainan / 1990s

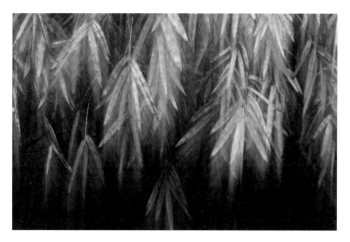

《彩竹》系列作品 / 張武俊攝 / 龍崎龍船窩 / 1997.2
A photo from the *Colored Bamboo series* / photo by Chang / Longchuanwo, Longqi / 1997.2

但彩竹變色時是在三月份。春季的時候，會變紅色，葉子掉了又發新
芽，都在同一個季節完成，所以我發現這個寶之後，就變得很有興趣
想要拍攝彩竹的變化，然而彩竹可以拍攝的時間其實很短，必須掌握
時間。[10]

為了藝術畫面的呈現，有時我會在拍攝後進行技術性的處理，我的展
覽專輯《彩竹的故鄉》裡就有一張，是我使用二次曝光的方式，造成
疊影的效果（上圖）。賴清德市長有一次前往日本訪問，也挑選我很
多的彩竹作品當作紀念品贈予日本人，我的作品等於被當成是臺南特
色了。

關：《彩竹》系列作品與《月世界》系列作品皆曾在臺北市立美術館巡迴展
　　出，聽聞您《彩竹》系列作品在展出前曾發生作品火燒事件，您還記
　　得事件經過嗎？

張：一年當中，竹子可以拍的時間差不多一個月，也有可能不到一個月，
　　因為竹子變色的時候，風吹過來，就把竹葉都吹落。我拍彩竹的第四
　　年，曾經拿底片和毛片請尚寶彩印公司幫我沖洗成12吋的相片，不料

送洗隔天沖洗店就發生火災，把我的底片和毛片燒光光，我拍四年的心血都燒掉了，留下的都是二軍、次級品。[11]

那時剛好是要在北美館展覽前兩年，被燒掉的都是早期一軍、最優秀的100張作品。[12]作品燒掉之後也只能趕快趁二到三個月時間趕緊補拍，我都跟朋友笑說最好的作品都被老天爺典藏了，也因為此次緊急的火燒事件，讓我後續激發出許多拍攝的想法與創意。我彩竹作品總共發生三次火燒事件，第二次燒掉是作品拿去新北三重裝裱，寄了10張作品過去，也是發生火災。

關： 在您沖洗出來的毛片中，經常可見您重新用筆在上面框取所要再次放大沖洗的角度與範圍，這似乎與畫家作畫前的構圖取景概念相同，關於畫意攝影風格的討論中，不乏將攝影與繪畫相互類比，請談談您認知的攝影與繪畫的關係。

張： 拍完照後，我會趕在當天把底片送交給沖印店沖洗，通常下午就可以拿到毛片，之後就這些洗出來的相片直接在上面修改、檢討；把想要的畫面擷取下來再請沖印店重新沖洗，這動作其實像你說的畫畫一般，你可以在毛片上看到我用色筆圈選的筆跡，有時一張照片我還不只框選一次（下圖）。攝影影像的取景與構圖很重要，所以拍攝者要多訓練自己的美感，多觀察自然。

張武俊在《彩竹》、《土角厝》系列作品毛片上的圈選痕跡 / 廖云翔提供
Initial prints from *Colored Bamboo* and *Earthen Houses at Moon World* marked by Chang Wu-chun for cropping provided by Liao Yun-xiang

攝影美學與個人風格形成

關： 經常有人用安瑟・亞當斯（Ansel Adams）的風景攝影來形容您對拍攝
技巧與美學風格的追求，是否您自己也曾參考他的作品、有意向其學
習？或曾受其他攝影學會與攝影家作品的影響？例如您曾因欣賞郎靜
山作品，特別寄送「夢幻月世界」系列作品給郎靜山先生，並邀請他
為展覽寫序。

張： 在攝影這條路上，我都是自己看書、多看作品，自學而來，沒有特別
向哪位攝影家學習。之前有買一些日本出版的攝影書，現在都捐給臺
南大學的圖書館了。[13]早年曾去上海參加攝影家的交流活動，與其他攝
影界人士一起討論、切磋，會後也到過黃山拍了一些作品，其中一張
我便放大洗出來，掛在家中。

張武俊家中懸掛於中國黃山拍攝的作品 / 孫耀天攝
臺南 / 2021
A photo taken by Chang Wu-chun at China's Yellow
Mountains, displayed in his home / photo by Sun / Tainan
2021

郎靜山在當時是臺灣很有名氣也是受各界尊敬的攝影師，我寄給
他《月世界》系列作品，用意想請他多多指教，並請他替我的展覽寫
序，沒想到能得到他的回音。

關： 您的作品中幾乎很少有「人」的存在，景 / 物在鏡頭下被放大或刻意地
排除其他過多形式，能否談談這類作品中的取景構圖，以及您對於拍
攝自然景 / 物的想法，特別是有關臺南孔廟與古厝等與人有關的主題攝
影，畫面中剔除「人」的存在，請問有什麼特殊意義嗎？

張： 在那段密集拍攝月世界的日子，如果月世界沒辦法拍，我就到孔廟去
取景。我拍照時如果遇到空檔，譬如月世界的天氣不好，但市區的天
氣條件夠好，我就會去孔廟，讓拍照的時間沒有間斷。拍攝《全臺首
學》——也就是孔廟系列作品大概是在民國81至84年間，會拍孔廟是
因為我可隨時掌控得到狀況，我平時會去那邊觀察，觀察季節光影的
變化，譬如冬季太陽較偏南，所以光影效果都不一樣，我空閒時就是
在那邊觀察。[14]

我拍孔廟時不喜歡拍人，把人放進畫面裡會不好看，所以我都是等沒
有人時才拍。在等待時我會細心觀察、想想如何表現題材。拍攝孔廟

的時間有時是凌晨，但大多是中午或下午的時間，看光影的變化伺機
而動。

關：孔廟系列作品是否也與您之前曾得獎的鹽水蜂炮作品不同？鹽水蜂炮
　　應該是以人活動為主的照片，您現在還有留存此系列作品嗎？

張：鹽水蜂炮的作品沒有留下來，這系列作品有拿去參加富士攝影公司舉
　　辦的比賽，這比賽的總獎金500萬，我有獲得慶典類的金牌獎。我認為
　　拍攝時心中有美的存在就可，不會執著於一定要拍人的形象。當初認
　　為孔廟是臺南的一級古蹟具有歷史意義，特別去拍，孔廟系列作品也
　　曾參加過全國美展。

關：由《夢幻月世界》、《全臺首學》、《彩竹的故鄉》等展覽作品轉換
　　到後來的《魚塭》系列作品，可漸漸看出您對於自然環境的捕捉除了
　　「寫實」、「寫意」，也著重藝術風格的表現，尤其是孔廟系列作品中
　　抽象的線條、光影對比與彩度變化所傳達出古蹟的悠久歷史深蘊；《魚
　　塭》系列更是完全地聚焦於魚池中抽象的線條與色彩律動，您還依此
　　恣意地命名作品的名稱，能否談談您對於作品從具象趨向抽象表現的
　　創作心得？是否也可歸類為注入個人情感表現的心象攝影？

張：我拍魚塭的時間是在每年梅雨季節來臨前，因為那時是最好拍攝的時
　　機，池水不會太乾，也不會等梅雨季來了之後，魚塭水暴漲就什麼也拍

《魚塭》系列作品〈熱舞〉/ 張武俊攝 / 臺南七股 / 2007
Heat Dance, from *the Fish Pond* series / photo by Chang / Qigu, Tainan / 2007

不了。拍攝魚塭一開始是受它表面造型的吸引，後來愈拍愈深入，也拍了很多年，發現魚塭很有變化的美感。而我習慣依拍攝結果所顯現的形狀、線條與色彩變化，來為作品命名，例如這張（頁158）像是蘭嶼人慶典時跳的頭髮舞，因此我取名為〈熱舞〉。如果將所見的化為一種自己認為的某種造型與美感，這種投注也可以像你說的是一種心象攝影吧。

臺南攝影發展與地方觀點的臺灣攝影史

關：您如何看待臺南或南臺灣攝影的發展？是否刻意選擇臺南地區特有的景色來表現自身對於鄉土的認同？您拍攝月世界期間正值1980年代經濟起飛的時代，陳映真主編的報導攝影雜誌《人間》也在此時創刊，延續七〇年代的紀實攝影與八〇年代的報導攝影潮流，您認為你創作年代中的「沙龍攝影」、「風景攝影」的面貌為何？與臺灣攝影發展的關係是？

張：我只拍我喜歡的題材，對於別人將我歸類於「沙龍攝影」或「風景攝影」並不在意，也不會考慮要去符合這些攝影分類的美學要求，只是想拍自己喜歡的題材。

關：2007年您開始進行《萬年峽谷》系列作品的拍攝活動，為何選擇草嶺地區？這似乎是您第一次拍攝臺南與高雄以外的景點？

張：草嶺拍出來的作品都是3×5的照片，那邊有很多題材可以拍，當時是朋友邀約，一群人坐一台車去，因為那邊地形比較險峻，人多可以互相留意。拍攝草嶺地區，只是單純想拍攝草嶺地區特有的地形之美。

關：在您存檔的照片中可看到您在二寮、草山、三股魚塭……等地拍攝了一萬張以上的照片，這些照片讓我們看到臺南地區各種奇特的景色，甚至可以當作一種勘察臺灣地景變遷的紀錄。在您三十幾年的拍攝歷程中，針對拍攝地點您是否會事先作地點探勘？或進行拍攝地區的歷史調查？

張：拍攝《月世界》系列作品時，我是一步步在二寮地區實地找尋題材，一開始也不知道哪裡有寶可拍，都是靠著自己的步伐走出來。去之前並沒有事先做調查或研究，有時還要靠在地人指路與說明。

關：您曾提到面對數位化時代的來臨，您已不再繼續拍照，您是否認為傳統相機也有其不可替代的「靈光」？您對於兩者之間差異的觀點是？

張：傳統攝影是瞬間動作的捕捉，拍起來較平面、無立體感；數位攝影則不同，可以移山倒海、較不受限，拍攝後甚至可以依照自己的想法、慢慢構圖。數位相機出現後，因為攝影的環境不同了，我也沒用數位相機拍照，就漸漸地不拍了。

其他訪談──陳次雄 [15]

關秀惠（以下簡稱關）：經張武俊老師告知，您曾與他一起至月世界拍攝且迄今仍與他保持聯繫，能否請您談談您如何認識張武俊？您們是否曾加入同個攝影社團？

陳次雄（以下簡稱陳）：一開始我們是因為同樣加入臺南市攝影學會才認識。我們都是臺南人，只要我回臺南幾乎每次都會去找他，現在也是。我還記得他當時用的相機是價值約2000-3000元的Konika c35。能夠參加學會的成員大都是經濟條件較好才能維持業餘攝影的興趣，當時加入學會的目的除了可以一起聽學會辦的演講、參加人像攝影活動，大家也會選定特定成員做為學習的目標，跟著前輩學習。

關：就像是學長制的學習方式，跟著厲害的前輩學攝影技巧？您們當時在臺南攝影學會也有遇到許淵富老師？他也是您們學會的前輩？

陳：對，在學會裡經驗較淺的人都會設定學習目標向資深的前輩學習，學習磨練時間久了後，便很少參加學會活動，但大家還是會相約一起出去外拍。許淵富當時是我們攝影學會的顧問，也曾是我們臺北點點攝影的顧問，他比較偏人文紀實攝影，不像我們專攻於風景攝影。

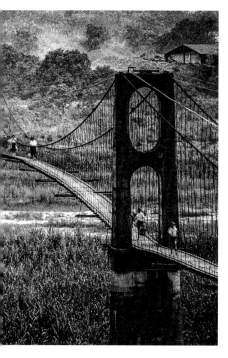

陳次雄於 1984 年獲得日本第 32 回二科會入選賞作品
陳次雄提供／臺南大內區危橋／1976
Chen Ci-Xiong's Bunka-Gakuin University Photography Department bronze award photo, Japan, 1984 / provided by Chen Ci-Xiong / 1976

關：您與張武俊何時一起前往月世界拍照？從選景、取景到攝影技巧是否彼此會相互切磋、學習？請談談您們彼此討論過的內容。

陳：雖然我與他都是臺南人，但我年青就到臺北打拼，總比不上他對臺南的熟悉。我大約是七〇、八〇年代有跟著他一起去臺南月世界拍照，每次回到臺南都會來找他，一大早坐他的車，跟著他去。例如這張我於1984年獲得日本二科會寫真部入賞獎的照片，就是他介紹的景點，而我是在1976年某日黃昏學生下課時，在臺南大內吊橋拍到。基本上他看上想拍的景都會很衝，到處找路、不顧危險也要去拍。我第一次看到他的月世界照片就覺得他拍的很棒，加上他有地利之便，因此建議他好好經營。他說一年365天其中有300天都是去月世界拍照。他有時也會拿拍完的照片給我看，或者送我他出版的攝影集。但我們這一輩攝影的人，很少會互相檢討彼此的照片，頂多相互瀏覽欣賞而已，大家都是一起出去，一番選景討論後，自己再各自找景、各自努力，個人的技巧較少討論。早期在攝影學會學習攝影時，大家會買書來看，因為外國攝影的書比較貴就會用交換的方式，例如《Nikon Camera 攝影月刊》，就是有的人買單月，有的人買雙月，彼此再互相交換著看。

關：臺灣早期風景攝影發展中，曾流行一陣至觀光勝地拍照的熱潮，張武俊也提過他曾至當年熱門景點——高雄田寮月世界拍過，但他後來卻對臺南地區的月世界美景情有獨鍾，您認為張武俊專精於臺南月世界的理由是什麼？能否談談您對他月世界作品的想法？例如他提到晨昏「色溫」的表現。

陳：高雄田寮月世界在當時已經是有名的景點了，我在1970年代左右也曾在高雄的308高地拍攝月世界，我記得有一天很意外地居然在那偏僻的地方巧遇周全池與張武俊二人來勘景，那是第一次在月世界遇到他們，其實拍攝風景的人都會不約而同地到處尋找拍攝的題材。現在講到臺南月世界的風景，沒有人比張武俊拍得更好，雖然他不是最早拍攝臺南月世界的人，但早期關於臺南月世界的照片，都是一些放羊人與惡地形的作品。他經常講他作品中的「色溫」表現就是我們拍攝風景時會注意到的K值，在清晨或黃昏時K值大約3000-4000，等到太陽出

來後的大白天，K值就會回歸到大約5000-6000的色溫，張武俊拍的藍色到紅色的色溫變化就是這樣的效果，例如我也曾拍過清晨時分的臺南月世界。

關： **您與張武俊都是拍攝風景的專家，您們是否認為自己的作品可被歸類為沙龍攝影？曾相互討論過臺灣風景攝影在臺灣攝影史的定位與發展嗎？**

陳： 我們當年加入攝影學會，從學會學習到的攝影類型就是沙龍攝影了。與那些拍攝人文紀實攝影的作品相較，我認為紀實攝影最重要的是等待一個絕佳的時機，再配合精美的構圖，瞬間拍下那一刻。但風景攝影卻需要更多次的踏訪、更多的技巧磨練與更多底片的消耗。我跟張武俊一樣，同樣的景點我們都前前後後跑了很多次才拍到心中想要的畫面。也許有人會問，為何拍風景的人每每喜歡拍攝日出、夕陽？因為太陽就像攝影需要的光源，有了光，一切事物才能成形，我們的作品就像一幅富有陰影變化、色彩亮麗的畫，但跟畫家類比，我們拍到一張優秀作品的背後卻可能比畫家還辛苦，所以我與張武俊都認為風景攝影相較其他攝影更有深度。

1. 本文除了陳次雄的訪談，為專書研究主編闊秀惠參照2014年因舉辦「堅毅的生命光影──張武俊攝影捐贈展」張武俊接受訪談的錄音檔，以及2004、2005與2006年張武俊在國立成功大學的演講影音檔，並於2021年1月14日、2月5日、2月21日、2月25日、3月16日於臺南張宅，進行訪問張武俊後彙編而成。
2. 參考資料：同註1錄音檔；李欽賢，〈臺南地景的表情──攝影家張武俊〉，《鹽分地帶文學》第55期（2014.12），頁29-39。
3. 同註1錄音檔。
4. 同註1錄音檔。
5. 取自《夢幻月世界》（1992）展覽專輯中張武俊的展覽自述。
6. 本段參考2004與2006年張武俊出席成大醫學院人文系列講座的影音檔。
7. 參考2005年張武俊出席成大醫學院人文系列講座的影音檔。
8. 同註1錄音檔。
9. 參考2005年張武俊出席成大醫學院人文系列講座的影音檔。
10. 同註1錄音檔。
11. 同註1錄音檔。
12. 張武俊2005年在成大演講時，曾拿出民國85年9月4日的《民生報》剪報，提到連民生報都有記載這起事件，報紙刊登失火的消息正是北美館彩竹展覽的前二年。
13. 2013年張武俊將約200多幅的月世界與彩竹作品，連同800多冊的攝影相關書籍捐贈給國立臺南大學圖書館，該校為感謝他的捐贈，同年亦在校園的美術系第一藝廊舉行「銳利凝視 深情詮釋─白堊・彩竹・左鎮情」詩、書、畫（攝影作品）聯展。
14. 同註1錄音檔。
15. 2021年4月2日研究主編闊秀惠於臺北採訪張武俊友人陳次雄。

Interviews of Chang Wu-chun

Introduction to and Early Study of Photography

Q: You mentioned that, after your first exposure to photography, you improved your skills by viewing others' photos, listening to judges' comments, and participating in competitions. Can you tell us about that process?

A: At first, I took photos of the kids as keepsakes; that was in 1968. I used a twin-lens reflex, but at a friend's suggestion I bought a Minolta single-lens reflex. A friend of mine said that with such a good camera, I should join a club, so I joined the Photographic Society of Tainan. One time they held an event where we took portrait photos of a young woman in Zhongshan Park. I showed up in a great mood with my SLR. Then I saw that everyone else there had all kinds of lenses, and there I was with just my one lens. I thought, how can I take photos like this? I was too embarrassed to even take my camera out, and went back home in frustration. After that, I bought whatever lenses people said were good, and sold the others. That was how I learned during that period.

After joining the Photographic Society, I took part in activities and competitions for three years, but my work never received recognition. My friend Lin Mao-fan said that, with portraits, it's a mistake to have other people in the background; that was all he taught me. So I avoided having people in the background in my portraits of young women, but that wasn't enough to get my work recognized. Three years later, I met Chen Jin-yuan, a senior member of the photographic community, and asked him why I never won awards. He asked whether I had ever observed the selection process, whether I read photography books and magazines, and whether I viewed other photographer's exhibitions. I hadn't done any of those things, but from then on, I always watched the judging at competitions, and that was a turning point for me too. So, I watched the judging and viewed others' works, and after that I won awards in all the competitions I entered, including gold medals in big competitions held by film companies like Sakura, Kodak, Fuji and Konika. By the 1980s, some of my friends had started calling me "Gold Medal Chang."

Q: Which photography groups have you joined? Can you tell us about that process, and why you might have resigned?

A: I joined groups both at home and abroad. First I joined the Photographic Society of Tainan and the photography section of the Tainan Fine Arts Association, then the Taiwan Provincial Photographic Society (renamed the Taiwan Photographic Society in 2005) and the Photographic Society of Taipei. Overseas I joined the New York Photographic Society, the Hong Kong Photographic Society of Mongkok, the Chinese Art Photographers Society,

the World Chinese Photographic Society, the Royal Society of Photography in England, and the China Photographic Society. Each of them made me a fellow with highest honors. Qualifying as a fellow wasn't easy, as you had to submit photos and take an exam. At present (2021), I don't necessarily participate in all the activities, but I've kept my director's positions and haven't resigned.

Q: **You've been made a fellow of the Royal Photographic Society of the UK and the Hong Kong Photographic Society of Mongkok. Please discuss the changes in your creative process and your ideas about it, from your early participation in competitions in Taiwan to earning fellowships in international associations. How did you apply for qualification in those international societies?**

A: When I was studying photography, I entered all kinds of competitions and always won prizes, but eventually I lost interest in prizes and started thinking about the next stage of my photography. I decided to try thematic photography, choosing lotus flowers as my first subject, which was in the early '80s. I began shooting a series of lotus photos around the Yanshui and Zhengziliao rivers, then at Tainan's famous Baihe scenic spot. I used 20 of those works to apply for membership in the Photographic Society of Taiwan, whereas for membership in the Royal Photographic Society in Hong Kong, I used works from my *Moon World* series. I continued with lotus-themed works even after 2000.

Q: **Why did you choose natural themes such as the lotus or Moon World for your photography? In the 1970s, there was a craze among photographers for well-known scenic tourist spots in Taiwan like the Moon World Landscape Park in Tianliao, Kaohsiung, which was suitable for outdoor photography. Hong Shuo-fu and Wang Zheng-ji established the Tainan Dian Dian Photography Club based on the Moon World as its starting point. Were you affected by this trend when you shot Moon World scenery?**

A: I started shooting at Moon World when I had difficulty finding good subjects. I recalled how in sixth grade we would take the narrow-gauge train from the sugar factory to Guanmiao, Tainan, then walk to Longqi Elementary School. Even if I had forgotten about those field trips, I never forgot the suspension bridge there. When I couldn't find a good subject, I thought I might find something valuable at the suspension bridge. Eventually my explorations took me almost everywhere around Longqi (in Tainan).

From 1987, I focused on Tainan's Moon World, but I was shooting the Moon World at Caoshan, not the one at Tianliao like Wang Zheng-ji and the others. That one was already too famous, though I too had been there to photograph the sheep. I focused on the Caoshan Moon World at Zuozhen, Tainan, though no one had heard of or photographed it then; it was deserted. I worked there for over 21 years, and during the first 15, I went every day. I covered the whole area in the dumbest way, just so I could catch all the changes in the landscape, but I never thought I'd spark any kind of trend. It became very popular after the 1990s, and now, if I show up too late, I might not find a spot where I can work.

The Photographic Process and Acquiring Skills

Q: In the album accompanying your 1992 solo exhibition, you said that, shooting for six years at Moon World, every day you were "out at 3:30 sharp" so as to shoot the skies at sunrise, using small apertures and long exposures. In the ever-changing weather, was expressing the scenery you saw related to the concept of "color temperature" you often mention?

A: Moon World was a treasure trove for me. My friends laughed and said there must be some cute girls there, otherwise why go every day? Moon World was a 25-minute drive from Tainan, so I would read the weather report and head out early the next day. From 3:30 to 8:00 a.m., I'd search for subjects to shoot; I discovered that, after a rain, floating mists would turn the whole area into a fairyland. After my first *Moon World* solo show in 1992, newspapers called me "The Magician of Moon World." But really, I just made use of changes in color temperature. Painters can mix colors on their palettes, but we photographers have to rely on God for a colorful palette. Blue expresses a high color temperature, while lower color temperatures are seen in red tones.

As an example, after a morning rain, Moon World would be full of churning clouds that might cover the hilltops unless you kept an eye on their movement. The changes in color temperature at sunrise were also arranged by God, who made me see how the tone of this photo would actually be blue before sunrise, but after sunrise, the addition of red to the blue would produce purple. These are the changing "color temperatures" (See p. 154). Some photos seem to have burning mists (See p. 155), an effect resulting from being struck by sunlight.

Q: Some have said that your *Moon World*, *Earthen Homes at Moon World*, and *Confucian Temple* series were characterized by a salon photography style. How do you feel about that viewpoint? Do you think your works have humanistic meaning beyond the technical concerns and aesthetic pursuits of the salon style?

A: Photography is a kind of art; it should express a sense of beauty. A visitor at my exhibition at the Taipei Fine Arts Museum told me, "All the works from the first to the third floor made me depressed. Only yours made me feel happy and at ease." My works express beauty; they give people a sense of simple pleasure. I don't pay much attention to criticism. I just observe and view other people's work as much as I can.

Aside from the unusual landforms and the sunrises at Moon World, I noticed the earthen homes built there in earlier times. I think they're the most important cultural artifacts of the region. Built with the wisdom of our ancestors, they were warm in winter and cool in summer, but like bamboo houses, they had either collapsed over time or had been destroyed and rebuilt. I just felt that someone should preserve images of those ancient homes. Photographers have a responsibility to society, to ensure that the next generation can see them.

Q: In interviews, you have said you sometimes used a flashlight for additional lighting, or had a bucket of water handy to spray in the air to create other kinds of images. Please discuss what you were thinking—were you trying to express a different kind of photographic beauty?

A: Once, shooting at Moon World, there were several months when I couldn't find good subjects. I felt anxious, and tried to create effects that would express different aesthetics. I didn't want to produce pure documentary photography, so sometimes I deliberately added things for a beautiful effect. For example, as I shot this very old house (See p. 156), I kept waiting for a cloud to pass by, but it just wouldn't move, so I eventually asked the owner to light his stove. That produced beautiful spirals of smoke and showed that it was still inhabited.

Q: Your *Colored Bamboo* photos are also an important and well-known series. Please tell us how you got the idea to shoot the colorful bamboo around Moon World, and how you produced these photos.

A: After shooting six years at Moon World, my *Dream of Moon World* exhibition toured Taiwan. The first stop was the Taipei Fine Arts Museum, then the Soka Gakkai Hsinchu Art and Culture Center and the National Taiwan Museum of Fine Arts, then on to the Tainan, Kaohsiung, Pingtung, and Chiayi cultural centers. After the exhibitions, I thought about my next move. Each day for six years, I had taken pictures at Moon World, rising early enough to reach my destination about an hour before sunrise, setting out as early as 3:00 a.m. in summer. So many people followed my lead that later the area was always full. As I made plans to find a new location, I discovered a new treasure: colored bamboo. Bamboo is everywhere in Taiwan, but at Moon World it changes color; I describe it as "the maple trees of Taiwan." But unlike maple leaves, which turn red in autumn, this bamboo turns color in March. The leaves turn red, fall, and new buds emerge all in the same season. I wanted to shoot those changes, but there is only a narrow window of time in which to do that.

Sometimes I process my photos for greater artistic effect. For one photo in my exhibition album, *The Hometown of Colored Bamboo*, I created overlapping images with a double exposure (See p. 157). On a visit to Japan, Mayor Lai Ching-de chose a number of my colored bamboo works to present as gifts to the Japanese – which is to say, my works are viewed as characteristic of Tainan.

Q: Your *Colored Bamboo* and *Moon World* series have both been shown in the Taipei Fine Arts Museum. It's known that some of your *Colored Bamboo* works were lost to fire before the exhibition. Do you remember how that happened?

A: The bamboo can be photographed for barely a month in any one year, because wind blows the leaves off once they change color. After shooting colored bamboo for four years, I had sent my negatives and unedited photos

to a color printing company to be developed into 12-inch photos, but a fire broke out the next day and burned them all. After four years of work, only my less successful photos were left.

That was two years before the Taipei Fine Arts Museum exhibition, and I lost 100 of my finest early photos. I could only try to hurriedly re-shoot what I had lost within a two- to three-month period. I joked with my friends that my best work was now part of God's collection, but that emergency spurred me to develop new creative ideas. I lost colored bamboo works to fire three times: the second time was when I sent 10 photos to Sanchong for mounting, and they were burned too.

Q: **How do you use the lens to photograph what you see? We've often seen that, in the initial prints, you use a pen to indicate a change in angle or an area to crop, like painters that choose just one part of a scene for their compositions. Analogies are often made between photography and painting—could you discuss how you think the two are related?**

A: After shooting, I would rush my film to the printing shop for processing, and usually get prints back the same day. I would then review the prints and make modifications directly on them, selecting the parts I wanted, and then get them developed again, which is like painting, as you said. You can see how I marked these prints with a colored pen, which I sometimes did more than once (See p. 158). Framing and composing the image is very important in photography, so photographers should develop their sense of aesthetics and observe nature.

Developing an Aesthetic and a Personal Style

Q: **People often refer to Ansel Adams' landscapes when they describe your landscape photography techniques and your visual style. Did you try to learn from him, or have other photography societies or photographers been an influence—for example, Lang Jingshan? You once sent your** *Dream of Moon World* **series of works to him, inviting him to write a preface for the exhibition, since you admired his work.**

A: I taught myself by reading and looking at the work of other photographers, but I didn't study any one particular photographer. I once had some Japanese photography books, but donated them to Tainan University. In the early years, I went to Shanghai to participate in an exchange where I discussed ideas with other photographers, and afterwards, I shot some photos at Yellow Mountain. I enlarged one of those and hung it in my home.

Lang Jing-shan was a famous and widely respected photographer in Taiwan. I sent him my *Moon World* works to ask for suggestions and ask him to write that preface. I didn't actually expect to get a response from him.

Q:	Very few human figures ever appear in your works. Scenery and objects are magnified, or they push out other extraneous forms. Please discuss your framing and composition, and your thoughts on shooting natural scenery/ objects, especially subjects related to people, such as the Tainan Confucian Temple or old houses. What does it mean to exclude people?

A:	When I was working intensively at Moon World, if the weather was sometimes unsuitable for shooting there, I'd go to the Confucian Temple instead, so as to keep up a regular work schedule. I shot the Tainan Confucian Temple—that is, the *Confucian Temple* series—from about 1981 to 1984. I photographed the temple because I could always control the circumstances, and I often went there to observe the seasonal changes in light and shadow, such as the more southerly sunlight in winter. I observed those things whenever I had free time.

	I didn't like to shoot photos of the Confucian Temple with people in them; they didn't turn out well. So as I was waiting for people to leave, I would study the best way of expressing my subject. Occasionally I photographed in the early morning, but mostly around noon or afternoon, watching the light and shadows and shooting as the opportunity arose.

Q:	Is the *Confucian Temple* series different from your previous award-winning photos of the Yanshui Beehive Fireworks Festival? Those were centered on human activities. Have you kept that series of photos?

A:	I haven't kept the Yanshui Fireworks photos. I entered them in a Fuji photography competition, which had a total of five million in prize money. I won the gold medal in the "festivals" category. When I take photographs, I don't insist on photographing people; as long as I have beauty in my heart, it's enough. At the time, I especially wanted to shoot the Confucian Temple, which is a Tainan Class 1 historical monument. That series was also shown in the National Fine Arts Exhibition.

Q:	From *Dream of Moon World*, *Confucian Temple*, and *The Hometown of Colored Bamboo* to the later *Fish Pond* works, we begin to see a concern for artistic style beyond your earlier realistic or lyrical approach. That shows especially in the abstract lines, contrasting shadows, and chromatic changes that express the long history of the Confucian Temple. In the *Fish Pond* series, you went even further, focusing exclusively the on abstract lines and coloristic rhythms you saw in the pond, and you freely named the works based on those elements. Please discuss your insights as you moved from concrete to abstract expression – can these works be considered a kind of mental imagery, instilled with personal feeling?

A:	I shot the *Fish Pond* works each year before the plum rains in spring. It's the best time to shoot—the pools aren't too dry, and later, when they're swollen with rain, you can't shoot anything. At first, I was attracted by their surfaces, but over time, I discovered the deeper beauty in their changing appearances. I typically name my photos based on their lines, shapes, or colors. This one

reminds me of the hair-flinging festival dances of the Lanyu Island people, so I named it *Heat Dance.* When you take what you see, and invest your energy to give it a form and beauty of your own, it can be the kind of mental imagery you mentioned.

The Development of Photography in Tainan, and a Local Perspective on Taiwan's Photographic History

Q: How do you view the development of photography in Tainan or southern Taiwan? Did you choose its unique scenery as a means of expressing your identification with the land? When you photographed Moon World in the 1980s, Taiwan's economy was booming. Chen Ying-zhen launched *Ren Jian Magazine*, the photographic reportage magazine, following the trends of documentary photography in the 1970s and the reportage photography in the 1980s. How would you characterize the "salon photography" and "landscape photography" of the era in which you worked, in relation to the development of photography in Taiwan?

A: I only shoot the subjects I like, and I don't care if my work is categorized as "salon photography" or "landscape photography." I don't try to match the aesthetic requirements of those categories. I just want to shoot my favorite subjects.

Q: In 2007, you started shooting the *Wannian Canyon* series. Why did you choose the Caoling area as your first scenic spot outside of Tainan and Kaohsiung?

A: The photos from Caoling are all 3x5s. Back then, a friend invited a group of us to go together, since the terrain is very steep and we could look after each other. I was just purely interested in the unique beauty of the terrain and landforms.

Q: In your archives, you have more than 10,000 photos from places like Erliao, Caoshan, and the Sangu fish ponds, showing the unusual scenery around Tainan. They virtually constitute a survey of Taiwan's changing landscape. During your more than 30-year career, would you survey your locations in advance, or investigate the local history of those areas?

A: While shooting the *Moon World* series, I searched for subjects step by step around Erliao. I didn't know where the valuable subjects might be; I had to find them at my own pace. There was no preliminary investigation or research, and sometimes I even relied on locals for directions.

Q: You mentioned that with the advent of the digital age, you stopped taking pictures. Do you think traditional cameras have a unique kind of "aura"? What do you think the differences are?

A: Traditional photography captures a moment of action; it's relatively flat, not so three-dimensional. Digital photography is freer. You can completely

alter the image, and restructure the composition in any way you like after shooting. When digital cameras came out, the environment for photography changed, and I gradually stopped taking pictures since I don't use digital cameras.

Other Interviews—Chen Ci-xiong

Q: **Chang Wu-chun has said that the two of you photographed Moon World together and are still in touch. Could you please talk about how you met? Were you ever in the same photography club?**

A: We first met as members of the Photographic Society of Tainan. We're both from Tainan, and even today I usually look him up when I go back. I remember the camera he had was a Konika C35, worth about NT$2000-3000 at the time. Most of the society's members were financially fairly secure, so they could support their photographic hobby. We joined the society so we could attend the lectures and join in the portrait photography activities. Most members would also pick specific senior members they felt they could learn from.

Q: **So it was like the upperclassmen system, where you learned from more skilled senior members? Did you meet and learn from Xu Yuan-fu as your senior at the Tainan Photographic Society?**

A: Yes, less experienced members would set goals for learning from senior members. As we gained more experience, we participated far less in society activities, but we'd meet to go out and shoot together. Xu Yuan-fu was a consultant for our Photographic Society as well as the Dian Dian Photography Club in Taipei. He was more of a humanistic documentary photographer, unlike those of us who specialized in landscape photography.

Q: **When did you and Chang Wu-chun take photos at Moon World? Please tell us what you talked about – did the two of you discuss scene selection, composition, and photography techniques?**

A: We're both from Tainan, but he knew the area better because I had since moved to Taipei. We went to Tainan's Moon World together in the 1970s and '80s. Whenever I was in Tainan, we'd head out in his car early in the morning. One example of what we did is this photo, which won an award from the Nikakai Association of Photographers in 1984. I took it when we went to the Danei Suspension Bridge.

He was very keen once he found a good scene to shoot, always looking for a path to his subject, regardless of the danger. When I saw his *Moon World* photos I thought they were great, and because of his location, I suggested he keep digging into that subject. He spent 300 days a year there. Sometimes he would show me his work or give me photography books he had gotten published. Photographers of our generation seldom critique each other; we'll usually just enjoy each other's work. We'd go out together and talk

about scenes to shoot, then find our own subjects and work individually, and we didn't discuss individual technique much. Early on in the Photographic Society, we'd buy photography books, but the foreign ones were expensive, so we'd exchange. Someone would buy *Nikon Camera* magazine in the odd months and someone else in the even months, and we'd pass it around.

Q: **In early landscape photography in Taiwan, there was a craze for shooting at tourist attractions, and Chang Wu-chun has said that he did take photos at Kaohsiung's popular Tianliao Moon World. Later, however, he had a special feeling for Tainan's Moon World. Why do you think he focused so exclusively on that? What's your view of his *Moon World* works, especially his use of "color temperature"?**

A: Kaohsiung's Tianliao Moon World was already a famous attraction then. In the 1970s I also photographed Moon World from Kaohsiung's Neimen 308 Highland. I once bumped into Zhou Quan-chi and Chang Wu-chun, who were scouting the scenery there; people who photograph landscapes would usually find the same places. No one has taken better photos of Tainan's Moon World than Chang Wu-chun, and while he was not the first, earlier photos tended to just show sheep and the harsh terrain, without any real distinguishing features. The "color temperature" he refers to in his works is the "K" value that we observe when shooting landscapes. At dawn or at dusk, the K value is about 3000-4000, but in full daylight it's about 5000-6000, and it's this change in color temperatures from blue to red that Chang Wu-chun captured. I also photographed Tainan's Moon World in the early morning, and you can see these effects.

Q: **You and Chang Wu-chun are expert landscape photographers. Do you think your work can be considered salon photography? Have you discussed with him how Taiwan's landscape photography developed, and its position in the overall history of photography in Taiwan?**

A: What we learned when we joined the Photographic Society was salon photography. In humanistic documentary photography, what's important is waiting for that perfect opportunity, when the most elegant composition occurs, and capturing that instant. But landscape photography means making more visits, acquiring more skill and experience, and using up a lot more negatives. Like Chang Wu-chun, I had to trek to the same scenic spots many times to get the shots I wanted. Some might ask, why do landscape photographers always like sunrise and sunset? It's because in photography, the sun is our light source, and it's only in the right light that things take shape. Our works are like beautiful paintings, with changes in light and shadow, but by contrast with painters, photographers may have to do much more behind-the-scenes work. So Chang Wu-chun and I both think that landscape work has more depth than other kinds photography.

傳記式年表
BIOGRAPHICAL TIMELINE
文 / 馬國安　Author / Ma Kuo-an

1942	出生於臺南保安（今臺南市仁德區保安里），父親任職於營造業，母親為家管。
1949	就讀臺南文賢國民學校。
1954	升入臺南歸仁（今臺南市歸仁區）新豐中學。
1957	進入國立成功大學附設高級工業職業進修學校（成大附工）。
1962	入伍，服役三年後退伍（1962-1965）。
1963	台灣省攝影學會（今臺灣攝影學會）成立。
1967	2月，與莊金玉女士結婚，年底長子張家禎出生。

青年張武俊肖像 / 臺南 / 1962-1965
Chang Wu-chun portrait / Tainan / 1962-1965

1968	｜得到人生第一部相機｜ 在孩子會走路之始，購入第一部相機（Konica c35），拍攝孩子的生活照。與妻子於臺南市東區經營「俊旭行」米店。
1969	次子張家豪出生。
1970	｜入台南市攝影學會｜ 經由友人林茂繁推薦，購入美能達（Minolta）機械單眼相機。因設備專業化，在友人鼓勵下，加入台南市攝影學會。
1971	長女張瑜芳出生。
1973	｜始獲攝影獎項｜ 在前輩陳金源指導下，開始觀摩學習他人的得獎作品，也研讀日本出版的攝影雜誌等相關讀物，於是開始不斷得獎。後隨著攝影技術不斷精進，陸續加入台北市攝影學會等團體。

張武俊初學攝影時拍攝子女與親戚兒女的黑白相片
臺南麻豆 / 1973
A black-and-white photo taken by Chang of his own and
other family members' children / Madou, Tainan / 1973

1942 Chang is born in Baoan, Tainan, his father a construction worker, his mother a housekeeper.

1949 Studies at Wenxian Junior High School in Tainan.

1954 Advances to Xinfeng Senior High School in Guiren, Tainan.

1957 Enters the Affiliated Senior Industrial Vocational High School of National Cheng Kung University.

1962 Serves in the military; is discharged after three years (1962-65).

1963 The Taiwan Provincial Photographic Society (today, the Taiwan Photographic Society) is established.

1967 Chang marries Zhuang Jin-yu in February. Their first son, Chang Chia-chen, is born at year's end.

1968 | Chang's first camera |

Buys his first camera, a Konica C35, for family photos as soon as his child can walk.
Manages the Jun Xu Hang rice shop in Tainan's East District with his wife.

1969 Chang's second son, Chang Chia-hao, is born.

1970 | Joining the Photographic Society of Tainan |

Buys a mechanical Minolta SLR recommended by Lin Mao-fan. With professional equipment and encouragement from friends, he joins the Photographic Society.

1971 Chang's daughter, Chang Yu-fan, is born

1973 | First photography awards |

Guided by Chen Jin-yuan, Chang learns from others' award-winning works, studies Japanese photography magazines, and wins numerous awards. As his technique improves, he joins the Photographic Society of Taipei and other groups.

張武俊於老家保安厝拍攝兒女身影 / 臺南 / 1973
A photo of his children taken by Chang at his old home in Bao-an / Tainan / 1973

1976 |受邀參與臺南點點攝影俱樂部|

是在1970年由當地土生土長的攝影愛好者組成的攝影研究與交流團體，之所以名為「點點」，主要是認為：舉凡影像都是由「點」所出發，構成「線」與「面」，而點點更象徵著如雨滴點點匯集成大海般，永恆不枯、生生不息、代代薪傳之意。

1980 獲台南市攝影學會碩學會士榮銜。

1981 |投入《荷花》系列創作|

對長年拍攝得獎作品感到疲乏，於是轉而投入專題攝影，開始以荷花為主題，在鹽水溪、鄭仔寮溪邊、中山公園等地拍攝，後來也有到臺南白河。申請臺灣攝影學會的碩學會士資格時，就是挑選了12張荷花專題作品投件。

- 獲得第14屆臺灣影展銀像獎與最佳創意獎、櫻花全國攝影大賽金牌獎（此年起連續三年獲柯尼卡櫻花攝影賽金牌獎）。

《荷花》系列作品 / 張武俊攝 / 臺南新營天鵝湖公園
2010.10.15
A work from the *Lotuses* series / photo by Chang / Xinying
Swan Lake Park, Tainan / 2010.10.15

1982
- 獲得台南市攝影學會博學會士榮銜FPSTN。
- 獲得台北市攝影學會碩學會士榮銜。

1983
- 獲得富士全國攝影大賽金牌獎。
- 獲得臺灣攝影沙龍年度金牌獎。

1984
- 獲得柯達全國攝影大賽金牌獎。
- 獲得台灣省攝影學會碩學會士榮銜。

1985
- 擔任台南市攝影學會常務理事與沙龍會員主席。
- 獲得中國攝影學會碩學會員榮銜。

1986
- 參與第一屆「中華民國當代美術大展」（高雄）。
- 獲得臺南市政府頒贈「攝影藝術貢獻獎」。
- 獲得台北市攝影學會博學會士榮銜。
- 獲得英國皇家攝影學會高級會士榮銜。

台北市攝影學會博學會士證書 / 1986
Doctoral Fellow certificate from Photographic Society of
Taipei / 1986

莊金玉女士家族合影 / 張武俊攝 / 臺南 / 1974
Chang's wife Chuang Jin-yu and family / photo by Chang
Tainan / 1974

1976 | Invitation to join Dian Dian Photography Club |

Tainan's Dian Dian Photography Club is formed for research and exchange in 1970 by local enthusiasts, who believe all images begin from dots ("dian"), which then form lines and planes, and like raindrops that form a sea, symbolize eternity, endless life, and the flow of knowledge.

1980 Acquires title of Master from the Photographic Society of Tainan.

1981 | Work begins on the *Lotuses* series |

Chang grows tired of shooting award-winning works and turns to thematic photography, shooting lotuses at Yanshui Creek, Zhengziliao Creek, and Zhongshan Park, and later at Baihe in Tainan. He submits 12 lotuses works to qualify as Master in the Photographic Society of Taiwan.

- Wins Silver Medal and Best Creative Award at the 14th Taiwan Film Festival; wins Gold Medal at Sakura National Photography Contest (and wins Konica Sakura Photo Contest Gold Medal three consecutive years).

1982
- FPSTN. Named a Fellow in the Photographic Society of Tainan (FPSTN).
- Obtains title of Master in the Photographic Society of Taipei.

1983
- Wins Fuji National Photo Contest Gold Medal.
- Wins Taiwan Photography Salon Annual Gold Medal.

1984
- Wins Kodak National Photography Contest Gold Medal.
- Obtains title of Master from the Taiwan Provincial Photographic Society.

1985
- Serves as Executive Director and Salon Membership Chair of the Photographic Society of Tainan.
- Receives honorary title of Master from the Chinese Photographic Society.

1986
- Participates in 1st *ROC Contemporary Art Exhibition* (Kaohsiung).
- Receives "Contribution to Photographic Art" award from the Tainan City Government.
- Obtains title of Doctor in the Photographic Society of Taipei.
- Wins title of Senior Fellow from the Royal Photographic Society of Great Britain.

張武俊全家春節出遊，於南橫公路留影 / 1982
Chang family traveling at Chinese New Year, photo taken on the Southern Cross-Island Highway / 1982

1987 ｜投入《月世界》系列創作｜

遇到創作瓶頸，開始尋找新的攝影題材。想起小學時遠足的經驗，找到臺南左鎮草山的月世界，被此地風光震懾，從此投入拍攝。一拍20年，若用行車距離計算，約莫10萬公里的里程。而為了輸出較大的作品，購入「賓德士（PENTAX 67）」120中片幅相機。

- 參與「荷花攝影聯展」（國立歷史博物館）。

- 獲得「佛光攝影獎」。

- 獲得美國紐約攝影學會高級會士FPSNY榮銜。

註： 美國紐約攝影學會（The Photographic Society of New York）是由七位愛好攝影的在美華僑成立於1949年紐約市，當時，成立者之一的梁光明於美國大眾攝影雜誌主辦之國際攝影比賽憑藉其彩色照片作品榮獲首獎及獎金五千元，故被推舉為會長。1952年，因成員益多，故學會於紐約市地威臣街（Division St.）將一間殘舊成衣廠裝修成為學會最早的正式會址。1958至1966年期間，學會主辦多屆全美華人攝影展覽，1972年起設立名銜制度，並於1976年擴大會務，開始招收海外會員。直到今日，紐約攝影學會仍是活躍於美東中外攝影愛好圈的國際型攝影學會。

美國紐約攝影學會高級會士證書 / 1987
Senior Fellow certificate from Photographic Society of New York / 1987

1988

- 獲得第36屆南美展攝影類第一名（即「南美獎」，台南美術研究會舉辦）。

- 獲得台灣省攝影學會博學會士榮銜。

台灣省攝影學會博學會士證書 / 1988
Doctoral Fellow certificate from Taiwan Provincial Photographic Society / 1988

1987 | Work begins on the *Moon World* series |

Creatively stymied, Chang looks for new themes, and recalls his hiking experiences in elementary school. He finds the Moon World at Zuozhen, Caoshan, near Tainan, and begins shooting landscapes, driving about 100,000 kilometers in his 20 years working there. For larger works, he buys a Pentax 67 medium-format camera.

- Participates in the *Lotus Photography Group Exhibition* (National Museum of History).

- Wins the Fo Guang Photography Award.

- Obtains Fellowship in the Photographic Society of New York, USA.

Note: The Photographic Society of New York was established in 1949 by seven overseas Chinese photographers. One of the founders, Liang Guangming, won first prize and 5,000 dollars for color photography in Popular Photography Magazine's international competition and was elected president. In 1952, its membership increasing, the Society renovated a dilapidated garment factory on Division Street for its early meetings. From 1958 to 1966, the Society hosted several national photography exhibitions for Chinese Americans, instituted a system of titles in 1972, and in 1976 began recruiting overseas members. It remains an international society for Chinese and foreign photography enthusiasts in the Eastern U.S.

1988 - Wins first place in photography at the *36th Tainan Arts Exhibition* (held by the Tainan Fine Arts Research Association).

- Obtains Doctoral Fellowship in the Taiwan Provincial Photographic Society.

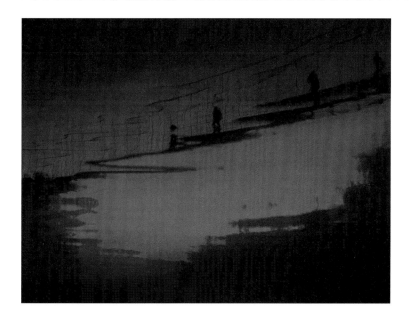

月世界風景 / 張武俊攝 / 動員 / 1989.12
Scenery of the Moon World /photo by
Chang Dongyuan / 1989.12

1989	• 獲得中國攝影學會博學會員榮銜。

• 參與第八屆永生的鳳凰美展「中堅美術工作者」聯展。

• 受邀參與成為台南美術研究會（以下簡稱「南美會」）攝影部會員。

• 該年起，持續參與南美會舉辦的「南美展」（國立國父紀念館，臺南、臺中、臺東等市立文化中心等地），一直到2010年。

註：南美會於1952年成立，由成功大學教授郭柏川等發起，是戰後臺灣最早的民間美術研究團體之一，其成立後的二年間，陸續舉辦了兩屆的南美展，也設立西畫、雕塑、攝影、國畫等四個研究部，並且創設了美術研究所。該會聚集了日治時期以來培養的美術人才，銜接戰後來臺的藝術傳承，使臺南躍升為當時南部地區最活躍的美術重鎮。1959年起，一年一度的南美展開始正式開放公開招募作品參展，也讓南美展成為全臺藝術創作者必爭的重要發表舞台。南美展的一項特色，就是獎項不設獎金，鼓勵參賽者表達對藝術熱愛的純粹初衷，而獲獎者由於都是激烈競爭中脫穎而出，也使「南美獎」成為臺灣藝術家眼中的最高榮譽之一。南美會也是臺灣各個美術團體中，第一個設有「攝影部」的團體。

張武俊於草山月世界拍攝的身影 / 臺南 / 1988-1989
Photo of Chang at Caoshan Moon World / Tainan
1988-1989

1990	• 參與臺灣省立美術館（今國美館）舉辦的中華民國「79年攝影大展」。

• 參與90年代臺灣攝影年鑑及國外作品交流展（國立臺灣藝術教育館）。

• 此年起，連續三年參與臺南市地方「美術家聯展」。

• 以《月世界》系列作品申請到英國皇家攝影學會FRPS博學會士榮銜。

1991	• 參與「四季美展」（國立臺灣藝術教育館）。

• 彩色作品〈金馬寮〉獲高雄市立美術館典藏。

• 〈孔廟守護者〉、〈十美圖〉、〈成長〉獲得國立臺灣藝術教育館典藏。

• 獲得台南市攝影學會榮譽博學會士榮銜。

1989
- Receives a Doctoral Fellowship from the Chinese Photographic Society.
- Participates in the *8th Yung-Sheng Phoenix Exhibition: Core Art Workers*.
- Invited to join the Tainan Fine Arts Research Association photography department (the Tainan Arts Association, or TAA).
- From this year until 2010, Chang participates in the TAA *Tainan Arts Exhibition* (at the National Sun Yat-sen Memorial Hall and other municipal cultural centers in Tainan, Taichung, and Taitung).

Note: The TAA, established in 1952 by Professor Guo Bo-chuan of National Cheng Kung University and others, was one of Taiwan's earliest post-war civic art research groups. It held the Tainan Arts Exhibition in each of its first two years; set up research departments for Western painting, sculpture, photography, and Chinese painting; and created the Fine Arts Research Institute. The TAA connected the talent cultivated during the Japanese occupation with the art introduced to Taiwan after the war, making Tainan southern Taiwan's most active art center. Since 1959, the annual Tainan Arts Exhibition's calls for submissions have made it an important competitive platform for artists throughout Taiwan. With no monetary awards and competition purely for the love of art, new talent often emerges; receipt of the "Tainan Arts Award" is a high honor among Taiwanese artists. The TAA was also the first of Taiwan's arts associations to establish a photography department.

1990
- Participates in the 1990 *ROC Photography Exhibition* held by the Taiwan Provincial Museum of Art (now the National Taiwan Museum of Fine Arts).
- Participates in the 1990s *Taiwan Photography Yearbook and Foreign Works Exchange Exhibitions* (National Taiwan Arts Education Center).
- Shows works at the local *Artists Joint Exhibition* in Tainan the following three years.
- Applies to become a Fellow in the Royal Photographic Society of Great Britain with works from his *Moon World* series.

1991
- Participates in the *Four Seasons Art Exhibition* (National Taiwan Arts Education Center).
- Chang's color photo *Jinmaliao* is added to the Kaohsiung Museum of Art permanent collection.
- Chang's *Guardians of the Confucian Temple, Ten Beautiful Pictures*, and *Growth* are added to the National Taiwan Arts Education Center permanent collection.
- Chang is made Honorary Fellow by the Photographic Society of Tainan.

1992

│投入《全臺首學》系列創作│

準備「月世界」的專題個展時，也出於對家鄉老建築與古蹟的感情，時常到臺南市區拍攝孔廟等古蹟建築，透過鏡頭下的光與影，表現孔廟古蹟的典雅、古樸與莊嚴。因市區天氣較草山穩定，當月世界的天氣狀況不佳，就移到市區拍攝孔廟專題，大約也與月世界的彩竹專題同時進行，持續拍攝到1995年發布「全臺首學」個展。

│「夢幻月世界」個展│

1992年4月起舉辦「夢幻月世界」攝影個展（臺北市立美術館、臺灣省立美術館、臺南縣立文化中心、臺南市立文化中心、屏東縣立文化中心）；並出版《夢幻月世界》（臺南：張武俊）攝影專輯。在準備與編輯《夢幻月世界》時，張武俊特別以作品致贈前輩郎靜山，希望能請郎大師提供評論與指教，後來據張武俊回憶，很驚喜獲得大師的佳評，甚至贈與題字，因此作品集封面採用的就是郎老手跡。

│投入《彩竹的故鄉》系列創作│

在月世界拍攝時，注意到當地彩竹的特殊植物地景。因為在發表《夢幻月世界》系列作品後，努力尋找新的題材，在發現了彩竹以後，開始以彩竹為新的專題攝影目標，持續拍攝了七、八年。所謂的「彩竹」，其實主要是指月世界的竹林，不但在初春三月時會變色，呈現如同秋季的楓紅，而變色的竹林，在張武俊鏡頭裡月世界清晨變幻莫測的光影世界中，彷彿呈現七彩光芒，故稱為「彩竹」。

- 參加文化建設委員會（今文化部）策劃，臺灣省立美術館（今國美館）承辦「映像與時代──中華民國國際攝影藝術大觀」徵件展，作品《夢幻月世界》與《鄉村寸景》分別獲得入選。

- 榮登92臺灣攝影家年度發表作家。獲第十三屆全國美展金龍獎攝影類第二名。

- 獲得香港旺角攝影學會（該學會已解散）高級會士FMPC榮銜。

郎靜山（中左）蒞臨張武俊（中右）「夢幻月世界」攝影展開幕首展 / 盧枝德攝 / 臺北市立美術館 / 1992.4.25
Lang Jing-shan (center left) arrives at the Chang Wu-chun (center right) *Dream of Moon World* opening photographic exhibition / photo by Lu Zhi-de / TFAM, Taipei / 1992.4.25

第十三屆全國美展金龍獎獎座 / 1992
13th National Art Exhibition Golden Dragon Award for photography / 1992

臺南市立文化中心舉辦「拍攝月世界的心路歷程」專題
演講，邀請張武俊主講 / 1992.6.14
In a lecture at Tainan Municipal Cultural Center, Chang
Wu-chun discusses the motivation and process behind
photographing Moon World / 1992.6.14

1992

| Work begins on the *Confucian Temple* series |

Preparing for his *Moon World* solo exhibition, Chang takes photos that show his feeling for Tainan's Confucian Temple and other historical sites, evoking the temple's elegance, simplicity and solemnity. When the weather at Moon World is unfavorable, Chang chooses to work at the Confucian Temple in the city, shooting these photos during the same period as those of Moon World's colored bamboo. His work on this theme culminates in the "Confucian Temple" solo exhibition of 1995.

| The *Dream of Moon World* solo exhibition |

Chang's *Dream of Moon World* solo exhibition is held in April, 1992 (at the Taipei Fine Arts Museum, Taiwan Provincial Museum of Art, Tainan Municipal Cultural Center) and an accompanying album published (Tainan: Chang Wu-chun). While preparing the "Dream of Moon World" album, Chang presents a work to master photographer Lang Jing-shan, hoping for comments and advice, and is pleased that Lang gives him both a good review and an inscription for the album's cover.

| Work begins on the *Hometown of Colored Bamboo* series |

Shooting at Moon World, Chang notices the colorful bamboo in the landscape. After the *Dream of Moon World* series is released, the colored bamboo becomes his new subject, which he photographs for about eight years. "Colored bamboo" refers mostly to the bamboo groves around Moon World, which change color in early spring and March, with hues like red maple leaves in autumn. Chang's photos show a great range of color in the unpredictable light and shadows of the early morning there, hence the name "colored bamboo."

- Participates in the *Image and the Era: The ROC International Photographic Art Exhibition* open-call exhibition organized by the Cultural Construction Committee (today's Ministry of Culture) and held at the Taiwan Provincial Museum of Art (today's National Taiwan Museum of Fine Arts); works from Dream of Moon World and Village Scenes are selected for exhibition.

- Honored as *Taiwanese Photographer of the Year* for 1882. Takes the second place Golden Dragon Award for photography at the 13th National Art Exhibition.

- Receives the title of Senior Fellow in the Hong Kong Mong Kok Photographic Society (now disbanded).

「夢幻月世界」攝影展 / 臺灣省立美術館（今臺中國美
館）/ 1992
Dream of Moon World photography exhibition / Taiwan
Museum of Art (currently the National Taiwan Museum of
Fine Arts) in Taichung / 1992

1993
- 作品〈守護神〉獲教育部文藝創作獎攝影類第二名。
- 《夢幻月世界》系列作品共五件獲臺北市立美術館典藏；〈守護神〉獲國立臺灣藝術教育館典藏。
- 參與臺南市地方美展「府城人現代情」。

1994
- 中國攝影家協會1994「國際攝影藝術欣賞」邀請展作家。
- 受邀臺灣首屆攝影典藏作品展售會（臺北福華沙龍）。
- 「夢幻月世界」攝影展應邀臺南縣立文化中心11周年慶展出。

1995 | 「全臺首學」個展 |

於臺北爵士藝廊、臺南市立文化中心舉辦「全臺首學」個展，並出版《全臺首學：張武俊攝影作品集》（臺南市立文化中心）。中華攝影文化協進會主辦第一屆（一說為第二屆，待考證）台北攝影節，以年度展覽的評選方式選出該年優秀展覽。張武俊當年於臺北、臺南兩地舉辦的「全臺首學」個展，獲台北攝影節年度優選獎。

- 參與首屆臺灣區攝影家書與作品聯展。
- 作品〈安平夜色〉獲國立臺灣藝術館典藏。
- 參與臺南市地方美展「美術風貌博覽」

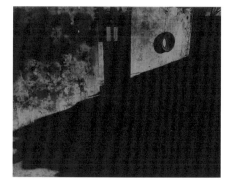

作品〈安平夜色〉獲國立臺灣藝術館典藏 / 張武俊攝
臺南 / 1992-1995
Anping Night enters the National Taiwan Museum of Art's collection / photo by Chang / Tainan / 1992-1995

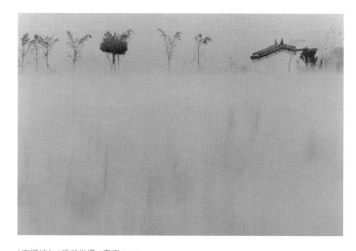

〈守護神〉/ 張武俊攝 / 臺南 / 1993
Guardian Spirit / photo by Chang / Tainan / 1993

「全臺首學」個展 / 臺南市立文化中心 / 1995
Confucian Temple solo exhibition / Tainan Municipal
Cultural Center / 1995

1993
- Chang's *Guardian Spirit* wins the second place Art and Literature Creative Award for photography from the Ministry of Education.

- Five works from the Dream of Moon World series are added to the Taipei Fine Arts Museum permanent collection; *Guardian Spirit* is added to the National Taiwan Arts Education Center permanent collection.

- Chang participates in the Local Art Exhibition, *The Modern Heart of the Fucheng People*, in Tainan.

1994
- Serves as writer for the Chinese Photographers Association 1994 "International Photography Appreciation" Invitational Exhibition.

- Receives an invitation to the "1st Taiwanese Photography Collection Selling Exhibition" (Taipei Fuhua Salon).

- The "Dream of Moon World" exhibition is shown at the Tainan County Cultural Center's 11th Anniversary Celebration.

1995
| The *Confucian Temple* Solo Exhibition |

The *Confucian Temple* solo exhibition is held at the Taipei Jazz Gallery and Tainan Municipal Cultural Center, and *Confucian Temple: Photographic Works of Chang Wu-chun* (Tainan Municipal Cultural Center) is published.

The Chinese Association for the Advancement of Photographic Culture hosts the 1st Taipei Photography Festival (or the 2nd; awaiting verification), with outstanding works for that year chosen from annual exhibitions. Chang's solo exhibition *Confucian Temple*, held in Taipei and Tainan, wins the Taipei Photography Festival annual merit award.

- Chang participates in the 1st Taiwan Region Joint Exhibition of Photographer Books and Works.

- Chang's *Anping Night* is added to the National Taiwan Museum of Art's collection.

- Chang participates in the Tainan local art exhibition *Art Style Expo*.

1996 | 「彩竹的故鄉」作品慘遭祝融 |

將拍攝四年、精選100張「彩竹的故鄉」系列影像送至尚寶彩色沖印處理，不料隔日廠房失火，多年創作付之一炬。這批作品原來預計兩年後展出，檔期已排好，但就算想重拍，一年中也只有半個月能拍出變色的竹林，於是為了重新累積足夠的作品，除每天清晨，更增加了午後到月世界拍照的行程；因必須在有限的時間內達到過去四年內的創作水平，也激發了過去不曾有的創意與視角。最終，包括此年的拍攝時數，張武俊總共投入約二萬餘小時在彩竹專題的創作。該年以後，張武俊長期與全濬彩色沖印店合作，並與經營者吳鐘淇成為好友，兩人時常一起外出拍照。

張武俊長期配合的全濬彩色沖印底片袋 / 廖云翔攝
2021
Negatives packet from Chang's long-term photo printer, Quan Jun Color Printing Shop / photo by Liao Yun-xiang
2021

- 參與「臺灣影像30年」展覽，作品並被收入同名攝影集（臺灣省立美術館）。

- 獲得第37屆中國文藝獎章美術類「藝術攝影獎」。

1997
- 參與「紀念郎靜山大師邀請展」（日本、美國三藩市金山國父紀念館）。

- 參與世界華人攝影學會會員展（美國、香港、新加坡）。

- 作品〈草山月世界全景〉獲高雄市立美術館典藏。

- 《自由中國評論》雜誌專題報導《夢幻月世界》系列作品。

- 文建會（今文化部）出刊的俄文雜誌 *Свободный Китай* 第6期（2007年11-12月）專文報導張武俊獲獎訊息，並刊載《月世界》與《彩竹》等系列作品。

張武俊長期配合的全濬彩色沖印底片袋 / 廖云翔攝 / 2021
Negatives packet from Chang's long-term photo printer, Quan Jun Color Printing Shop / photo by Liao Yun-xiang / 2021

1996 | *Hometown of Colored Bamboo* works destroyed in fire |

After four years of shooting, Chang chooses 100 images from the *Hometown of Colored Bamboo* series to be developed by Shangbao Color Printing, which are destroyed by a fire at the shop the next day. The photos were scheduled for exhibition in two years, and even if he could recreate them, colored bamboo can only be shot during a half-month period in any given year. Chang again shoots every morning, and adds afternoon sessions at Moon World. Chang's creativity is stimulated by the attempt to recapture the previous four years' attainments; he spends over 20,000 hours on the colored bamboo theme, including re-shooting these photos. From this point on, Chang works with the Quanjun Color Printing Shop and befriends its owner, Wu Zhong-qi, and they frequently go out on shoots together.

- Chang's work is shown in the *30 Years of Taiwan Images* exhibition and included in the photography album of the same name (Taiwan Provincial Museum of Art).

- Chang wins the Art Photography Award in the 37th China Literature and Art Medal competition.

1997
- Participates in the *Master Lang Jingshan Commemorative Invitation Exhibition* (Japan; Dr. Sun Yat-Sen Memorial Hall of San Francisco).

- Participates in members exhibition of the World Chinese Photographic Society (U.S.; Hong Kong; Singapore).

- Chang's *Caoshan Moon World Panorama* is added to Kaohsiung Museum of Art's permanent collection.

- *The Free China Review* publishes feature on the *Dream of Moon World* series.

- The 6th issue of the Russian-language magazine *Свободный Китай*, published by the Council for Cultural Affairs (today's Ministry of Culture), reports on awards won by Chang and publishes works from the *Moon World* and *Colored Bamboo* series.

「彩竹的故鄉」攝影展 / 臺北市立美術館 / 1998
Hometown of Colored Bamboo photographic exhibition
Taipei Museum of Fine Art / 1998

1998

| 「彩竹的故鄉」個展 |

8月起，首次舉辦「彩竹的故鄉」個展（臺北市立美術館、臺灣省立美術館、高雄市立文化中心、新竹縣立文化中心、嘉義市立文化中心、臺南縣立文化中心、臺南市立文化中心、台灣創價學會新竹藝文中心），並於台南市攝影學會舉辦之「彩竹的故鄉攝影學術研討會」中擔任主講者；出版《彩竹的故鄉：張武俊攝影作品集》（國家文化藝術基金會贊助），封面題字邀請淡江大學建築攝影家張敬德贈字。

- 參與「發現臺灣之美攝影展」（國立國父紀念館）。
- 參與「海峽兩岸、日本攝影藝術交流展」（國立臺灣藝術教育館）。
- 參與世界華人攝影學會會員展（上海），也利用參展機會，到大陸各地（包括安徽黃山）旅行拍攝。
- 獲得中華藝術攝影家學會高級會士FCAPA榮銜。

《彩竹的故鄉》封面 / 1998
Cover of *The Hometown of Colored Bamboo* album 1998

1999

- 巡迴舉辦「彩竹的故鄉」個展（嘉義市立文化中心、新竹縣立文化中心、臺南縣立文化中心）。
- 此年起至2004年，持續參與臺南市「府城美術展覽會」（今臺南市地方美術展覽會），是臺南市最重要的地區性綜合美展。
- 該年起，持續參與中華藝術攝影家會員聯展，一直到2010年。
- 參與「攝影七人展」（臺南市立文化中心）。
- 參與1999-2000年行政院新聞局「臺灣映像」歐洲巡迴展。
- 獲美國紐約攝影學會榮譽會士榮銜。

美國紐約攝影學會榮譽會士證書 / 1999
Honorary Fellow certificate from the Photographic Society of New York / 1999

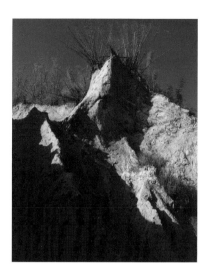

《彩竹的故鄉》系列作品 / 大匏崙 / 1996.1.12
A work from *The Hometown of Colored Bamboo* series / Dapaolun / 1996.1.12

1998

| The *Hometown of Colored Bamboo* Solo Exhibition |

In August, Chang has his first *Hometown of Colored Bamboo* solo exhibition (Taipei Fine Arts Museum; Taiwan Provincial Museum of Art; Tainan Municipal Cultural Center; Kaohsiung Municipal Cultural Center and Hsinchu Art Center of Taiwan Soka Association), and is keynote speaker for the Photographic Society of Tainan's "Hometown of Colored Bamboo Photography Seminar." *The Hometown of Colored Bamboo: Photographic Works of Chang Wu-chun* is published (sponsored by the National Culture and Arts Foundation). Architectural photographer Zhang Jing-de of Tamkang University provides the cover inscription.

- Participates in *Discover the Beauty of Taiwan Photo Exhibition* (National Sun Yat-sen Memorial Hall).

- Participates in *Cross-Strait and Japan Photographic Art Exchange Exhibition* (National Taiwan Arts Education Center).

- Participates in *World Chinese Photography Society Members Exhibition* (Shanghai), and photographs sites in China (including Anhui's Yellow Mountain).

- Receives title of Senior Fellow from the Chinese Art Photographers Society.

1999

- Holds solo exhibition *Hometown of Colored Bamboo* (Chiayi Municipal Cultural Center; Hsinchu County Cultural Center; Tainan County Cultural Center).

- Participates until 2004 in Tainan's *Fucheng Art Exhibition* (now the Tainan City Local Art Exhibition), Tainan's most important regional exhibition.

- Participates from 2004 to 2010 in the *Chinese Art Photographer Members' Joint Exhibition.*

- Participates in the *Seven Photographers Exhibition* (Tainan Municipal Cultural Center).

- Participates in Executive Yuan Government Information Office's *Images of Taiwan* exhibition on tour in Europe, 1999-2000.

- Named Honorary Fellow of the Photographic Society of New York.

2000

|拍攝月世界「古厝」與「菅芒花」主題|

開始投入拍攝月世界的「古厝」與「菅芒花」，此二主題與
「夢幻月世界」和月世界的「彩竹」構成張武俊的「月世界四
寶」。由於在月世界拍攝多年，對此地的一草一木與在地居民
都熟悉的彷如自己家人，因此除了拍攝地景，也注意到當地流
失的人口所造就的荒廢聚落，於是聚焦月世界的土角厝老屋，
希望能夠透過攝影，捕捉消逝中的舊日時光與居民生活的殘
跡。而同樣在月世界蔓生的菅芒花叢，在張武俊的眼裏，則象
徵臺灣人「壓不倒」的精神，透過鏡頭下的光影呈現，也構成
月世界獨特的文化地景之一。

《月世界土角厝》系列作品 / 臺南鹿陶洋 / **2011.12.27**
A work from the *Earthen Houses at Moon World* series
Lutaoyang, Tainan / 2011.12.27

- 以《彩竹》系列作品參與「長枝仔的春天──南瀛鄉土文化
 特展」（國立國父紀念館）。

- 參與臺南藝術人系列聯展（臺南梵藝術中心）。

- 《彩竹》系列作品獲選為《天下雜誌》20周年特刊《319鄉向
 前行》封面，並同步刊載〈「十步芳草」張武俊──鏡頭特
 寫臺灣之美〉一文。

- 參與世界華人攝影學會會員展（香港）。

2003

- 參與「時代顯影」攝影典藏展（高雄市立美術館）。

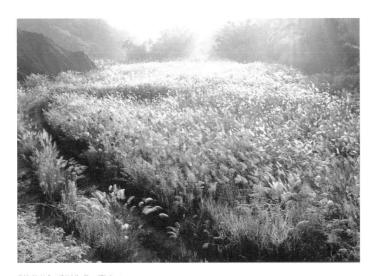

《菅芒花》系列作品 / 臺南 / 2004-2011
A work from the *Swordgrass* series / Tainan / 2004-2011

2000

| Photographing "ancient homes" and "swordgrass" subjects at Moon World |

Chang begins photographing ancient homes and swordgrass at Moon World. These, and his *Dream of Moon World* and *Colored Bamboo* themes, become Chang's "four treasures of Moon World." After working so many years at Moon World, its residents and even the local flora seem like family to him, and he also notices its declining population and deserted settlements. He then focuses on old earthen houses at Moon World, hoping to capture a fading era and the remnants of the residents' lives. The swordgrass that grows at Moon World also symbolizes for Chang the indomitable spirit of the Taiwanese people; the light and shadow captured by his lens constitute a kind of unique cultural landscape at Moon World.

- Shows *Colored Bamboo* works in *Spring for Long-Shoot Bamboo— A Nanying Native Culture Special Exhibition* (National Sun Yat-sen Memorial Hall).

- Participates in *Tainan Artists Series Joint Exhibition* (Fine Art Center, Tainan).

2001
- *Commonwealth* Magazine chooses a *Colored Bamboo* photo for the cover of its special 20th anniversary issue, *319 Townships Moving Ahead*, which includes "Ten Steps in the Grass: Chang Wu-chun—The Beauty of Taiwan in Close-ups."

- Participates in the members exhibition of the World Chinese Photography Society (Hong Kong).

2003
- Participates in *Impressions of the Age: The Museum Photographic Collection* exhibition (Kaohsiung Museum of Fine Arts).

張武俊參與世界華人攝影學會年會留影 / 香港 / 2001
Photo of Chang at the annual World Chinese Photography Society / Hong Kong / 2001

張武俊長年開車前往月世界取景
Chang visits Moon World throughout the year to take photographs

2004

| 投入《魚塭》系列創作 |

4月梅雨季開始前，往臺南七股拍攝魚塭。此後每年的梅雨季節前後，持續前往拍攝，捕捉光線映射下的藝術畫面，一直拍到2013年的夏天。不同於寫實路線的鄉土攝影，張武俊鏡頭下的魚塭以水波構成的光影線條為特色，在極為日常的主題之中，加入了攝影家對美的認知，較少被公開發表，但重要性並不亞於早期的《月世界》系列。

| 「夢幻月世界」攝影講座 |

受邀至國立成功大學醫學院舉辦攝影講座，分享於臺南左鎮與龍崎拍攝的《月世界》與《彩竹》景色。並於臺南市攝影文化會館與雪嶺文化事業合辦一系列影像藝術講座中，主講《夢幻月世界》專題。

- 彩色作品〈彩竹的故鄉〉獲國立臺灣美術館典藏。
- 獲聘為「南瀛藝術獎」視覺藝術類評審委員。
- 獲得中華藝術攝影家學會聘為第五屆郎靜山紀念攝影獎評審委員。
- 參與「千禧之愛」兩岸攝影聯展（國立國父紀念館）。

《魚塭》系列作品 / 張武俊攝 / 臺南 / 2009
A work from *the Fish Pond* series / photo by Chang
Tainan / 2009

2005

| 「家在山的那一邊」攝影講座 |

受邀至國立成功大學舉辦攝影講座，分享個人投入攝影的歷程、分析拍攝經驗與技巧，並介紹《月世界》、《彩竹》、《土角厝》等專題攝影作品，以及拍攝背後的故事。

- 擔任台南市攝影學會榮譽顧問。
- 獲聘為「南瀛藝術獎」視覺藝術類評審委員。
- 獲聘為二十三屆嘉義市攝影展評審委員。
- 參與「聚焦臺灣」唯美與寫實典藏展（國立臺灣美術館）。

2006

| 「由攝影看鄉土」演講 |

4月11日受邀前往成功大學醫學院演講，分享作品外，也說明個人的拍照目的，除了記錄行將流逝的古物，更注入自己對於視覺美感的追求。

- 參與「攝影作品典藏展」（臺北市立美術館）。

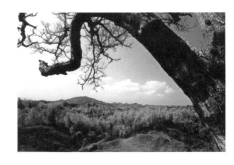

《彩竹的故鄉》系列作品 / 臺南 / 2010.2.27
A work from *The Home Town of Colored Bamboo* series
Tainan / 2010.2.27

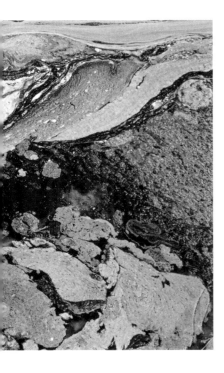

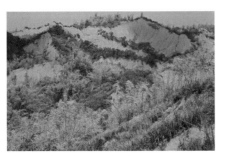

2004

| Work begins on the *Fish Pond* series |

Before the April rainy season, Chang travels to Qigu, Tainan, to shoot fish ponds, and continues each year both before and after the rainy season, artistically capturing reflected light until the summer of 2013. Unlike the realism of local photographers, Chang finds patterns of light and shadow on the waves that reflect a sense of beauty even in this commonplace subject. Less often seen by the public, these photos are no less important than Chang's earlier *Moon World* series.

| The "Dream of Moon World" Photography Lectures |

Chang lectures at the National Cheng Kung University School of Medicine, sharing *Moon World and Colored Bamboo* series photos from Zuozhen and Longqi in Tainan. He speaks about his *Dream of Moon World* in lectures hosted by the Tainan Photographic Culture Center and Hsueh Ling Cultural Enterprise.

- Chang's *Hometown of Colored Bamboo* photos are added to the National Taiwan Museum of Fine Arts collection.

- Appointed jury member in visual arts for the Nanying Art Award.

- Juries the 5th Lang Jing-shan Memorial Photography Award of the Chinese Art Photographers Association.

- Shows work in the *Millennium Love: Cross-Strait Photography Joint Exhibition* (National Sun Yat-sen Memorial Hall).

2005

| The "Home Is on the Far Side of the Mountain" lecture |

Chang lectures at National Cheng Kung University, sharing his growth and techniques as a photographer and the stories behind his *Moon World, Colored Bamboo*, and *Earthen Homes* works.

- Becomes honorary consultant for the Photographic Society of Tainan.

- uries the *23rd Chiayi Photographic Exhibition*.

- Shows works in the *Focus on Taiwan Aesthetic and Realistic Collection Exhibition* (National Taiwan Museum of Fine Arts).

2006

| Speech: "Our Native Land in Photographs" |

Chang lectures on April 11 at the National Cheng Kung University School of Medicine, sharing photos and explaining his desire to preserve images of fading relics and to pursue visual beauty.

- Participates in the *Photographic Works Collection Exhibition* (Taipei Fine Arts Museum).

《彩竹的故鄉》系列作品 / 臺南 / 2010.2.28
A work from *The Home Town of Colored Bamboo* series
Tainan / 2010.2.28

2007

| 投入《萬年峽谷》系列創作 |

在朋友邀約下，開始拍攝雲林古坑草嶺地區《萬年峽谷》專題，持續了五、六年。由於張武俊幾乎每天都有拍攝的行程，也會技巧性的依照天氣、光線等因素排定一天中工作的地點，因此通常都是同時進行不同拍攝主題的創作。該系列和2004開啟的《魚塭》看似不同，但在張武俊的鏡頭下，都構成具有獨特美感的文化地景。

• 參與世界華人攝影學會會員展（上海）。

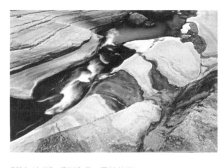

《萬年峽谷》系列作品 / 雲林草嶺 / 2007-2009
A work from the *Wannian Canyon* series
Caoling, Yunlin / 2007-2009

2008

• 協助《聚焦府城—臺南市攝影發展史及史料》（臺南市政府）之編撰。

• 中華電信MOD臺南營運處為張武俊拍攝紀錄片《月世界的夢》。

2011

• 〈孔廟系列之一〉獲臺南市美術館籌備處典藏。

• 「用心看臺南」攝影邀請展（臺南市立新營文化中心）。

• 參與「時代之眼——臺灣百年身影」展（臺北市立美術館）。

2013

| 發表《萬年峽谷》專題系列 |

《萬年峽谷》專題系列發表於《藝術家》雜誌，由蕭瓊瑞撰寫專文〈鄉土的色溫：張武俊的萬年峽谷攝影〉介紹。蕭瓊瑞給予《萬年峽谷》系列作品極高的評價，認為是張武俊眾多系列中「色彩最具變化、構成最為自由」者。

| 作品捐贈 |

捐贈臺南市美術館籌備處共672件攝影作品，作品目前隸屬於臺南市政府文化局。

捐贈200多件作品與800多冊攝影類書籍，給國立臺南大學圖書館典藏，並參與國立臺南大學美術系舉辦的「銳利凝視深情詮釋——白堊・彩竹・左鎮情」詩、書、畫（攝影作品）聯展。

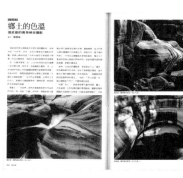

〈鄉土的色溫：張武俊的萬年峽谷攝影〉專文頁面
2013
Pages from the essay "The Color Temperature of our Native Land: Chang Wu-chun Photographs the *Wannian Canyon*" / 2013

2007 | Work begins on the *Wannian Canyon* series |

At a friend's invitation, Chang makes the *Wannian Canyon*, in the Caoling region of Yunlin's Gukeng, as his subject for about six years. With shoots scheduled nearly every day, Chang considers factors such as weather and light so as to simultaneously work on different themes. While this series differs from the *Fish Pond* series begun in 2004, both contribute to the cultural landscape with their unique kinds of beauty.

- Participates in the *World Chinese Photography Society Members Exhibition* (Shanghai).

2008
- Assists with compilation of *Focus on Fucheng—History and Related Materials on the Development of Photography in Tainan* (Tainan City Government).
- Chunghwa Telecom's Tainan MOD Operations Office films the documentary *Dream of Moon World* for Chang.

2011
- *Confucian Temple Series, No. 1* is added to the Tainan Art Museum Preparatory Office collection.
- *Attention on Tainan Invitational Photography Exhibition* (Tainan Municipal Xinying Cultural Center).
- Participates in *Eye of the Times: Centennial Images of Taiwan* exhibition (Taipei Fine Arts Museum).

2013 | Publication of the *Wannian Canyon* thematic series |

The *Wannian Canyon* series is published in *Artist* magazine, with introductory essay, "The Color Temperature of our Native Land: Chang Wu-chun Photographs Wannian Canyon," by Xiao Qiong-rui. Xiao praises the series as possessing "the freest compositions and most varied colors" among Chang's many photographic series.

| Donation of Works |

Chang donates 672 photos to the Tainan Art Museum, which are now held at the Tainan Cultural Affairs Bureau.

Chang donates more than 200 works and 800 books on photography to National Tainan University, and participates in the university's group exhibition of poems, calligraphy, and paintings (or photographs), *Sharp Gaze, Loving Interpretation—Chalk, Colored Bamboo, and Love for Zuozhen.*

〈孔廟守護者〉/ 臺南 / 張武俊攝
Guardians of the Confucian Temple / Tainan
photo by Chang

2014

｜舉辦「堅毅的生命光影──張武俊攝影捐贈展」｜

展覽設於臺南蕭壠文化園區A4館。本展覽為臺南市美術館籌備處為感謝張武俊前一年捐贈672件作品而籌畫，該展以「月世界」、「彩竹」、「古厝」、「印象風景」等四個主題呈現其作品。

｜「攝影家張武俊」專文介紹｜

《鹽分地帶文學》第55期（2014年12月號）中，李欽賢以專文〈臺南地景的表情──攝影家張武俊〉介紹張武俊其人其作。文中特別點出張武俊的誠懇與認真，雖然身為攝影人，但從不強調器材或理論，只堅持腳踏實地，對家鄉風土的用心觀察與紀錄。本文也公開發表了部分的《魚塭》與《月世界土角厝》系列作品，並透過這兩套新的系列作品，對張武俊獨特的鏡頭語彙做了進一步的賞析。

• 獲頒南美會「成就獎」。

張武俊（左）與南美會理事長佘明娟合影 / 2016
Chang (left) with Director-General of the Tainan Arts
Association, She Ming-juan / 2016

2015

• 受邀擔任第63屆南美會評審。

2016

•《月世界土角厝》系列作品獲南美會典藏。

2018

｜文化局「焦點攝影家張武俊」計畫｜

臺南市文化局展開「台南國際攝影節：焦點攝影家張武俊」研究工作。由策展人陳伯義、研究員廖云翔針對張武俊尚未公開發表的作品，包括土角厝、菅芒花、魚塭等系列進行底片原件掃描與創作背景紀錄。

南美會成就獎 / 2014
The Tainan Arts Association Achievement
Award / 2014

2021

獲臺南市政府頒贈「臺南卓越市民」。

張武俊參與第 63 屆南美會 / 2015
Chang attends the 63rd Tainan Arts Association
competition / 2015

2014 | Holding the *Life's Persistent Light and Shadow—A Chang Wu-chun Photography Donation Exhibition* |

Organized by the Tainan Art Museum to thank Chang for his donation of 672 works, the exhibition is held in Tainan's Soulangh Cultural Park, and focuses on four of Chang's themes: *Moon World, Colored Bamboo, Ancient Homes*, and *Impressionistic Scenery*.

| Publication of Chang Wu-chun essay |

The 55th issue of *Salt Zone Literature* (December 2014) introduces Chang and his works in an essay by Li Qin-xian, "Expressions of Tainan's Landscape—Photographer Chang Wu-chun." The article highlights Chang as a serious photographer less concerned with theory or equipment than with observing and recording local scenes. Works from Chang's *Fish Pond* and *Earthen Homes at Moon World* series accompany the article to augment understanding of his unique photographic vocabulary.

- Receives Achievement Award from the Tainan Arts Association.

2015 • Juries the 63rd Tainan Arts Association Competition.

2016 • The *Earthen Homes at Moon World* series is added to the Tainan Arts Association collection.

2018 | The Cultural Affairs Bureau's "Focus on Photographer Chang Wu-chun" Project |

The Tainan Bureau of Culture launches the "Tainan International Photography Festival: Focus on Photographer Chang Wu-chun" research project. Curator Chen Bo-yi and researcher Liao Yun-xiang scan original negatives and document the background of Chang's unpublished works, including photos from the *Earthen Homes, Swordgrass,* and *Fish Pond* series.

2021 The Tainan City Government confers its "Outstanding Citizen of Tainan" award on Chang.

針對底片元件掃描、檔案數位化的工作歷程記錄
廖云翔攝 / 臺南 / 2021
Scanning Chang's donated negatives and creating
digital files / photo by Liao Yun-xiang / Tainan / 2021

張武俊簡歷

1942年出生於臺南，臺灣
現居住於臺南

個展

2014	「堅毅的生命光影——張武俊攝影捐贈展」，臺南蕭壠文化園區A4館，臺灣
1999	「彩竹的故鄉」個展，嘉義市立文化中心、新竹縣立文化中心、臺南縣立文化中心，臺灣
1998	「彩竹的故鄉」個展，臺北市立美術館、臺灣省立美術館、臺南市立文化中心、高雄市立文化中心、臺灣創價學會新竹藝文中心，臺灣
1995	「全臺首學」個展，臺北爵士藝廊、臺南市立文化中心，臺灣
1994	「夢幻月世界」攝影展，臺南縣立文化中心，臺灣
1992	「夢幻月世界」攝影個展，臺北市立美術館、臺灣省立美術館、臺南市立文化中心，臺灣

聯展選錄

2011	「時代之眼——臺灣百年身影」展，臺北市立美術館，臺灣
2006	「攝影作品典藏展」，臺北市立美術館，臺灣
2005	「聚焦臺灣」唯美與寫實典藏展，國立臺灣美術館，臺中，臺灣
2003	「時代顯影」攝影典藏展，高雄市立美術館，臺灣
1986	第一屆「中華民國當代美術大展」，高雄，臺灣

作品典藏

2016	《月世界土角厝》，台南美術研究會，臺南，臺灣
2011	〈孔廟系列之一〉，臺南市美術館籌備處，臺灣
2004	〈彩竹的故鄉〉，國立臺灣美術館，臺中，臺灣
1997	〈草山月世界全景〉，高雄市立美術館，臺灣
1995	〈安平夜色〉，國立臺灣藝術館，臺北，臺灣
1993	《夢幻月世界》系列作品五件，臺北市立美術館，臺灣
1993	〈守護神〉，國立臺灣藝術教育館，臺北，臺灣
1991	〈金馬寮〉，高雄市立美術館，臺灣
1991	〈孔廟守護者〉、〈十美圖〉、〈成長〉，國立臺灣藝術教育館，臺北，臺灣

獲獎

2021	臺南卓越市民獎，臺南市政府，臺灣
2014	南美會「成就獎」，臺南，臺灣
1996	第37屆中國文藝獎章美術類「藝術攝影獎」，臺灣
1993	教育部文藝創作獎攝影類第二名，臺灣
1992	第十三屆全國美展金龍獎攝影類第二名，臺灣
1988	第36屆南美展攝影類第一名，臺南美術研究會，臺灣
1986	攝影藝術貢獻獎，臺南市政府，臺灣
1984	柯達全國攝影大賽金牌獎，臺灣
1983	臺灣攝影沙龍年度金牌獎，臺灣
1983	富士全國攝影大賽金牌獎，臺灣
1981	第14屆臺灣影展銀像獎與最佳創意獎，臺灣
1981	櫻花全國攝影大賽金牌獎，臺灣

Chang Wu-chun Biography

Born in 1942 in Tainan, Taiwan
Living in Tainan, Taiwan

Solo Exhibitions

2014 *The Persistent Light and Shadow of Life—A Chang Wu-chun Photography Donation Exhibition*, Tainan's Soulangh Cultural Park, Taiwan

1999 *Hometown of Colored Bamboo* solo exhibition, Chiayi Municipal Cultural Center, Hsinchu County Cultural Center, Tainan County Cultural Center, Taiwan

1998 *Hometown of Colored Bamboo* solo exhibition, Taipei Museum of Fine Art, Taiwan Provincial Museum of Art, Tainan Municipal Cultural Center, Kaohsiung Municipal Cultural Center, Hsinchu Art Center of Taiwan Soka Association, Taiwan

1995 *Confucian Temple* solo exhibition, Taipei Jazz Gallery and Tainan Municipal Cultural Center

1994 *Dream of Moon World* exhibition, Tainan County Cultural Center, Taiwan

1992 *Dream of Moon World* solo photography exhibition, Taipei Fine Arts Museum, Taiwan Provincial Museum of Art, Tainan Municipal Cultural Center, Taiwan

Group Exhibitions (Selected)

2011 *Eye of the Times: Centennial Images of Taiwan* exhibition, Taipei Fine Arts Museum, Taiwan

2006 *Photographic Works Collection Exhibition*, Taipei Fine Arts Museum, Taiwan

2005 *Focus on Taiwan* Aesthetic and Realistic Collection Exhibition, National Taiwan Museum of Fine Arts, Taichung, Taiwan

2003 *Impressions of the Age: The Museum Photographic Collection* exhibition, Kaohsiung Museum of Fine Arts, Taiwan

1986 1st *ROC Contemporary Art Exhibition*, Kaohsiung, Taiwan

Collections

2016 *Earthen Homes at Moon World* series, Tainan Arts Association, Taiwan

2011 *Confucian Temple Series No. 1*, Tainan Art Museum Preparatory Office, Taiwan

2004 *Hometown of Colored Bamboo*, National Taiwan Museum of Fine Arts, Taichung, Taiwan

1997 *Caoshan Moon World Panorama*, Kaohsiung Museum of Arts, Taiwan

1995 *Anping Night*, National Taiwan Museum of Arts, Taichung, Taiwan

1993 Five works from the *Dream Moon World* series, Taipei Municipal Art Museums, Taiwan

1993 *Guardian Spirit*, National Taiwan Arts Education Centers, Taipei, Taiwan

1991 *Jinmaliao*, Kaohsiung Museum of Arts, Taiwan

1991 *Guardians of the Confucian Temple*, *Ten Beautiful Pictures*, and *Growth*, National Taiwan Arts Education Centers, Taipei, Taiwan

Awards

2021 "Outstanding Citizen of Tainan" award, The Tainan City Government, Taiwan

2014 "Achievement Award" from the Tainan Arts Association, Taiwan

1996 37th China Literature and Art Medal, art category, Taiwan

1993 The Second place Art and Literature Creative Award for photography from the Ministry of Education, Taiwan

1992 The Second place Golden Dragon Award for photography at the 13th National Art Exhibition, Taiwan

1988 The First place 36th Tainan Arts Exhibition, Tainan Fine Arts Research Association, Taiwan

1986 "Contribution to Photographic Art" award from Tainan City Government, Taiwan

1984 Gold medal in Fuji National Photo Contest, Taiwan

1983 Gold medal in the Taiwan Photography Salon, Taiwan

1983 Gold medal in Fuji National Photo Contest, Taiwan

1981 Silver Medal and Best Creative Award at the 14th Taiwan Film Festival, Taiwan

1981 Gold Medal at the Sakura National Photography Contest, Taiwan

《夢幻月世界》
高雄燕巢 / 1987
Dream of Moon World
Yanchao, Kaohsiung / 1987
P.66-67

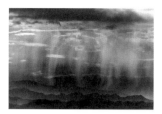

《夢幻月世界》
龍崎大坪 / 1988.5
Dream of Moon World
Daping, Longqi / 1988.5
P.46

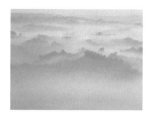

《夢幻月世界》
大林尾 / 1988.8.5
Dream of Moon World
Dalinwei / 1988.8.5
P.52

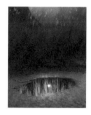

《夢幻月世界》
二寮 / 1989.10
Dream of Moon World
Erliao / 1989.10
P.55

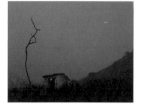

《月世界土角厝》/ 動員
1989.12.21
Earthen Houses at Moon World
Dongyuan / 1989.12.21
P.102

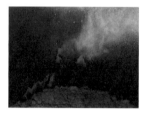

《夢幻月世界》
金山 / 1990.1
Dream of Moon World
Jinshan / 1990.1
P.64-65

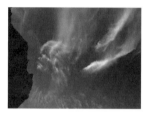

《夢幻月世界》
茵夢湖 / 1990.5.17
Dream of Moon World
Yinmen Lake / 1990.5.17
P.53

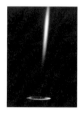

《夢幻月世界》
青瓜寮 / 1990.12.8
Dream of Moon World
Qinggualiao / 1990.12.8
P.49

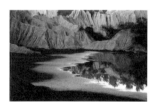

《夢幻月世界》
心仔寮 / 1990.12.24
Dream of Moon World
Sinzihliao / 1990.12.24
P.48

《夢幻月世界》
金馬寮 / 1990.12
Dream of Moon World
Jinmaliao / 1990.12
P.47

《夢幻月世界》
動員 / 1991.3.8
Dream of Moon World
Dongyuan / 1991.3.8
P.59

《夢幻月世界》
金馬寮 / 1991.3.24
Dream of Moon World
Jinmaliao / 1991.3.24
P.56

《夢幻月世界》
金馬寮 / 1991.3
Dream of Moon World
Jinmaliao / 1991.3
P.68

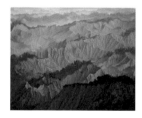

《夢幻月世界》
大林尾 / 1991.12.26
Dream of Moon World
Dalinwei / 1991.12.26
P.50-51

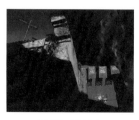

《安平》安平夜色
臺南 / 1992-1995
Anping, Night in Anping
Tainan / 1992-1995
P.103

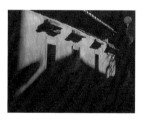

《安平》安平夜色
臺南 / 1992-1995
Anping, Night in Anping
Tainan / 1992-1995
P.103

《安平》安平夜色
臺南 / 1992-1995
Anping, Night in Anping
Tainan / 1992-1995
P.103

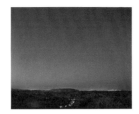

《夢幻月世界》
龍崎烏山頭 / 1993.1
Dream of Moon World
Wushantou, Longqi / 1993.1
P.57

《全臺首學》
臺南 / 1993.8.15
Confucian Temple
Tainan / 1993.8.15
P.85

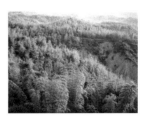

《彩竹的故鄉》
烏山頭 / 1994.1.6
The Hometown of Colored Bamboo
Wushantou / 1994.1.6
P.70

《彩竹的故鄉》
山月湖 / 1994.2
The Hometown of Colored Bamboo
Mountain Moon Lake / 1994.2
P.75

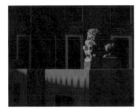

《全臺首學》
臺南 / 1994.4.8
Confucian Temple
Tainan / 1994.4.8
P.89

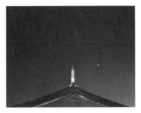

《全臺首學》
臺南 / 1994.4.20
Confucian Temple
Tainan / 1994.4.20
P.90-91

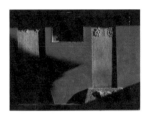

《全臺首學》
臺南 / 1994.5.15
Confucian Temple
Tainan / 1994.5.15
P.86

《全臺首學》
臺南 / 1994.8.6
Confucian Temple
Tainan / 1994.8.6
P.84

《全臺首學》
臺南 / 1994.8.23
Confucian Temple
Tainan / 1994.8.23
P.87

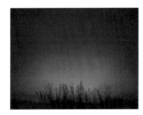

《彩竹的故鄉》
玉井後坑 / 1995.12
The Hometown of Colored Bamboo
Houkeng, Yujing / 1995.12
P.80

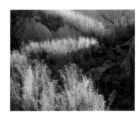

《彩竹的故鄉》
丘園 / 1996.3.17
The Hometown of Colored Bamboo
Qiuyuan / 1996.3.17
P.71

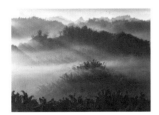

《彩竹的故鄉》
二寮 / 1996.6.6
The Hometown of Colored Bamboo
Erliao / 1996.6.6
P.72

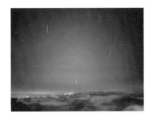

《夢幻月世界》
二寮 / 1996.8.6
Dream of Moon World
Erliao / 1996.8.6
P.60

《彩竹的故鄉》
龍崎 / 1996.9
The Hometown of Colored Bamboo
Longqi / 1996.9
P.78-79

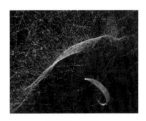

《彩竹的故鄉》
大林尾 / 1996.10
The Hometown of Colored Bamboo
Dalinwei / 1996.10
P.73

《彩竹的故鄉》
龍崎石嘈 / 1996.10
The Hometown of Colored Bamboo
Shihcao, Longqi / 1996.10
P.74

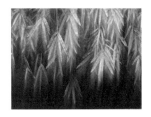

《彩竹的故鄉》
龍崎龍船窩 / 1997.2
The Hometown of Colored Bamboo
Wushantou, Longqi / 1997.2
P.76-77

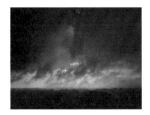

《夢幻月世界》
二寮 / 1997.6.27
Dream of Moon World
Erliao / 1997.6.27
P.61

《彩竹的故鄉》
烏山頭 / 1997
The Hometown of Colored Bamboo
Wushantou / 1997
P.81

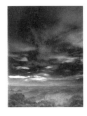

《夢幻月世界》
二寮 / 1998.6.22
Dream of Moon World
Erliao / 1998.6.22
P.62

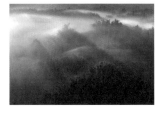

《夢幻月世界》
二寮 / 1998.7.26
Dream of Moon World
Erliao / 1998.7.26
P.58

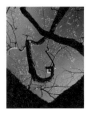

《梅花》
風櫃斗 / 1998-2011
Plum Blossom
Fonggueidou / 1998-2011
P.118

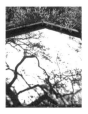

《梅花》
南投信義 / 1998-2011
Plum Blossom
Xinyi, Nantou / 1998-2011
P.119

《梅花》
嘉義阿里山 / 1998-2011
Plum Blossom
Alishan, Chiayi / 1998-2011
P.119

《全臺首學》
臺南 / 1999.1.19
Confucian Temple
Tainan / 1999.1.19
P.88

《月世界土角厝》
龍崎大坪 / 1999.10.23
Earthen Houses at Moon World
Daping, Longqi / 1999.10.23
P.92

《月世界土角厝》
龍崎大坪 / 1999.10.30
Earthen Houses at Moon World
Daping, Longqi / 1999.10.30
P.93

《月世界土角厝》
龍崎烏樹林 / 1999.11.26
Earthen Houses at Moon World
Wushulin, Longqi / 1999.11.26
P.97

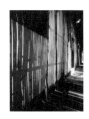

《月世界土角厝》
二寮楊春安宅 / 1999.12.9
Earthen Houses at Moon World
Erliao / 1999.12.9
P.100

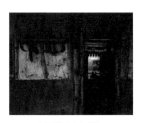

《月世界土角厝》
龍崎土崎村 / 1999.12.10
Earthen Houses at Moon World
Tsuchi Village, Longqi / 1999.12.10
P.96

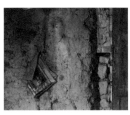

《月世界土角厝》
龍崎牛埔 / 2000.2.7
Earthen Houses at Moon World
Nioupu, Longqi / 2000.2.7
P.94

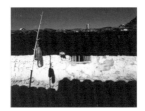

《月世界土角厝》
龍崎蝦蜞埔 / 2000.4.30
Earthen Houses at Moon World
Wuqipu, Longqi / 2000.4.30
P.99

《月世界土角厝》
龍崎大坪 / 2000.5.14
Earthen Houses at Moon World
Daping, Longqi / 2000.5.14
P.96

《月世界土角厝》
內門 / 2000.12.17
Earthen Houses at Moon World
Neimen / 2000.12.17
P.95

《月世界土角厝》
龍崎牛埔 / 2000.12.21
Earthen Houses at Moon World
Nioupu, Longqi / 2000.12.21
P.98

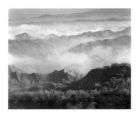

《彩竹的故鄉》
308 高地優美山莊 / 2001.3.27
The Hometown of Colored Bamboo
Beautiful Villa / 2001.3.27
P.71

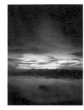

《夢幻月世界》
二寮 / 2001.6.19
Dream of Moon World
Erliao / 2001.6.19
P.63

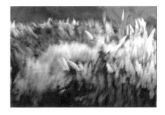

《菅芒花》
五里坑 / 2004.9.26
Swordgrass
Wulikeng / 2004.9.26
P.106

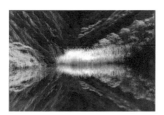

《菅芒花》
臺南 / 2004-2011
Swordgrass
Tainan / 2004-2011
P.107

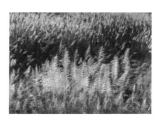

《菅芒花》
臺南 / 2004-2011
Swordgrass
Tainan / 2004-2011
P.108

《菅芒花》
臺南 / 2004-2011
Swordgrass
Tainan / 2004-2011
P.110

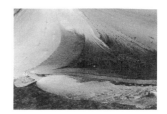

《魚塭》
七股 / 2004-2013
Fish Pond
Qigu / 2004-2013
P.130

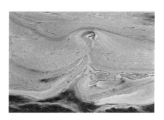

《魚塭》
七股 / 2004-2013
Fish Pond
Qigu / 2004-2013
P.131

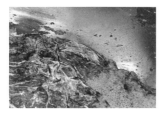

《魚塭》
七股 / 2004-2013
Fish Pond
Qigu / 2004-2013
P.132

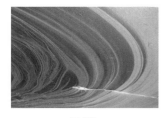

《魚塭》
七股 / 2004-2013
Fish Pond
Qigu / 2004-2013
P.133

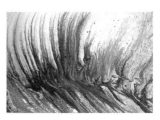

《魚塭》
七股 / 2004-2013
Fish Pond
Qigu / 2004-2013
P.135

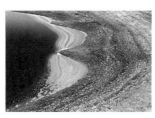

《魚塭》
七股 / 2004-2013
Fish Pond
Qigu / 2004-2013
P.140

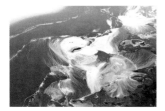

《魚塭》
七股 / 2004-2013
Fish Pond
Qigu / 2004-2013
P.141

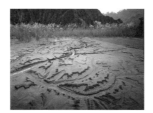

《菅芒花》
燕巢金山 / 2006.9.18
Swordgrass
Jinshan, Yanchao / 2006.9.18
P.108

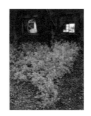

《鳳凰木》
大湖 / 2007.5.21
Royal Poinciana
Dahu / 2007.5.21
P.116

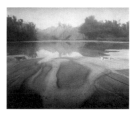

《夢幻月世界》
青瓜寮 / 2007.10.25
Dream of Moon World
Qinggualiao / 2007.10.25
P.69

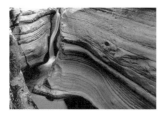

《萬年峽谷》
雲林草嶺 / 2007.12.21
Wannian Canyon
Caoling, Yunlin / 2007.12.21
P.144

《萬年峽谷》
雲林草嶺 / 2007.12.28
Wannian Canyon
Caoling, Yunlin / 2007.12.28
P.149

《魚塭》
七股 / 2007
Fish Pond
Qigu / 2007
P.136-137

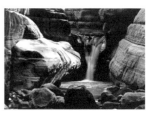

《萬年峽谷》
雲林草嶺 / 2007
Wannian Canyon
Caoling, Yunlin / 2007
P.144-145

《鳳凰木》
大湖 / 2008.5
Royal Poinciana
Dahu / 2008.5
P.116

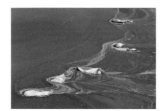

《魚塭》
十份 / 2008.6.19
Fish Pond
Shifen / 2008.6.19
P.129

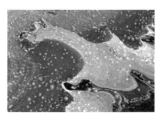

《魚塭》
十份 / 2008.10.25
Fish Pond
Shifen / 2008.10.25
P.129

《魚塭》
三股 / 2009.5.30
Fish Pond
Sangu / 2009.5.30
P.138

《魚塭》狂歡
三股 / 2009.7.12
Spree from Fish Pond,
Sangu / 2009.7.12
P.128

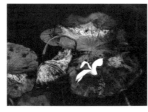

《荷花》
沙崙 / 2009.8.15
Lotuses
Shalun / 2009.8.15
P.113

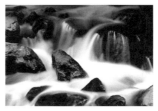

《萬年峽谷》
雲林草嶺 / 2009.10.31
Wannian Canyon
Caoling, Yunlin / 2009.10.31
P.145

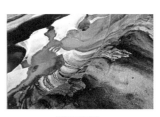

《萬年峽谷》
雲林草嶺 / 2009.11.22
Wannian Canyon
Caoling, Yunlin / 2009.11.22
P.146-147

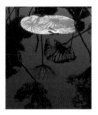

《荷花》
臺南 / 2009-2013
Lotuses
Tainan / 2009-2013
P.111

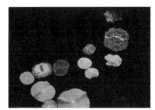

《荷花》
沙崙 / 2010.4.18
Lotuses
Shalun / 2010.4.18
P.114

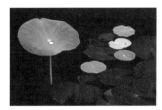

《荷花》
沙崙 / 2010.4.23
Lotuses
Shalun / 2010.4.23
P.114

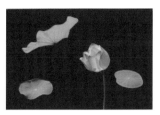

《荷花》
沙崙 / 2010.7.15
Lotuses
Shalun / 2010.7.15
P.115

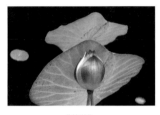

《荷花》
沙崙 / 2010.7.25
Lotuses
Shalun / 2010.7.25
P.115

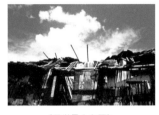

《月世界土角厝》
新光村 / 2010.9.10
Earthen Houses at Moon World
Xinguang Villiage / 2010.9.10
P.99

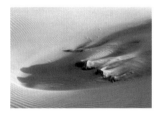

《濱海沙丘》
三股 / 2011.1.18
Coastal Dunes
Sangu / 2011.1.18
P.122

《荷花》
臺南永康公園 / 2011.6.25
Lotuses
Yongkang Park, Tainan / 2011.6.25
P.113

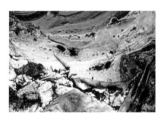

《魚塭》
海埔 / 2011.7.26
Fish Pond
Haipu / 2011.7.26
P.134

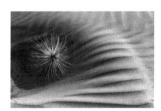

《濱海沙丘》
三股 / 2011.8.26
Coastal Dunes
Sangu / 2011.8.26
P.123

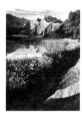

《菅芒花》
青瓜寮 / 2011.9.29
Swordgrass
Qinggualiao / 2011.9.29
P.109

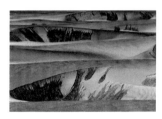

《濱海沙丘》
三股 / 2011
Coastal Dunes
Sangu / 2011
P.124-125

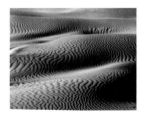

《濱海沙丘》
三股 / 2011
Coastal Dunes
Sangu / 2011
P.126

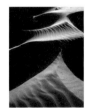

《濱海沙丘》
三股 / 2011
Coastal Dunes
Sangu / 2011
P.127

《魚塭》
三股 / 2012.5.14
Fish Pond
Sangu / 2012.5.14
P.139

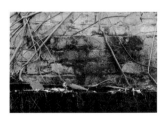

《鳳凰木》
大湖 / 2012.5.19
Royal Poinciana
Dahu / 2012.5.19
P.117

《荷花》
新營天鵝湖 / 2013.9
Lotuses
Swan Lake, Xinying / 2013.9
P.112

參考書目 ————————

一、中文專書

1. Heinrich Wolfflin著，曾雅雲譯，《藝術史的原則》，臺北：雄獅美術，1987。
2. 郭力昕，《再寫攝影》，臺北：田園城市，2014。
3. 張武俊，《夢幻月世界：張武俊攝影作品集》，臺北：臺北市立美術館，1992。
4. 張武俊，《彩竹的故鄉》，臺北：臺北市立美術館，1998。
5. 許淵富，《1860-2006聚焦府城——臺南市攝影發展史及史料》，臺南：臺南市政府，2008。
6. 潘福總編輯，《覓南美9——捕捉月世界的風情萬種 張武俊》，臺南：臺南市美術館，2020。
7. 簡永彬，《看見的時代——影會時期的影像追尋1940s-1970s》，臺北：夏綠原國際，2014。

二、中文期刊論文

1. 王雅倫，〈隱匿的風景——郎靜山「風景攝影」作品與西方的第一次接觸〉，《年代風華——郎靜山逝世13週年紀念展》座談會論文，臺北：國立歷史博物館，2008，頁28。
2. 李欽賢，〈臺南地景的表情——攝影家張武俊〉，《鹽分地帶文學》第55期（2014.12），頁30-31。
3. 作者不詳，〈臺灣之自然界〉，《臺灣博物學會會報》第3卷第11號（1913），頁113。
4. 許汝玉，〈背著相機彩繪天地——記月世界中的痴人張武俊〉，《鄉城生活雜誌》第55期（1998.8），頁67。
5. 黃華安，〈三十年磨一劍的月世界守護者〉，《覓南美》，第9卷（2020.8），頁21。
6. 游永福，〈照見臺灣的容顏——1871年英國攝影家約翰·湯姆生南臺灣驚艷〉，《高雄文獻》第4卷第3期（2014.12），頁178-180。
7. 盧施福，〈我的藝術攝影觀〉，《中國攝影》第11期（2017），頁91。
8. 謝震乾，〈心象風景〉，《台灣攝影》第22期（1966.8.25）。
9. 關秀惠，〈臺南市攝影學會的記憶溯源——訪問攝影家王徵吉〉，《南美館月訊》（2018.4）版2。
10. 蕭瓊瑞，〈鄉土的色溫——張武俊的萬年峽谷攝影〉，《藝術家》第458期（2013.7），頁256、259。

三、博碩士論文

1. 宋南萱，〈臺灣八景從清代到日據時期的轉變〉，國立中央大學藝術學研究所碩士論文，2000。

四、外文資料

1. W.J.T. Mitchell, "Introduction," *Landscape and Power*, Chicago: The University of Chicago Press, 1994, pp. 1-2
2. 〈臺灣山岳會の科學的使命 調查部の內容を充實せよ〉，《臺灣日日新報》（1927.8.23）版2。
3. 〈本島學界の權威者連　南湖大山を蹈破　學術的の深究を行ふ　臺灣山岳會の主催〉，《臺灣日日新報》（1928.10.19）夕版1。
4. 社團法人臺灣山岳會，〈月の世界探勝（徒步第十九回）〉，《臺灣山岳彙報》第14卷第6期（1942.6），頁5-6。
5. 作者不詳，〈臺灣山岳會設立趣意書〉，《臺灣山岳》第1期（1927.4），頁3。
6. 作者不詳，〈世に珍しい　泥火山見物　恰も月の世界をさまよふ如き奇觀〉，《臺灣日日新報》（1929.4.5）版5。
7. 齋藤齋，〈火炎山と泥火山〉，《臺灣山岳彙報》第15卷第3期（1943.3），頁1。

五、其他

1. 張武俊演講，〈夢幻月世界：張武俊老師〉（2004.1.22），網址：https://www.youtube.com/watch?v=v9oTuh-Dl94，2021.7.11瀏覽。
2. 張武俊演講，〈由攝影看鄉土-醫學生自我成長系統〉（2006.4.11），網址：https://www.youtube.com/watch?v=g6csQxWSHnk，2021.6.9瀏覽。
3. 簡永彬，〈何謂沙龍？何謂寫實？——臺灣攝影文化發展的一段艱辛〉，《夏門攝影企劃研究室》，網址：https://zh-cn.facebook.com/media/set/?set=a.478035122219539.104311.386967567992962&type=1，2021.7.14瀏覽。

臺灣攝影家 Photographers of Taiwan

張武俊 CHANG Wu-chun

研究主編兼主筆｜關秀惠
專文｜郭懿萱
年表｜馬國安

指導單位｜文化部
出 版 者｜國立臺灣美術館
發 行 人｜梁永斐
編輯委員｜汪佳政 亢寶琴 蔡昭儀 黃舒屏 薛燕玲
　　　　　賴岳貞 曾淑錢 劉木鎮 張智傑 陳俊廷
諮詢委員｜姚瑞中 孫松榮 陳伯義 張蒼松 簡榮泰
審查委員｜沈昭良 莊　靈 高志尊 張蒼松 陳伯義 簡榮泰 蕭瓊瑞
執行編輯｜蔡旻螢
英譯審稿｜陳柏旭
地　　址｜403 臺中市西區五權西路一段2號
電　　話｜04-2372-3552
傳　　真｜04-2372-1195
網　　址｜https://www.ntmofa.gov.tw

編輯印製｜左右設計股份有限公司
專書審訂｜王雅倫
文字審校｜呂筱渝
英文翻譯｜William Dirks（杜文宇）
英譯審稿｜T. C. Lin（林道明）
影像提供｜張武俊 廖云翔 洪碩甫 陳次雄 關秀惠 臺灣大學圖書館
　　　　　臺北市立美術館 高雄市立美術館
總　　監｜施聖亭
執行編輯｜蘇香如 張欣宇
圖片編輯｜廖云翔
美術設計｜孫秋平 吳明黛 鍾文深
影像處理｜廖云翔
地　　址｜106 臺北市大安區仁愛路3段17號3樓
電　　話｜02-2781-0111

初　　版｜2021年12月
定　　價｜980 元
GPN　1011001475
ISBN　978-986-532-417-9

國家圖書館出版品預行編目資料

臺灣攝影家：張武俊 / 關秀惠、郭懿萱、馬國安撰文.
-- 初版.--
臺中市：臺灣美術館，2021.12
208 面；21.5 × 27.1 公分
ISBN 978-986-532-417-9（硬殼精裝）
1. 張武俊 2. 攝影師 3. 攝影集
959.33　　　　　　　　　　　　　　　110016432

展售處

國立臺灣美術館精品商店
403535　臺中市西區五權西路一段2號
04-2372-3552

五南文化廣場
400002　臺中市中區中山路6號
04-2226-0330

國家書店
104472　臺北市松江路209號1樓
02-2518-0207

國家攝影文化中心－臺北館
100007　臺北市中正區忠孝西路一段70號